CINDY SHERMAN

OCTOBER FILES

George Baker, Yve-Alain Bois, Benjamin H. D. Buchloh, Leah Dickerman, Hal Foster, Denis Hollier, Rosalind Krauss, Annette Michelson, Mignon Nixon, and Malcolm Turvey, editors

Richard Serra, edited by Hal Foster with Gordon Hughes
Andy Warhol, edited by Annette Michelson
Eva Hesse, edited by Mignon Nixon
Robert Rauschenberg, edited by Branden W. Joseph
James Coleman, edited by George Baker
Cindy Sherman, edited by Johanna Burton

CINDY SHERMAN

edited by Johanna Burton

essays by Craig Owens, Douglas Crimp, Judith Williamson, Abigail Solomon-Godeau, Laura Mulvey, Norman Bryson, Rosalind Krauss, Kaja Silverman, Hal Foster, and Johanna Burton

OCTOBER FILES 6

The MIT Press
Cambridge, Massachusetts
London, England

MIT Press books may be purchased at special quantity discounts for business or sales promotional use. For information, please e-mail special_sales@mitpress.mit.edu or write to Special Sales Department, The MIT Press, 55 Hayward Street, Cambridge, MA 02142.

This book was set in Bembo and Stone Sans by Graphic Composition, Inc., Athens, Georgia, and printed and bound in Spain.

Library of Congress Cataloging-in-Publication Data

Cindy Sherman / edited by Johanna Burton ; essays by Craig Owens . . . [et al.].
 p. cm. — (October files ; 6)
 ISBN-10: 0-262-02608-2 ISBN-13: 978-0-262-02608-6 (alk. paper)
 ISBN-10: 0-262-52463-5 ISBN-13: 978-0-262-52463-6 (pbk : alk. paper)
 1. Photographic criticism. 2. Sherman, Cindy—Criticism and Interpretation.
 I. Sherman, Cindy. II. Burton, Johanna. III. Owens, Craig. IV. Series.
 TR187.C56 2006
 770.92—dc22
 2006046242

10 9 8 7 6 5 4 3 2 1

Contents

In some cases, the essays in this volume were published in more than one incarnation. In the interest of maintaining the original sequence chronicling authors in direct dialogue with one another, essays with two publication dates reflect both the time of the initial writing and the date for subsequent versions. In these essays, the later version has generally been amended by its author for clarity and reflects no radical change in content.—Ed.

OCTOBER Files addresses individual bodies of work of the postwar period that meet two criteria: they have altered our understanding of art in significant ways, and they have prompted a critical literature that is serious, sophisticated, and sustained. Each book thus traces not only the development of an important oeuvre but also the construction of the critical discourse inspired by it. This discourse is theoretical by its very nature, which is not to say that it imposes theory abstractly or arbitrarily. Rather, it draws out the specific ways in which significant art is theoretical in its own right, on its own terms and with its own implications. To this end we feature essays, many first published in *OCTOBER* magazine, that elaborate different methods of criticism in order to elucidate different aspects of the art in question. The essays are often in dialogue with one another as they do so, but they are also as sensitive as the art to political context and historical change. These "files," then, are intended as primers in signal practices of art and criticism alike, and they are offered in resistance to the amnesiac and antitheoretical tendencies of our time.

The Editors of *OCTOBER*

Acknowledgments

Craig Owens's "The Allegorical Impulse: Toward a Theory of Postmodernism, Part 2" originally appeared in *October* 13 (Summer 1980) and was later published in Owens's *Beyond Recognition: Representation, Power, and Culture* (Berkeley: University of California Press, 1992). "The Photographic Activity of Postmodernism" by Douglas Crimp first appeared in *October* 15 (Winter 1980) and was subsequently published in his *On The Museum's Ruins* (Cambridge: MIT Press, 1993). Judith Williamson's essay, originally titled "Images of 'Woman'—the Photographs of Cindy Sherman," appeared first in *Screen* vol. 24, no. 6 (November/December 1983) and in the form reprinted here as "A Piece of the Action: Images of 'Woman' in the Photography of Cindy Sherman" in Williamson's *Consuming Passions: The Dynamics of Popular Culture* (London: Marion Boyars, 1986). "Suitable for Framing: The Critical Recasting of Cindy Sherman" by Abigail Solomon-Godeau is reprinted from *Parkett* no. 29 (1991). Laura Mulvey's contribution was originally titled "A Phantasmagoria of the Female Body: The Work of Cindy Sherman" and appeared in *New Left Review* no. 188 (July/August 1991); it was published, in the form reprinted here, as "Cosmetics and Abjection: Cindy Sherman 1977–87" in *Fetishism and Curiosity* (London: British Film Institute, 1996). Norman Bryson's "House of Wax" and Rosalind Krauss's "Cindy Sherman: Untitled" both appeared in the monograph *Cindy Sherman 1975–1993* (New York: Rizzoli International, 1993); Krauss's essay was subsequently reprinted in a collection of her essays, *Bachelors* (Cambridge: MIT Press, 1999). "How to Face the Gaze" (2005) by Kaja Silverman is a revised version of her essay "The Screen," which first appeared in her *The Threshold of the Visible World*

(New York: Routledge, 1996). Hal Foster's "Obscene, Abject, Traumatic," was published in *October* 78 (Fall 1996). "A Body Slate: Cindy Sherman" by Johanna Burton was written for this volume. Slight typographical modifications have been made to all reprinted texts for editorial consistency. I would like to thank all the above publishers for making the appearance of these essays in the current volume possible.

Cindy Sherman's images are provided courtesy of the artist and Metro Pictures Gallery. I am extremely grateful to Cindy Sherman and to everyone at Metro Pictures for their enthusiastic assistance with this project, particularly Helene Winer and Janelle Reiring, Allison Card and Tom Heman; a special thanks is owed to Peter Schuette, who helped every step of the way with images. My deepest appreciation goes to Hal Foster, who continually provides unmatched generosity and deeply valued support. Thanks are also due to Lisa Pasquariello, Suzanne Hudson, and Tim Griffin for their aid in this and nearly all of my projects. For their unwavering assistance, expertise, and good will, I offer sincere gratitude to Roger Conover, Yasuyo Iguchi, Marc Lowenthal, and Sandra Minkkinen, at The MIT Press, and to Thomas Kozacheck for his fine index. Obviously this book would not have been possible without the inspiring contributions of the authors; I thank them not only for the brilliance of their observations but for their willingness to reprint their essays in this context.

CINDY SHERMAN

The Allegorical Impulse: Toward a Theory of Postmodernism, Part 2

Craig Owens

> We write in order to forget our foreknowledge of the total opacity of words and things or, perhaps worse, because we do not know whether things have or do not have to be understood.
>
> —Paul de Man, *Allegories of Reading*

Here is the beginning of an allegory, a brief parable of reading from the opening of Laurie Anderson's *Americans on the Move.*[1]

> You know when you're driving at night like this it can suddenly occur to you that maybe you're going in completely the wrong direction. That turn you took back there . . . you were really tired and it was dark and raining and you took the turn and you just started going that way and then the rain stops and it starts to get light and you look around and absolutely everything is completely unfamiliar. You know you've never been here before and you pull into the next station and you feel so awkward saying, "Excuse me, can you tell me where I am?" . . .

This passage, with its images of driving (Anderson's metaphor for consciousness: "I am in my body the way most people drive in their cars") and obscurity, is reminiscent of the opening of *The Divine Comedy* ("Nel mezzo del cammin di nostra vita mi ritrovai per una selva oscura/che le diritta via era smarrita. . . . Io non so ben ridir com' io v'entrai,/tant'era pieno di sonno a quel punto/che la verace via abbondonai"[2]), or rather of that state of perplexity which initiates so many allegories. And Anderson's

night driver soon encounters her Virgil in the guise of a grease monkey, who reveals that her befuddlement is the result of her failure to "read the signs"—a failure which is not, however, attributed to a subject who has either neglected or misread directional signals, but to the fundamental unreadability of the signs themselves. Commenting on a projection of the image that was emblazoned on the Pioneer spacecraft—a nude man and woman, the former's right arm raised at the elbow, palm proffered—her Virgil in overalls inquires: "In our country, we send pictures of our sign language into outer space. They are speaking our sign language in these pictures. Do you think they will think his hand is permanently attached that way? Or do you think they will read our signs? In our country, goodbye looks just like hello."

Two alternatives: either the extraterrestrial recipient of this message will assume that it is simply a picture, that is, an analogical likeness of the human figure, in which case he might logically conclude that male inhabitants of Earth walk around with their right arms permanently raised. Or he will somehow divine that this gesture is addressed to him and attempt to read it, in which case he will be stymied, since a single gesture signifies both greeting and farewell, and any reading of it must oscillate between these two extremes. The same gesture could also mean "Halt!" or represent the taking of an oath, but if Anderson's text does not consider these alternatives that is because it is not concerned with ambiguity, with multiple meanings engendered by a single sign; rather, two *clearly defined but mutually incompatible* readings are engaged in blind confrontation in such a way that it is impossible to choose between them. It is, of course, in allegory that "one and the same object can just as easily signify a virtue as a vice,"[3] and this works to problematize the activity of reading, which must remain forever suspended in its own uncertainty.

"In the illusory babels of language," Robert Smithson wrote, "an artist might advance specifically to get lost."[4] Anderson is such an artist, and her performances are narratives of losing one's way in labyrinths of signs. Although she employs, in addition to lyrics and spoken texts, photographs, drawings, films, and music, all of these are implicated in a general thematics of reading that extends far beyond the limits of the written text. For Anderson, the world is a vast network of signs and, as such, continually elicits reading, interpretation. Consciousness, being in the world, is in fact identified with reading—an identification which is not, however, unproblematic, for the legibility of signs is always uncertain. And it is to the problem of illegibility that Anderson's work is addressed.

Americans on the Move continually returns to the fundamental ambivalence of signs and to the barrier they thereby erect in the path of understanding. A photograph of a woman shrugging her shoulders, palms turned upwards, elicits the conundrum: "Does this woman think it's raining? Or do you think it's all the same to her?" An earlier version of the work included the following story about consulting a palmist (a *Reader and Advisor*) in Albuquerque:

> The odd thing about the reading was that everything she told me was totally wrong. She took my hand and said, "I see here by these lines that you are an only child . . ." (I have seven brothers and sister) ". . . I read here that you love to fly . . ." (I'm totally terrified of planes) and so on. But she seemed so sure of this information that eventually I began to feel like I'd been walking around for years with these false documents permanently tattooed to my hands. It was very noisy in the house, family members kept walking in and out speaking a high clicking kind of language that sounded like Arabic. Books and magazines in Arabic were strewn all over the carpet. Suddenly I realized that maybe it was a translation problem—maybe she had been reading from right to left instead of left to right—and thinking of mirrors, I gave her my other hand. She didn't take it, but instead, held out her own hand. We sat there for a minute or two in what I assumed was some sort of strange participatory, invocatory ritual. Finally I realized that her hand was out because she was waiting . . . waiting for money.

In this passage, which treats the metaphor of communication as economic exchange—the exchange of meaning balanced by an exchange of currency—Anderson proposes that the same "text" read backwards and forwards might engender antithetical meanings. It thus recalls her palindromes, which rarely read the same in both directions: in her *Song for Juanita,* the first syllable "Juan-" is reversed into "no," producing a rhythmic oscillation "no-one-no-one"; morphemes are thus revealed to contain the seed of their own contradiction.[5] Palindromes, puns, and "translation problems" recur throughout Anderson's works, allowing us to identify them as what Paul de Man, in his recent *Allegories of Reading,* calls "allegories of unreadability." De Man recognizes allegory as the structural interference of two distinct levels or usages of language, literal and rhetorical (metaphoric), one of which denies precisely what the other affirms. In most allegories a literal reading will "deconstruct" a metaphorical one;

recalling medieval schemas of textual exegesis, de Man identifies such readings as tropological. Yet because literal language is itself rhetorical, the product of metaphoric substitutions and reversals, such readings are inevitably implicated in what they set out to expose, and the result is allegory.

> The paradigm for all texts consists of a figure (or a system of figures) and its deconstruction. But since this model cannot be closed off by a final reading, it engenders, in its turn, a supplementary figural superposition which narrates the unreadability of the prior narration. As distinguished from primary deconstructive narratives centered on figures and ultimately always on metaphor, we can call such narratives to the second (or third) degree allegories. *Allegorical narratives tell the story of the failure to read* whereas tropological narratives . . . tell the story of the failure to denominate. The difference is only a difference in degree and the allegory does not erase the figure. Allegories are always allegories of metaphor and, as such, they are always allegories of the impossibility of reading—a sentence in which the genitive "of" has itself to be read as a metaphor.[6]

De Man illustrates his thesis of allegorical illegibility with examples drawn from both literary and philosophical discourse (although allegory tends to blur this distinction), from Rilke and Proust to Rousseau and Nietzsche. The way in which attention to the incongruence of literal and figurative language upsets our presumed mastery of canonical texts is succinctly demonstrated in his introductory reading of Yeats's "Among School Children," which concludes with the famous line "How can we know the dancer from the dance?"—a line frequently quoted as testimony to the indissoluble unity of sign and meaning that characterizes the (symbolic) work of art. Yet this "meaning" hinges upon reading the line as a rhetorical question, that is, as a rhetorical *statement* of their indissolubility. But what if we read it literally, de Man asks; and the result, not surprisingly, is allegory—the distance which separates signifier from signified, sign from meaning:

> It is equally possible, however, to read the last line literally rather than figuratively, as asking with some urgency the question we asked earlier in the context of contemporary criticism: not that the sign and referent are so exquisitely fitted to each other that all the difference between them is at times blotted out but, rather, since the two essen-

tially different elements, sign and meaning, are so intricately inter-
twined in the imagined "presence" that the poem addresses, how can
we possibly make the distinctions that would shelter us from the er-
ror of identifying what cannot be identified? The clumsiness of the
paraphrase reveals that it is not necessarily the literal reading which is
simpler than the figurative one . . . ; here the figural reading, which
assumes the question to be rhetorical, is perhaps naive, whereas the
literal reading leads to greater complication of themes and statement.
For it turns out that the entire schema set up by the first reading can
be undermined, or deconstructed, in terms of the second, in which
the final line is read literally as meaning that, since the dancer and the
dance are not the same, it might be useful, perhaps even desperately
necessary—for the question can be given a ring of urgency, "Please
tell me, how *can* I know the dancer from the dance"—to tell them
apart. But this will replace the reading of each symbolic detail by a
divergent interpretation. . . . This hint should suffice to suggest that
two entirely coherent but entirely incompatible readings can be made
to hinge on one line, whose rhetorical mode turns the mood as well
as the mode of the poem upside down. Neither can we say . . . that
the poem simply has two meanings that exist side by side. The two
readings have to engage each other in direct confrontation, for the
one reading is precisely the error denounced by the other and has to
be undone by it. Nor can we in any way make a valid decision as to
which of the readings can be given priority over the other; none can
exist in the other's absence. There can be no dance without a dancer,
no sign without a referent. On the other hand, the authority of the
meaning engendered by the grammatical structure is fully obscured
by the duplicity of a figure that cries out for the differentiation that it
conceals.[7]

I have quoted this lengthy passage in full not only because it illumi-
nates the structure of Laurie Anderson's art and allows us to identify it as
allegorical, but also because it demonstrates that modernist texts such as
Yeats's contain within themselves the seed of their own allegorization. Al-
legory can no longer be condemned as something merely appended to the
work of art, for it is revealed as a structural possibility inherent in every
work. In modernism, however, the allegory remains *in potentia* and is ac-
tualized only in the activity of reading, which suggests that the allegorical
impulse that characterizes postmodernism is a direct consequence of its

preoccupation with reading. It is not surprising, then, that we should en-
counter Robert Rauschenberg, on the threshold of postmodernism, exe-
cuting works which transform our experience of art from a visual to a
textual encounter, and entitling these works *Obelisk, Rebus, Allegory.*

The displacement enacted by Rauschenberg's art was first acknowl-
edged by Leo Steinberg, who identified it as a shift from nature to culture.[8]
But Steinberg presumes the nature/culture opposition to be a stable one,
a presupposition that postmodern artists—not to mention their post-
structuralist counterparts—are determined to subvert. In postmodernist
art, nature is treated as wholly domesticated by culture; the "natural" can
be approached only through its cultural representation. While this does
indeed suggest a shift from nature to culture, what it in fact demonstrates
is the impossibility of accepting their opposition. This is the point of a
recent allegorical project by Sherrie Levine, who has selected, mounted,
and framed Andreas Feininger's photographs of natural subjects. When
Levine wants an image of nature, she does not produce one herself but
appropriates another image, and this she does in order to expose the de-
gree to which "nature" is always already implicated in a system of cultural
values which assigns it a specific, culturally determined position. In this
way she reflects Duchamp's readymade strategy, utilizing it as an unsettling
deconstructive instrument.

This reference to Duchamp suggests that the postmodernist "shift"
should not be characterized as from nature to culture, but as a shift in elo-
cutionary mode, from history to discourse, the terms which Émile Ben-
veniste uses to distinguish between impersonal, third-person narration and
direct address, which he associates with the personal pronouns *I* and *you.*[9]
In her "Notes on the Index . . ." Rosalind Krauss demonstrates that this
shift of pronominal emphasis is characteristic of all of Duchamp's work, and
that it signals a "tremendous arbitrariness with regard to meaning, a break-
down of . . . the linguistic sign."[10] All of Duchamp's works read as messages
addressed to the spectator—explicitly in *Anemic Cinema* and *Tu m'* and *To
Be Looked At (from the Other Side of the Glass) with One Eye, Close to, for Al-
most an Hour;* implicitly in the readymades *Fountain* and *Trébuchet*[11]—and it
should be remembered that allegories are frequently exhortative, addressed
to the reader in an attempt to manipulate him or to modify his behavior. It
is on the basis of this shift to a discursive mode that a reading of what
Duchamp himself identified as the "allegorical appearance" of the *Large
Glass*—itself an elaborate *psychomachia*—should proceed.

This shift from history to discourse, from a third- to a second-person
mode of address, also accounts for the centrality which postmodernist art

assigns to the reader/spectator;[12] significantly, Steinberg frequently refers to Rauschenberg's reorientation of the conventional picture field from a horizontal to a "flatbed" position as a form of "spectator modification." Krauss observed that Rauschenberg's art follows a discursive model by compelling a part-by-part, image-by-image reading that is temporal in character.[13] Yet it remains impossible to read a Rauschenberg, if by reading we mean the extraction from a text of a coherent, monological message. All attempts to decipher his works testify only to their own failure, for the fragmentary, piecemeal combination of images that initially impels reading is also what blocks it, erects an impenetrable barrier to its course. Rauschenberg thus confounds the attitude towards reading as an unproblematic activity—which persists, as we know, under the dubious banner "iconography" in art-critical and art-historical discourse, which are thereby paralyzed when confronted with his work, and with postmodernism in general—substituting for it something remarkably similar to Roland Barthes's "stereographic" view of the text:

> A text is made of multiple writings, drawn from many cultures and entering into mutual relations of dialogue, parody, contestation, but there is one place where this multiplicity is focused and that place is the reader, not, as was hitherto said, the author. The reader is the space on which all the quotations that make up the writing are inscribed without any of them being lost; a text's unity lies not in its origin but in its destination. Yet this destination can no longer be personal: the reader is without history, biography, psychology; he is simply that *someone* who holds together in a single field all the traces by which the written text is constituted.[14]

Here, then, is Rauschenberg's *Allegory,* a "combine painting" executed in 1959–60, exactly one year after the artist began his series of illustrations for *The Divine Comedy* (the project during which the transfer process characteristic of his subsequent work was "discovered"). Couched in its flatbed surface there is a random collection of heterogeneous objects: a red umbrella, stripped from its frame and splayed like a fan; rusted sheet metal, crumpled into a cascade of metallic drapery and mounted on mirrors; red block lettering, apparently from a broadside that has been ripped apart and dispersed; swatches of fabric; bits of clothing. It is difficult, if not impossible to discover in this inventory any common property that might coherently link these things, justify their bedding down together. The only metaphor that suggests itself is that of a dumping ground, and it is

hardly a new one: with his customary precision of language, Steinberg described Rauschenberg's typical picture surface as "dump, reservoir, switching center." Krauss also characterizes Rauschenberg's art in terms of place: discussing the "equal density" which disparate images acquire in *Small Rebus,* she is "struck by the fact that the surface of this painting is a *place,* a *locale,* where this kind of equalization can happen."[15] Both Steinberg and Krauss describe the work in this way in order to analogize it to the human mind; Rauschenberg's works thus become allegories of consciousness or, perhaps, the unconscious.

Is this then what makes *Allegory* an allegory? By making works which read as *sites,* however, Rauschenberg also seems to be declaring the fragments embedded there to be beyond recuperation, redemption; this is where everything finally comes to rest. *Allegory* is thus also an emblem of mortality, of the inevitable dissolution and decay to which everything is subject. But can we in fact be certain that this is an allegorical image; might it not be an image of allegory itself, of the disrepute into which it has fallen? All three readings are correct, but only in part; if, however, we were to superimpose them then the work would become the narrative—the allegory—of its own fundamental illegibility.

In his essay "On the Museum's Ruins," Douglas Crimp proposes another locale suggested by Rauschenberg's art: the museum, the dumping grounds of culture.[16] If we accept for the moment—and I believe we must—this identification of Rauschenberg's works as "museum paintings," in the sense that Michel Foucault attributes to Manet—painting as "a manifestation of the existence of museums and the particular reality and interdependence that paintings acquire in museums"[17] then it follows that they will acquire their fullest measure of significance only when seen *in situ.* Rauschenberg's art remains *in potentia* until it is seen in the museum, where it opens a dazzling *mise en abyme* reminiscent of Husserl's Dresden Gallery passage in *Ideas:*

> A name on being mentioned reminds us of the Dresden Gallery and of our last visit there: we wander through the rooms, and stand before a picture of Teniers which represents a picture gallery. When we consider that pictures of the latter would in their turn portray pictures which on their part exhibited readable inscriptions and so forth, we can measure what interweaving of presentations, and what links of connexion between the discernible features in the series of pictures, can really be set up.[18]

The illegibility of a Rauschenberg, however, works to deny the possibility of precisely such "links of connexion" as Husserl proposes, which hinge on the *readability* of the "inscriptions." There is no escape from this situation, no clear route back to the "reality" it purports to describe, as Jacques Derrida, in his Borgesian critique of this passage, indicates: "The gallery is the labyrinth which includes in itself its own exits."[19] The acquisition of Rauschenberg's canvases by museums of modern art is thus their final, ironic triumph. They become that term in the series of works exhibited there that permits the allegorization of the entire series. But this triumph is ultimately an equivocal one, for in order to function as deconstructions of the discourse of the museum, of its claims to coherence, homogeneity—the ground of its alleged intel-legibility—they must also declare themselves to be part of the dumping ground they describe. They thus relapse into the "error" they denounce, and this is what allows us to identify them as allegorical.

What I am imputing to Rauschenberg, then, is a peculiar form of site specificity: museum painting for the museum. This gesture is both economic and strategic, for if, in his works, Rauschenberg enacts a deconstruction of the museum, then his own deconstructive discourse—like Daniel Buren's—can take place only within the museum itself. It must therefore provisionally accept the terms and conditions it sets out to expose. This is of course the constraint to which any deconstructive discourse is subject, as the deconstructors themselves frequently remind us: Derrida, for example, speaks of the methodological necessity of preserving as an instrument a concept whose truth value is being questioned. (Significantly, his example is Claude Lévi-Strauss's ethnographic discourse, which must utilize the nature/culture opposition even while rejecting it.[20]) There is thus a danger inherent in deconstruction: unable to avoid the very errors it exposes, it will continue to perform what it denounces as impossible and will, in the end, affirm what it set out to deny. Deconstructive discourses thus leave "a margin of error, a residue of logical tension" frequently seized upon by critics of deconstructionism as its failure. But this very failure is what raises the discourse, to use de Man's terminology, from a tropological to an allegorical level:

> Deconstructive readings can point out the unwarranted identifications achieved by substitution, but they are powerless to prevent their recurrence even in their own discourse, and to uncross, so to speak, the aberrant exchanges that have taken place. Their gesture merely

reiterates the rhetorical defiguration that caused the error in the first place. They leave a margin of error, a residue of logical tension that prevents the closure of the deconstructive discourse and accounts for its narrative and allegorical mode.[21]

Reading Rousseau's *Second Discourse* as the narrative of its own deconstruction, de Man concludes:

> To the extent that it never ceases to advocate the necessity for political legislation and to elaborate the principles on which such a legislation could be based, it resorts to the principles of authority that it undermines. We know this structure to be characteristic of what we have called allegories of unreadability. Such an allegory is metafigural; it is an allegory of a figure (for example, metaphor) which relapses into the figure it deconstructs. The *Social Contract* falls under this heading to the extent that it is structured like an aporia: it persists in performing what it has shown to be impossible to do. As such, we can call it an allegory.[22]

The "figure," then, deconstructed in Rauschenberg's work is that which proposes the substitution of the "heap of meaningless and valueless fragments of objects [contained within the museum] ... either metonymically for the original objects or metaphorically for their representations."[23] Exposing this substitution to be impossible, Rauschenberg imputes the same impossibility to his own work, thereby opening it to criticism that it merely perpetuates the confusion it sets out to expose. Postmodernist art is frequently attacked on exactly this point; for example, it is said of Troy Brauntuch's reproductions of Hitler's drawings that, because they lack captions or identifying labels that might inform us of their origin, the work remains mute, meaningless. It is, however, precisely this opacity that Brauntuch sets out to demonstrate, and this is what enables us to identify his works as allegories. Whether or not we will ever acquire the key necessary to unlock their secret remains a matter of pure chance, and this gives Brauntuch's work its undeniable *pathos,* which is also the source of its strength.

Similarly, Robert Longo's work, which treats the aestheticization of violence in contemporary society, participates of necessity in the activity it denounces. In a recent series of aluminum reliefs, entitled *Boys Slow Dance* and generated from film stills, Longo presents three images of men

locked in . . . deadly combat? amorous embrace? Like Anderson's parables, Longo's images resist ambiguity; they might, in fact, serve as emblems of that blind confrontation of antithetical meanings which characterizes the allegory of unreadability. Suspended in a static image, a struggle to the death is transformed into something that "has all the elegance of a dance."[24] Yet it is precisely this ambivalence that allows violence to be transformed into an aesthetic spectacle in photographs and films, and on television.

Longo's manipulation of film stills calls attention to the fact that, despite its suppression by modern theory—or perhaps because of it— allegory has never completely disappeared from our culture. Quite the contrary: it has renewed its (ancient) alliance with popular art forms, where its appeal continues undiminished. Throughout its history allegory has demonstrated a capacity for widespread popular appeal, suggesting that its function is social as well as aesthetic; this would account for its frequent appropriation for didactic and/or exhortative purposes. Just as Lévi-Strauss's structural (allegorical) analysis of myths reveals that the function of myth is to resolve the conflicts which confront primitive societies by maintaining them in paralogical suspension,[25] so too allegory may well be that mode which promises to resolve the contradictions which confront modern society—individual interest versus general well-being, for example—a promise which must, as we know, be perpetually deferred. The withdrawal of the modernist arts from allegory may thus be one factor in their ever-accelerating loss of audience.

The Western, the gangster saga, science fiction—these are the allegories of the twentieth century. They are also genres most intimately associated with film; that film should be the primary vehicle for modern allegory may be attributed not only to its unquestioned status as the most popular of contemporary art forms, but also to its mode of representation. Film composes narratives out of a succession of concrete images, which makes it particularly suited to allegory's essential pictogramatism. (As stated in Part 1 of this essay, "In allegory, the image is a hieroglyph; an allegory is a rebus, writing composed of concrete images.") Film is not, of course, the only medium to do so, as Barthes has indicated:

> There are other "arts" which combine still (or at least drawing) and story, diegesis—namely the photo-novel and the comic-strip. I am convinced that these "arts," born in the lower depths of high culture, possess theoretical qualifications and present a new signifier. . . . This is acknowledged as regards the comic-strip but I myself experience

this slight trauma of *significance* faced with certain photo-novels: "*their stupidity touches me.*" There may thus be a future—or a very ancient past—truth in these derisory, vulgar, foolish, dialogical forms of consumer subculture.[26]

Borges condemned allegory as "stupid and frivolous"; yet for Barthes its very stupidity functions as an index to its potential "truth." He goes on to designate a new object for aesthetic investigation: "And there is an autonomous 'art' (a 'text'), that of the *pictogram* ('anecdotalized' images, obtuse meanings placed in diegetic space); this art taking across historically and culturally heteroclite productions: ethnographic pictograms, stained glass windows, Carpaccio's *Legend of Saint Ursula, images d'Epinal,* photo-novels, comic strips."[27]

These remarks on the pictogram occur in a footnote to the essay "The Third Meaning: Research Notes on Some Eisenstein Stills," in which Barthes attempts to locate and define the specifically "filmic," which he discovers not in the movement of images, but in the still. Despite the essentialist undertones of this project, and whether or not we agree with Barthes's characterization of film as static in essence, or with his interpretation of Eisenstein's work, this essay remains extremely important because, in order to describe the still, Barthes elaborates a three-fold schema of interpretation highly reminiscent of the three- and four-fold schemas of medieval textual exegesis—a parallel of which Barthes himself is not unaware. This schema is necessitated by a description of the still in terms traditionally associated with allegory: it is a fragment, a quotation, and the meaning it engenders is supplementary, excessive, "parodic and disseminatory." An arbitrary cut, the still suspends not only motion but also story, diegesis; engendered by the syntagmatic disjunction of images, it compels a vertical or paradigmatic reading. ("Allegory is the epitome of counter-narrative, for it arrests narrative in place, substituting a principle of syntagmatic disjunction for one of diegetic combination. In this way allegory superinduces a vertical or paradigmatic reading of correspondences upon a horizontal or syntagmatic chain of events"—Part 1.)

In Barthes's allegorical schema, the first level of meaning is informational, referential, to make its parallel with exegesis more apparent, *literal*. This is the level of the anecdote, and it comprises setting, costume, characters, and their relations. It unproblematically assumes the reality of what it denotes, that is, that the sign is transparent to a referent. The second level is *symbolic*—Barthes calls it obvious, relating it to theology, in which, "we are told, the obvious meaning is that 'which presents itself quite naturally

to the mind.'"[28] Significantly, Barthes describes this level in terms that allow us to identify it as *rhetorical:* "Eisenstein's 'art' is not polysemous, it chooses the meaning, imposes it, hammers it home. . . . The Eisensteinian meaning devastates ambiguity. Here, by the addition of an aesthetic value, emphasis, Eisenstein's decorativism has an economic function: it proffers the truth."[29] Rhetoric, which is always emphatic, is both decorative and persuasive, a system of tropes frequently employed in oratory to manipulate the listener, to incite him to action. All of the Eisenstein stills analyzed by Barthes function simultaneously on both rhetorical levels: a clandestinely clenched fist, for example, a metaphoric synecdoche for the proletariat, is meant to inspire revolutionary determination.

In contradistinction to the literal and rhetorical meanings, the third, or "obtuse" meaning is difficult to formulate; Barthes's description of it is elusive, vague:

> The obtuse meaning is a signifier without a signified, hence the difficulty of naming it. *My reading remains suspended* between the image and its description, between definition and approximation. If the obtuse meaning cannot be described, that is because, in contrast to the obvious meaning, it does not copy anything—how do you describe something that does not represent anything?[30]

Nevertheless, the third meaning, Barthes tells us, has "something to do" with disguise; he identifies it with isolated details of make-up and costume (which properly belong to the literal level) which, through excess, proclaim their own artifice. If Barthes refuses to assign such details a referent, he does accord them a function: they work to expose the image as *fiction.* Barthes's reluctance, even inability to specify obtuse meaning cannot be considered an evasion, a ruse; it is a theoretical necessity. For as de Man observes:

> What makes a fiction a fiction is not some polarity of fact and representation. Fiction has nothing to do with representation but is the absence of any link between utterance and a referent, regardless of whether this link be causal, encoded, or governed by any other conceivable relationship that could lend itself to systematization. In fiction thus conceived the "necessary link" of the metaphor [of the symbol, we might add, recalling Coleridge] has been metonymized beyond the point of catachresis, and the fiction becomes the disruption of the narrative's referential illusion.[31]

The obtuse meaning differs not only in kind (since it refers to noth-ing, copies nothing, symbolizes nothing) from the literal and the sym-bolic; it is also *sited* differently: "Take away the obtuse meaning and communication and signification still remain, still circulate, still come through."[32] The *absence* of obtuse meaning is, in fact, the very condition of communication and signification, but its presence works to problema-tize these activities. Since the obtuse meaning has no objective, indepen-dent existence, it depends upon the literal and the rhetorical, which it nevertheless undoes. An unwelcome supplement, it exposes the literal level of the image to be a fiction, implicating it in the web of substitutions and reversals properly characteristic of the symbolic. The actor is revealed as the (metaphoric) substitute for the character; his facial contortions, the emblem of grief, not its direct expression. Hence every image that partic-ipates in what photography criticism calls the directorial, as opposed to the documentary, mode is open to the intervention of obtuse meaning. And the symbolic dimension of the image, which depends upon the univocity of the literal, is thereby disfigured; erected upon an unstable base of sub-stitutions and displacements, it becomes metafigural, the figure of a figure. The "necessary link" which characterized it as metaphoric is rendered contingent, "metonymized," as de Man has it. The projection of metaphor as metonymy is one of the fundamental strategies of allegory, and through it the symbolic is revealed for what it truly is—a rhetorical manipulation of metaphor which attempts to program response.

> The presence of an obtuse, supplementary, third meaning . . . radi-cally recasts the theoretical status of the anecdote: the story (the die-gesis) is no longer just a strong system (the millennial system of narrative) but also and contradictorily a simple space, a field of per-manences and permutations. It becomes that configuration, that stage, whose false limits multiply the signifier's permutational play, the vast trace which, by difference, compels . . . a *vertical* reading, that false order which permits the turning of the pure series, the aleatory combination (chance is crude, a signifier on the cheap) and the at-tainment of a structuration which *slips away from the inside.*[33]

Insofar as Barthes claims that the third meaning is that in the image which is "purely image," and because he identifies it with the "free play" of the signifier, he is open to charges that he is merely reiterating, in semi-ological jargon, aesthetic pleasure in the Kantian sense, delight in the form of a representation apart from the representation of any object whatsoever.

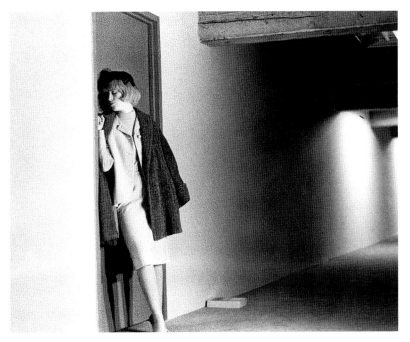

1 *Untitled Film Still #4*, 1977
black-and-white photograph
8 × 10 inches

And since the concept of a "signifier without a signified" presupposes that the referential function of language can, in fact, be suspended or bracketed, Barthes in fact repeats the postulate that lies at the base of every formalist aesthetic. The obtuse meaning does indeed appear reducible to the aesthetic; but I am interested in what motivates Barthes to insert it into the slot left vacant by the allegorical in an ancient interpretive scheme.

Barthes's interest in the theoretical value of the film still is paralleled today by several artists who derive their imagery from stills—Longo and James Birrell, who work to isolate that in the image which is purely image—or whose works deliberately resemble stills—Suzan Pitt's Disneyesque treatments of surrealism; Cindy Sherman's "untitled studies for film stills." These latter treat the subject of mimesis, not simply as an aesthetic activity, but as it functions in relation to the constitution of the self. Sherman's works are all self-portraits, but in them the artist invariably appears masked, disguised: she first costumes herself to resemble familiar female stereotypes—career girl, ingenue, sex object . . . —and then photographs herself in poses and settings reminiscent of the cinematic culture of

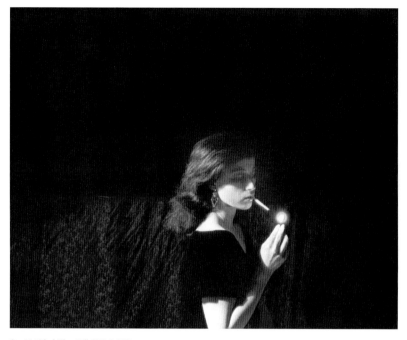

2 *Untitled Film Still #32,* 1979
black-and-white photograph
8 × 10 inches

the 1950s and '60s. Her "characters" frequently glance anxiously outside
the frame at some unspecified menace, thereby implying the presence of
a narrative even while withholding it. This—the "still"—effect prevents
us from mistaking Sherman's women for particular human subjects caught
up in narrative webs of romance or intrigue (a reading which would cor-
respond to Barthes's first, or literal level, which indicates the position of
the image in the anecdote). Instead it compels a typological reading: Sher-
man's women are not women but images of women, specular models of
femininity projected by the media to encourage imitation, identification;
they are, in other words, tropes, figures. (In works which appropriate
images of maternity from popular magazines, Sherrie Levine deals with
the same rhetorical function of images: it is the picture which inspires imi-
tation, mimesis, not the other way around.)

 And yet the uncanny precision with which Sherman represents these
tropes, the very perfection of her impersonations, leaves an unresolved
margin of incongruity in which the image, freed from the constraints of

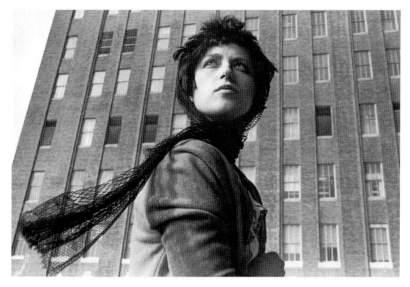

3　*Untitled Film Still #58,* 1980
black-and-white photograph
8 × 10 inches

referential and symbolic meaning, can accomplish its "work." That work is, of course, the deconstruction of the supposed innocence of the images of women projected by the media, and this Sherman accomplishes by *re*-constructing those images so painstakingly, and identifying herself with them so thoroughly, that artist and role appear to have merged into a seamless whole in such a way that it seems impossible to distinguish the dancer from the dance. It is, however, the urgent necessity of making such a distinction that is, in fact, at issue.

For in Sherman's images, disguise functions as parody; it works to expose the identification of the self with an image as its dispossession, in a way that appears to proceed directly from Jacques Lacan's fundamental tenet that the self is an Imaginary construct, "and that this construct disappoints all [the subject's] certitudes. For in the labor with which he undertakes to reconstruct this construct *for another,* he finds again the fundamental alienation which has made him construct it *like another one,* and which has always destined it to be stripped from him *by another.*"[34] (Significantly, in *The Four Fundamental Concepts of Psychoanalysis,* Lacan describes mimicry, mimesis, as the mechanism whereby the subject transforms himself into a picture.) By implicating the mass media as the false mirror

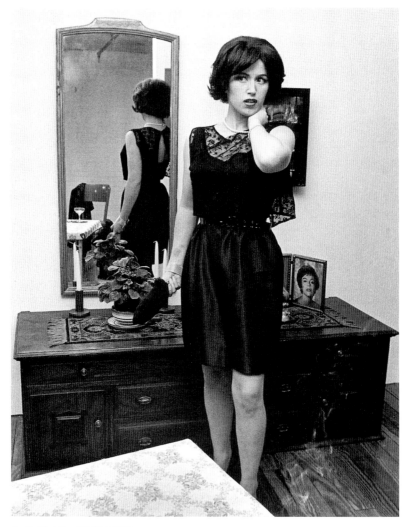

4 *Untitled Film Still #14*, 1978
black-and-white photograph
10 × 8 inches

which promotes such alienating identifications, Sherman registers this "truth" as both ethical and political.

But there is also an impossible complicity inscribed within Sherman's works, a complicity which accounts for their allegorical mode. For if mimicry is denounced in these images, it is nevertheless through mimetic strategies that this denunciation is made. We thus encounter once again the unavoidable necessity of participating in the very activity that is being denounced *precisely in order to denounce it*. All of the work discussed in this essay is marked by a similar complicity, which is the result of its fundamentally deconstructive impulse. This deconstructive impulse is characteristic of postmodernist art in general and must be distinguished from the self-critical tendency of modernism. Modernist theory presupposes that mimesis, the adequation of an image to a referent, can be bracketed or suspended, and that the art object itself can be substituted (metaphorically) for its referent. This is the rhetorical strategy of self-reference upon which modernism is based, and from Kant onwards it is identified as the source of aesthetic pleasure. For reasons that are beyond the scope of this essay, this fiction has become increasingly difficult to maintain. Postmodernism neither brackets nor suspends the referent but works instead to problematize the activity of reference. When the postmodernist work speaks of itself, it is no longer to proclaim its autonomy, its self-sufficiency, its transcendence; rather, it is to narrate its own contingency, insufficiency, lack of transcendence. It tells of a desire that must be perpetually frustrated, an ambition that must be perpetually deferred; as such, its deconstructive thrust is aimed not only against the contemporary myths that furnish its subject matter, but also against the symbolic, totalizing impulse which characterizes modernist art. As Barthes has written elsewhere:

> It is no longer the myths which need to be unmasked (the doxa takes care of that), it is the sign itself which must be shaken; the problem is not to reveal the (latent) meaning of an utterance, of a trait, of a narrative, but to fissure the very representation of meaning, is not to change or purify the symbols, but to challenge the symbolic itself.[35]

Notes

This is the second of two essays written by Craig Owens devoted to allegorical aspects of contemporary art. The first installment, "The Allegorical Impulse: Toward a Theory of Postmodernism," initially appeared in *October* 12 (Spring 1980), pp. 67–86.—Ed.

1. *Americans on the Move,* a performance by Laurie Anderson, was presented at The Kitchen Center for Video, Music, and Dance in April 1979. Several texts from it were published in *October* 8 (Spring 1979), pp. 45–57. All quotations are taken from this source.

2. "In the middle of the journey of our life I came to myself within a dark wood where the straight way was lost. . . . I cannot rightly tell how I entered there, I was so full of sleep at that moment when I left the true way." *Dante's Inferno,* trans. John D. Sinclair (New York: Oxford University Press, 1939), p. 23.

3. Karl Giehlow, *Die Hieroglyphenkunde . . . ,* quoted in Walter Benjamin, *The Origin of German Tragic Drama,* trans. John Osborne (London: NLB, 1977), p. 174.

4. Robert Smithson, "A Museum of Language in the Vicinity of Art," in *The Writings of Robert Smithson,* ed. Nancy Holt (New York: New York University Press, 1979), p. 67. I discuss the centrality of this passage to Smithson's enterprise in my review, "Earthwords," *October* 10 (Fall 1979), pp. 121–30.

5. Laurie Anderson, "Song for Juanita," *Airwaves* (recording, New York: One Ten Records, 1977). Liner notes by the artist.

6. Paul de Man, *Allegories of Reading* (New Haven: Yale University Press, 1979), p. 205, italics added.

7. Ibid., pp. 11–12.

8. Leo Steinberg, "Other Criteria," in *Other Criteria* (New York: Oxford University Press, 1972), pp. 84f.

9. Émile Benveniste, "Les relations de temps dans le verbe français," *Problèmes de linguistique générale,* I, pp. 237–50. There is an interesting application of Benveniste's distinction to film theory in Christian Metz, "Histoire/Discours (Note sur deux voyeurismes)," in *Le signifiant imaginaire* (Paris: Union Générale d'Editions [Collection 10:18], 1977), pp. 113–20.

10. Rosalind Krauss, "Notes on the Index: Seventies Art in America," *October* 3 (Spring 1977), p. 77.

11. In *Passages in Modern Sculpture,* Rosalind Krauss describes the readymades' interrogative structure: "The readymades became . . . part of Duchamp's project to make certain kinds of strategic moves—moves that would raise questions about what exactly is the nature of the work in the term 'work of art.' Clearly, one answer suggested by the readymades is that a work might not be a physical object but rather a question, and that the making of art might, therefore, be reconsidered as taking a perfectly legitimate form in the speculative act of posing questions" (New York: Viking, 1977), pp. 72–73.

12. Consider Krauss's treatment, in *Passages,* of the emblem in abstract expressionism: "All these qualities—frontality, centralization, and literal size and shape—characterize the developed work of most of the abstract-expressionist painters; even those who, like Pollock and Newman, eventually dropped some of these emblematic features continued to work with the most central aspect of the sign or emblem. And that is its mode of address. For while we can think of a traditional picture or a photograph as creating a relationship between author and object that exists independent of an audience, addressing no one in particular, we must think of a sign or emblem as existing specifically in relation to a receiver. It takes the form of a directive addressed *to* someone, a directive that exists, so to speak, in the space of confrontation between the sign or emblem and the one who views it" (Ibid., pp. 150, 152). Like de Man's reading of "Among School Children," Krauss's passage suggests that abstract-expressionist painting may indeed contain the seed of its own allegorization.

13. Rosalind Krauss, "Rauschenberg and the Materialized Image," *Artforum* 13 (December 1974), p. 37.

14. Roland Barthes, "The Death of the Author," in *Image—Music—Text,* trans. Stephen Heath (New York: Hill and Wang, 1977), p. 148.

15. Krauss, "Rauschenberg," p. 41, italics added.

16. Douglas Crimp, "On the Museum's Ruins," *October* 13 (Summer 1980), pp. 41–57.

17. Michel Foucault, "Fantasia of the Library," in *Language Counter-Memory, Practice,* trans. Donald F. Bouchard and Sherry Simon (Ithaca: Cornell University Press, 1977), p. 92.

18. Edmund Husserl, *Ideas,* trans. W. R. B. Gibson (New York: Collier, 1962), p. 270.

19. Jacques Derrida, *Speech and Phenomena,* trans. David B. Allison (Evanston: Northwestern University Press, 1973), p. 104.

20. Jacques Derrida, "Structure, Sign, and Play in the Discourse of the Human Sciences," in *Writing and Difference,* trans. Alan Bass (Chicago: University of Chicago Press, 1978), pp. 282 ff.

21. de Man, *Allegories of Reading,* p. 242.

22. Ibid., p. 275.

23. Eugenio Donato, "The Museum's Furnace: Notes toward a Contextual Reading of *Bouvard and Pécuchet,*" in *Textual Strategies,* ed. Josué V. Harari (Ithaca: Cornell University Press, 1979), p. 223.

24. Douglas Crimp, *Pictures* (New York: Artists Space, 1977), p. 26.

25. Claude Lévi-Strauss, "The Structural Study of Myth," in *Structural Anthropology,* trans. Claire Jacobson and B. G. Schoepf (New York: Basic Books, 1963), p. 229. Lévi-Strauss, however, seems to consider this suspension of contradiction to be perfectly logical: "The purpose of myth is to provide a logical model capable of overcoming contradiction (an impossible achievement if, as it happens, the contradiction is real)." Rosalind Krauss, however, has properly described it as "paralogical" ("Grids," *October* 9 [Summer 1979], p. 55). On the allegorical character of structuralist analysis, see Joel Fineman, "The Structure of Allegorical Desire," *October* 12 (Spring 1980), pp. 47–66.

26. Roland Barthes, "The Third Meaning: Research Notes on Some Eisenstein Stills," in *Image—Music—Text,* p. 66.

27. Ibid.

28. Ibid., p. 54.

29. Ibid., p. 56.

30. Ibid., p. 61, italics added.

31. de Man, *Allegories of Reading,* p. 292.

32. Barthes, "The Third Meaning," p. 60.

33. Ibid., p. 64.

34. Jacques Lacan, "The Function of Language in Psychoanalysis," in *The Language of the Self,* trans. Anthony Wilden (New York: Delta, 1975), p. 11.

35. Roland Barthes, "Change the Object Itself," in *Image—Music—Text,* p. 167.

The Photographic Activity of Postmodernism

Douglas Crimp

It is a fetishistic, fundamentally anti-technical notion of art with which theorists of photography have tusseled for almost a century, without, of course, achieving the slightest result. For they sought nothing beyond acquiring credentials for the photographer from the judgment-seat which he had already overturned.

—Walter Benjamin, "A Short History of Photography"

That photography had overturned the judgment-seat of art is a fact that modernism found it necessary to repress, and so it seems that we may accurately say that postmodernism constitutes a return of the repressed. Postmodernism represents a specific breach with modernism, with those institutions that are the preconditions for and shape the discourse of modernism. The institutions can be named at the outset: first, the museum; then, art history; and, finally, in a more complex sense, because modernism depends on both its presence and its absence, photography. Postmodernism is about art's dispersal, its plurality, by which I do not mean pluralism. Pluralism entails the fantasy that art is free, free of other discursive practices and institutions, free above all, of history. And this fantasy of freedom can be maintained because every work of art is held to be absolutely unique and original. Against this pluralism of originals, I want to speak of the plurality of copies.

In an essay of 1979 called "Pictures," in which I first found it useful to employ the term *postmodernism,* I attempted to sketch a background to the work of a group of younger artists who were just beginning to exhibit in New York.[1] I traced the genesis of their concerns to what had been

5 *Untitled Film Still #37*, 1979
black-and-white photograph
10 × 8 inches

pejoratively labeled the theatricality of minimal sculpture and the extensions of that theatrical position into the art of the 1970s.[2] I suggested that the aesthetic mode that was exemplary during the 1970s was performance art—all those works that were constituted in a specific situation and for a specific duration; works for which it could be said literally that you had to be there; works, that is, that assumed the presence of a spectator in front of the work as the work took place, thereby privileging the spectator instead of the artist.

In my attempt to continue the logic of the development I was outlining, I came eventually to a stumbling block. What I wanted to explain was how to get from this condition of presence—the *being there* necessitated by performance—to the kind of presence that is possible only through the absence that we know to be the condition of representation. For what I was writing about was the work that had taken on, after half a century of its repression, the question of representation. I effected that transition with a kind of fudge, an epigraph quotation suspended between two sections of the text. The quotation, taken from one of the ghost tales of Henry James, was a false tautology, which played on the double, indeed antithetical, meaning of the word *presence:* "The presence before him was a presence."

What I just said was a fudge was perhaps not really that, but rather it was a hint of something crucial about the work I was describing, which I would like now to elaborate. In order to do so, I want to add a third definition to the word *presence.* To the notion of presence that is about *being there,* being in front of, and the notion of presence that Henry James uses in his ghost stories, the presence that is a ghost and therefore really an absence, the presence that is *not there,* I want to add the notion of presence as a kind of increment to being there, a ghostly aspect of presence that is its excess, its supplement. This notion of presence is what we mean when we say, for example, that Laurie Anderson is a performer with presence. We mean by such a statement not simply that she is there, in front of us, but that she is more than there, that in addition to being there, she has presence. If we think of Laurie Anderson in this way, it might seem a bit odd, because Laurie Anderson's particular presence is effected through the use of reproductive technologies that really make her quite absent, or only there as the kind of presence that Henry James meant when he said, "The presence before him was a presence."

This is the kind of presence that I attributed to the performances of Jack Goldstein, such as *Two Fencers,* and to which I would add the performance by Robert Longo called *Surrender.* These performances were little

6 *Untitled Film Still #53,* 1980
black-and-white photograph
8 × 10 inches

else than presences, performed tableaux that were there in the spectator's space but that appeared ethereal, absent. They had the odd quality of holograms, very vivid and detailed and present and at the same time ghostly, absent. Goldstein and Longo are artists whose work, together with that of a great number of their contemporaries, approaches the question of representation through photographic modes, particularly all those aspects of photography that have to do with reproduction, with copies, with copies of copies. The peculiar presence of this work is effected through absence, through its unbridgeable distance from the original, from even the possibility of an original. Such presence is what I attribute to the kind of photographic activity I call postmodernist.

This quality of presence would seem to be just the opposite of what Walter Benjamin had in mind when he introduced the notion of aura into the language of criticism. For the aura has to do with the presence of the original, with authenticity, with the unique existence of the work of art in the place in which it happens to be. It is that aspect of the work that can be put to the test of chemical analysis or connoisseurship, that aspect that the discipline of art history, at least in its guise as *Kunstwissenschaft,* is able to prove or disprove, and that aspect, therefore, that either admits the work

of art into or banishes it from the museum. For the museum has no truck with fakes or copies or reproductions. The presence of the artist in the work must be detectable; that is how the museum knows it has something authentic.

But it is this very authenticity, Benjamin tells us, that is inevitably depreciated through mechanical reproduction, diminished through the proliferation of copies. "That which withers in the age of mechanical reproduction is the aura of the work of art," is the way Benjamin puts it.[3] But, of course, the aura is not an ontological category as employed by Benjamin but rather a historical one. It is not something a handmade work has that a mechanically made work does not have. In Benjamin's view, certain photographs have an aura, whereas even a painting by Rembrandt loses its aura in the age of mechanical reproduction. The withering away of the aura, the dissociation of the work from the fabric of tradition, is an *inevitable* outcome of mechanical reproduction. This is something we have all experienced. We know, for example, the impossibility of experiencing the aura of such a picture as the *Mona Lisa* as we stand before it at the Louvre. Its aura has been utterly depleted by the thousands of times we've seen its reproduction, and no degree of concentration will restore its uniqueness for us.

It would seem, though, that if the withering away of the aura is an inevitable fact of our time, then equally inevitable are all those projects to recuperate it, to pretend that the original and the unique are still possible and desirable. And this is nowhere more apparent than in the field of photography itself, the very culprit of mechanical reproduction.

Benjamin granted a presence or aura to only a very limited number of photographs. These were photographs of the so-called primitive phase, the period prior to photography's commercialization after the 1850s. He said, for example, that the people in these early photographs "had an aura about them, a medium which mingled with their manner of looking and gave them a plenitude and security."[4] This aura seemed to Benjamin to be a product of two things: the long exposure time during which his subjects grew, as it were, into the images and the unique, unmediated relationship between the photographer, who was "a technician of the latest school," and the sitter, who was "a member of a class on the ascendant, replete with an aura which penetrated to the very folds of his bourgeois overcoat or bow-tie."[5] The aura in these photographs, then, is not to be found in the presence of the photographer in the photograph in the way that the aura of a painting is determined by the presence of the painter's unmistakable

hand in his or her picture. Rather, it is the presence of the subject, of what is photographed, "the tiny spark of chance, of the here and now, with which reality has, as it were, seared the character of the picture."[6] For Benjamin, then, the connoisseurship of photography is an activity diametrically opposed to the connoisseurship of painting; it means looking not for the hand of the artist but for the uncontrolled and uncontrollable intrusion of reality, the absolutely unique and even magical quality not of the artist but of his or her subject. And that is perhaps why it seemed to Benjamin so misguided that photographers began, after the commercialization of the medium, to simulate the lost aura through the application of techniques imitative of those of painting. His example was the gum bichromate process used in pictorial photography.

Although it may at first seem that Benjamin lamented the loss of the aura, the contrary is in fact true. Reproduction's "social significance, particularly in its most positive form, is inconceivable," he wrote, "without its destructive, cathartic aspect, its liquidation of the traditional value of the cultural heritage."[7] That was for him the greatness of Eugène Atget: "He initiated the liberation of the object from the aura, which is the most incontestable achievement of the recent school of photography."[8] "The remarkable thing about [Atget's] pictures . . . is their emptiness."[9]

This emptying operation, the depletion of the aura, the contestation of the uniqueness of the work of art, has been accelerated and intensified in the art of the past two decades. From the multiplication of silkscreened photographic images in the works of Rauschenberg and Warhol to the industrially manufactured, repetitively structured works of minimal sculptors, everything in radical artistic practice seemed to conspire in that liquidation of traditional cultural values that Benjamin spoke of. And because the museum is the institution founded on those values, whose job it is to sustain those values, it has faced a crisis of considerable proportions. One symptom of that crisis is the fact that our museums, around 1970, one after another abdicated responsibility toward contemporary artistic practice and turned with nostalgia to the art that had previously been relegated to their storerooms. Revisionist art history soon began to be vindicated by "revelations" of the achievements of academic artists and minor figures of all kinds.

By the mid-1970s another, more serious symptom of the museum crisis appeared, the one I have already mentioned: the various attempts to recuperate the auratic. These attempts are manifest in two contradictory phenomena: the resurgence of expressionist painting and the triumph of

photography-as-art. The museum has embraced both of these phenomena with equal enthusiasm.

Little, I think, needs to be said about the return to a painting of personal expression. We see it everywhere we turn. The marketplace is glutted with it. It comes in all guises—pattern painting, new-image painting, neo-constructivism, neoexpressionism; it is pluralist, to be sure. But within its individualism, this painting is utterly conformist on one point: its hatred of photography. In a manifesto-like text for the catalogue of her *American Painting: The Eighties,* Barbara Rose wrote,

> The serious painters of the eighties are an extremely heterogeneous group—some abstract, some representational. But they are united on a sufficient number of critical issues that it is possible to isolate them as a group. They are, in the first place, dedicated to the preservation of painting as a transcendental high art, and an art of universal as opposed to local or topical significance. Their aesthetic, which synthesizes tactile with optical qualities, defines itself in conscious opposition to photography and all forms of mechanical reproduction which seek to deprive the art work of its unique "aura." It is, in fact, the enhancement of this aura, through a variety of means, that painting now self-consciously intends—either by emphasizing the artist's hand, or by creating highly individual visionary images that cannot be confused either with reality itself or with one another.[10]

That this kind of painting should so clearly see mechanical reproduction as the enemy is symptomatic of the threat to inherited ideas (the only ideas known to this painting) posed by the photographic activity of postmodernism. But in this case it is also symptomatic of a more limited and internecine threat: the one posed to painting when photography itself suddenly acquires an aura. Now it's not only a question of ideology; now it's real competition for the acquisition budget and wall space of the museum.

But how is it that photography has suddenly had conferred upon it an aura? How has the plenitude of copies been reduced to the scarcity of originals? And how do we know the authentic from its reproduction?

Enter the connoisseur. But not the connoisseur of photography, of whom the type is Walter Benjamin, or, closer to us, Roland Barthes. Neither Benjamin's "spark of chance" nor Barthes's "third meaning" would guarantee photography's place in the museum.[11] The connoisseur needed

for this job is the old-fashioned art historian with his chemical analyses and, more important, his stylistic analyses. To authenticate photography requires all the machinery of art history and museology, with a few additions and more than a few sleights of hand. To begin, there is, of course, the incontestable rarity of age, the vintage print. Certain techniques, paper types, and chemicals have passed out of use, and thus the age of a print can easily be established. But this kind of certifiable rarity is not what interests me, nor is its parallel in contemporary photographic practice, the limited edition. What interests me is the subjectivization of photography, the ways in which the connoisseurship of the photograph's "spark of chance" is converted into a connoisseurship of the photograph's style. For now, it seems, we can detect the photographer's hand after all, except, of course, that it is the eye, his or her unique vision (although it can also be the hand; one need only listen to the partisans of photographic subjectivity describe the mystical ritual performed by the photographer in the darkroom).

I realize, of course, that in raising the question of subjectivity I am reviving the central debate in photography's aesthetic history—between the straight and the manipulated print, or the many variations on that theme. But I do so here in order to point out that the recuperation of the aura of photography would in fact subsume under the banner of subjectivity *all* of photography, the photography whose source is the human mind and the photography whose source is the world around us, the most thoroughly manipulated photographic fictions and the most faithful transcriptions of the real, the directorial and the documentary, the mirrors and the windows,[12] *Camera Work* in its infancy, *Life* in its heyday. But these are only the terms of style and mode of the agreed-on spectrum of photograph-as-art. The restoration of the aura, the consequent collecting and exhibiting, does not stop there. It is extended to the carte-de-visite, the fashion plate, the advertising shot, the anonymous snap or polaroid. At the origin of each there is an Artist, and therefore each can find its place on the spectrum of subjectivity. For it has long been a commonplace of art history that realism and expressionism are only matters of degree, matters, that is, of style.

The photographic activity of postmodernism operates, as we might expect, in complicity with these modes of photography-as-art, but it does so only in order to subvert or exceed them. And it does so precisely in relation to the aura, not, however, to recuperate it, but to displace it, to show that it too is now only an aspect of the copy, not the original. A group of

young artists working with photography have addressed photography's claims to originality, showing those claims for the fiction they are, showing photography to be always a *re*presentation, always-already-seen. Their images are purloined, confiscated, appropriated, *stolen*. In their work, the original cannot be located, is always deferred; even the self that might have generated an original is shown to be itself a copy.

In a characteristic gesture, Sherrie Levine begins a statement about her work with an anecdote that is very familiar:

> Since the door was only half closed, I got a jumbled view of my mother and father on the bed, one on top of the other. Mortified, hurt, horrorstruck, I had the hateful sensation of having placed myself blindly and completely in unworthy hands. Instinctively and without effort, I divided myself, so to speak, into two persons, of whom one, the real, the genuine one, continued on her own account, while the other, a successful imitation of the first, was delegated to have relations with the world. My first self remains at a distance, impassive, ironical, and watching.[13]

Not only do we recognize this as a description of something we already know—the primal scene—but our recognition might extend even further to the Moravia novel from which it has been lifted. For Levine's autobiographical statement is only a string of quotations pilfered from others, and if we might think this a strange way of writing about one's own working methods, then perhaps we should turn to the work it describes.

At a recent exhibition, Levine showed six photographs of a nude youth. They were simply rephotographed from the famous series by Edward Weston of his young son Neil, available to Levine as a poster published by the Witkin Gallery. According to copyright law, the images belong to Weston—or now to the Weston estate. I think, to be fair, however, we might just as well give them to Praxiteles, for if it is the *image* that can be owned, then surely these belong to classical sculpture, which would put them in the public domain. Levine has said that when she showed her photographs to a friend, he remarked that they only made him want to see the originals. "Of course," she replied, "and the originals make you want to see that little boy, but when you see the boy, the art is gone." The desire that is initiated by that representation does not come to closure around that little boy, is not at all satisfied by him. The desire of representation

exists only insofar as it can never be fulfilled, insofar as the original is always deferred. It is only in the absence of the original that representation can take place. And representation takes place because it is always already there in the world *as* representation. It was, of course, Weston who said that the photograph must be visualized in full before the exposure is made.[14] Levine has taken the master at his word and in so doing has shown him what he really meant. The a priori Weston had in mind was not really in his mind at all; it was in the world, and Weston only copied it.

This fact is perhaps even more crucial in those series by Levine where that a priori image is not so obviously confiscated from high culture—by which I intend both Weston and Praxiteles—but from the world itself, where nature poses as the antithesis of representation. The images that Levine confiscated from books of photographs by Andreas Feininger and Elliot Porter show scenes of nature that are utterly familiar. They suggest a new interpretation of Roland Barthes's description of the tense of photography as the "having been there."[15] The presence that such photographs have for us is the presence of déjà vu, nature as already having been seen, nature as representation.

If Levine's photographs occupy a place on that spectrum of photography-as-art, that place would be at the farthest reaches of straight photography, not only because the photographs she appropriates operate within that mode but also because she does not manipulate her photographs in any way; she merely, and literally, *takes* photographs. At the opposite end of that spectrum is the photography that is self-consciously composed, manipulated, fictionalized, the so-called directorial mode, in which we find such *auteurs* of photography as Duane Michaels and Les Krims. The strategy of this mode is to use the apparent veracity of photography against itself, creating one's fictions through the appearance of a seamless reality into which has been woven a narrative dimension. Cindy Sherman's photographs function within this mode, but only in order to expose an unwanted aspect of that fiction, for the fiction Sherman discloses is the fiction of the self. Her photographs show that the supposed autonomous and unitary self out of which those other "directors" would create their fictions is itself nothing other than a discontinuous series of representations, copies, and fakes.

Sherman's photographs are all self-portraits in which she appears in disguise enacting a drama whose particulars are withheld. This ambiguity of narrative parallels the ambiguity of the self that is both actor in the narrative and creator of it. For though Sherman is literally self-created in

7 *Untitled Film Still #44,* 1979
black-and-white photograph
8 × 10 inches

these works, she is created in the image of already known feminine stereo-
types; her self is therefore understood as contingent on the possibilities
provided by the culture in which Sherman participates, not by some in-
ner impulse. As such, her photographs reverse the terms of art and auto-
biography. They use art not to reveal the artist's true self but to show the
self as an imaginary construct. There is no real Cindy Sherman in these
photographs; there are only the guises she assumes. And she does not cre-
ate these guises; she simply chooses them in the way that any of us do. The
pose of authorship is dispensed with not only through the mechanical
means of making the image but also through the effacement of any con-
tinuous, essential persona or even recognizable visage in the scenes.

The aspect of our culture that is most thoroughly manipulative of the
roles we play is, of course, mass advertising, whose photographic strategy
is to disguise the directorial mode as a form of documentary. Richard
Prince steals the most frank and banal of these images, which register, in
the context of photography-as-art, as a kind of shock. But ultimately their

8 *Untitled Film Still #59,* 1980
black-and-white photograph
8 × 10 inches

rather brutal familiarity gives way to strangeness, as an unintended and unwanted dimension of fiction reinvades them. By isolating, enlarging, and juxtaposing fragments of commercial images, Prince points to their invasion by these ghosts of fiction. Focusing directly on the commodity fetish, using the master tool of commodity fetishism, Prince's rephoto-graphed photographs take on a Hitchcockian dimension; the commodity becomes a clue. It has, we might say, acquired an aura, only now it is a function not of presence but of absence, severed from an origin, from an originator, from authenticity. In our time, the aura has become only a presence, which is to say, a ghost.

Notes

1. Douglas Crimp, "Pictures," *October,* no. 8 (Spring 1979), pp. 75–88. This essay is a re-vised version of the catalogue for an exhibition of the same title that I organized for Artists Space, New York, in the fall of 1977.

2. The famous condemnation of minimal sculpture's theatricality is Michael Fried's "Art and Objecthood," *Artforum* 5, no. 10 (June 1967), pp. 12–23.

3. Walter Benjamin, "The Work of Art in the Age of Mechanical Reproduction," in *Illuminations,* trans. Harry Zohn (New York: Schocken Books, 1969), p. 221.

4. Walter Benjamin, "A Short History of Photography," trans. Stanley Mitchell, *Screen* 13, no. 1 (Spring 1972), p. 18.

5. Ibid., p. 19.

6. Ibid., p. 7.

7. Benjamin, "Work of Art," p. 221.

8. Benjamin, "Short History," p. 20.

9. Ibid., p. 21.

10. Barbara Rose, *American Painting: The Eighties* (Buffalo: Thoren-Sidney Press, 1979), n.p.

11. Photography's "third meaning" is theorized in Roland Barthes, "The Third Meaning: Research Notes on Some Eisenstein Stills," in *Image—Music—Text,* trans. Stephen Heath (New York: Hill and Wang, 1977), pp. 52–68.

12. I refer here to John Szarkowski, *Mirrors and Windows: American Photography since 1960* (New York: Museum of Modern Art, 1978).

13. Sherrie Levine, unpublished statement, 1980.

14. Weston's notion that the photograph must be *previsualized* is stated in many variations throughout his large body of writings. It first appears at least as early as his "Random Notes on Photography" of 1922. See Peter C. Bunnell, ed., *Edward Weston on Photography* (Salt Lake City: Peregrim Smith Books, 1983).

15. See Roland Barthes, "Rhetoric of the Image," in *Image—Music—Text,* pp. 32–51.

A Piece of the Action: Images of "Woman" in the Photography of Cindy Sherman

Judith Williamson

When I rummage through my wardrobe in the morning I am not merely faced with a choice what to wear. I am faced with a choice of images: the difference between a smart suit and a pair of overalls, a leather skirt and a cotton dress, is not just one of fabric and style, but one of identity. You know perfectly well that you will be seen differently for the whole day, depending on what you put on; you will appear as a particular kind of woman with one particular identity *which excludes others.* The black leather skirt rather rules out girlish innocence, oily overalls tend to exclude sophistication, ditto smart suit and radical feminism. Often I have wished I could put them all on together, or appear simultaneously in every possible outfit, just to say, How dare you think any one of these is *me.* But also, See, I can be all of them.

 This seems to me exactly what Cindy Sherman achieves in her series of "Film Stills" and later "Untitled" photographs. To present all those surfaces at once is such a superb way of flashing the images of "Woman" back where they belong, in the recognition of the beholder. Sherman's pictures force upon the viewer that elision of image and identity which women experience all the time: as if the sexy black dress made you *be* a femme fatale, whereas "femme fatale" is, precisely, an image, it needs a viewer to function at all. It's also just one splinter of the mirror, broken off from, for example, "nice girl" or "mother." Sherman stretches this phenomenon in two directions at once—which makes the tension and sharpness of her work. *Within* each image, far from deconstructing the elision of image and identity, she very smartly leads the viewer to *construct* it; but by presenting a whole lexicon of feminine identities, all of them played by "her," she undermines your little constructions as fast as you can build them up.

"Image" has a double sense, both as the kind of woman fantasized (is your "image" aggressive, cute, femme fatale, dumb blonde, etc.), and as the actual representation, the photograph. What Sherman does is to make you see type of "woman," of femininity, as inseparable from the literal presentation of the image—lighting, contrast, composition, photographic style. The "Film Stills" are the most obvious example of this. The grainy print and ominous shadows in *Untitled Film Still #4* (fig. 1) are part of what makes up our idea of the woman shown leaning against the door. The low angle, crisp focus, and sharp contrasts of *Untitled Film Still #16* (fig. 9) are part of the woman's sophisticated yet fragile image, just as the slightly soft focus and low contrast of *#40* are part of *her* more pastoral, Renoir-esque femininity. The composition of the recognizably "New Wave Art Movie" *Still #63,* the smallness of the figure in the harshly geometric architecture, is part of the little-girl-lostness that we feel as coming from the woman. In the "Untitled Film Stills" we are constantly forced to recognize a visual style (often you could name the director) simultaneously with a type of femininity. The two cannot be pulled apart. The image suggests that there is a particular kind of femininity in the *woman* we see, whereas in fact the femininity is in the image itself, it *is* the image—"a surface which suggests nothing but itself, and yet insofar as it suggests there is something behind it, prevents us from considering it as a surface."[1]

Apart from the interest of this for anyone analyzing how film and photographic representations work, it is, as I have tried to suggest, particularly important for women. I find the recognition of this process, that the "woman" is constructed in the image, very liberating; I want to say "You see?!" to any man standing next to me looking at the photos in the exhibition. Because the viewer is forced into complicity with the way these "women" are constructed: you recognize the styles, the "films," the "stars," and at that moment when you recognize the picture, your reading *is* the picture. In a way, "it" is innocent: *you* are guilty, you supply the femininity simply through social and cultural knowledge. As one reviewer says, "she shows us that, in a sense, we've bought the goods."[2] The stereotypes and assumptions necessary to "get" each picture are found in our own heads. Yet, at the risk of being attacked as "essentialist," I really do think the complicity of viewing is different for women and men. For women, I feel it shows us that we needn't buy the goods, or at least, we needn't buy them as being our "true selves." But in a discussion at the first Sherman retrospective in Britain, I remember a man getting incredibly worked up about how sexist the images were, and furious at "Cindy Sherman." He

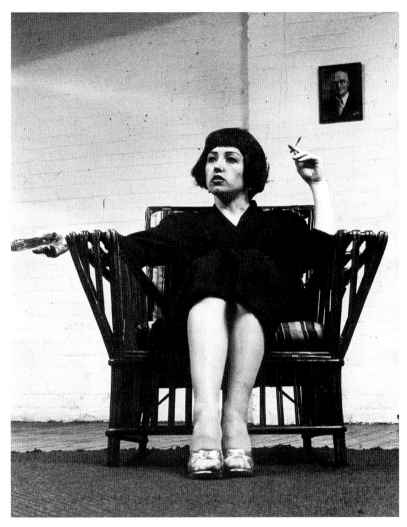

9 *Untitled Film Still #16,* 1978
black-and-white photograph
10 × 8 inches

kept saying there were enough images of women as sexual objects, passive, doll-like, all tarted up. Although his rhetoric sounded Right On, I was certain his anger must have come from a sense of his own involvement, the way those images speak not only *to* him but *from* him—and he kept blaming Sherman herself for it, deflecting his sexism onto her, as if she really was a bit of a whore. This idea of what she "really is" I'll return to later. But the way we are forced to supply the femininity "behind" the photos through recognition is part of their power in showing how an ideology works—not by undoing it, but by *doing* it. The moment we recognize a "character," it is as if she must already exist.

For what we construct from the surface of each picture is an interior, a mixture of emotions. Each setting, pose, and facial expression seems literally to express an almost immeasurable interior which is at once mysteriously deep, and totally impenetrable: a feminine identity. Obviously this is what acting is about, but these still images are like frozen moments of performance and so the sense of personality seems more trapped in the image itself. It is both so flat, and so full (it seems) of feeling. But what links the emotions portrayed in the pictures is that they are all emotional *responses.* The woman's expression is like an imprint of a situation, there is some action and her face registers a *reaction.* Certain photos make this very explicit: *Untitled #96,* where a girl holds a scrap of newspaper in her hand, shows precisely the way that we read into her fundamentally "unreadable" face some emotional response which is both very definite, and entirely ambiguous. She looks thoughtful, but whether she is happy or unhappy, worried or perfectly all right, we have no clue. She looks, exactly, uncertain. Yet between the newspaper cutting and her face there is an endless production of significance which seems inevitable (it's always already started) and almost clear in its vagueness. Another photo from the same group, *Untitled #90* (fig. 10), shows a teenager lying, equally ambiguous in her expression, by a telephone. Is she happily dreaming, or anxiously awaiting a call? (It's just like the ads for home pregnancy testing kits which manage to get the model looking both as if she's hopefully waiting for the good news of having a baby, *and* as if she can't wait to be put out of her fear that she might be pregnant.) Either way, her expression is an index of something and someone else, something we don't know about but which everything in the frame points to. (In semiotic terms it literally is an index, as a footprint is to a foot—a relevant metaphor since so many Sherman women look as if they were trodden on by men, fate, or a B-movie plot.) With the cutting, the telephone, or the letter in *Untitled*

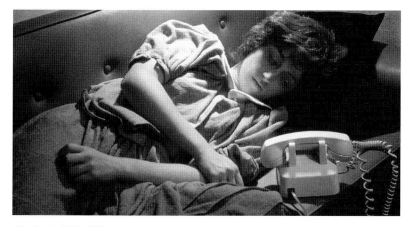

10 *Untitled #90,* 1981
color photograph
24 × 48 inches

Film Still #5 (where there seems to be a response to two things—the letter and someone else off screen left) something is put in the image as a snippet representative of the unknown narrative; but these images simply make explicit what happens in all of them, which is that meaning is thrown endlessly back and forth between a "woman" and a story. The cutting gives expression to the face, the face gives a story to the cutting.

This is exactly what happens in films, news photos, advertisements, and media generally. An image of a woman's face in tears will be used by a paper or magazine to show by *impression* the tragedy of a war, or the intensity of, say, a wedding. From the face we are supposed to read the emotion of the event. But conversely, it is the event that gives the emotion to the face; we have to know whether it is a war or a wedding to interpret correctly its well of meaning. Similarly in films the use of close-ups— woman screaming, woman weeping, woman watching, woman terrified, woman impressed—function as an imprint of the action, like a thermometer constantly held to the narrative. And no matter what the nature or content of the imprint, it is this imprintedness itself which seems to constitute femininity.

In Sherman's "Film Stills" the very reference to film invites this interpretation. Film stills are by definition a moment in a narrative. In every still, the woman suggests something other than herself, she is never complete: a narrative has to be invoked. Who, or what, is the dark-haired

woman in *#16* responding to? What is troubling the Hitchcockian hero-ine in *#21* (fig. 28)? What is that young French girl in *#40* looking side-ways at? But in the later works simply called "Untitled," the questions are perhaps more interesting and subtle, precisely because they aren't pre-sented as "film stills." *Something* is worrying, not to say frightening, the women in photos like *Untitled #80*—at least 90 minutes' worth of some-thing. In this group, back-projection is used to create the setting, the backdrop scenario which interacts with the woman's face to produce the story, and the visual effect stays quite close to film. The next series, from which *Untitled #90* and *#96* (fig. 20) were selected, comes closer in to the woman's body than many of the earlier works, but still adds a prop, a clue to the story. However, the most recent work uses no props and a less "filmy" style, so we seem to be nearer an actual woman, presented more "neutrally." These photos are closer to advertisements than films; they still rely on clothes, lighting, and a facial expression which is evocative of something outside the frame. Here we don't get *any* of the story, only the response.

But the point is, the story *is her*. As we piece together, or guess, or as-sume, some meaning in the narrative, we find that the meaning is the woman. She appears to express the meaning of events. How like every narrative and photographic medium this is, and also how like actual life, the "they've got it, she wears it" of personal relations. In tapping the rela-tion between women and meaningfulness Sherman's work resonates through many other areas. Certainly it also illuminates the process of read-ing all still images, especially ads, in the way objects, details, arrangements, and settings construct a story and an identity simultaneously. Women are not always necessarily a part of this visual and ideological process. But in Sherman's work, what comes out of the imagined narratives is, specifi-cally, femininity. It is not just a range of feminine expressions that are shown but the *process* of the "feminine" as an effect, something acted on.

However, this femininity is not all form and no content. The emo-tions that bounce between the narrative and the woman in each picture, though unclear, are nearly all suggestive of fear, suspicion, vulnerability, anxiety, or at best uncertainty. And Sherman brilliantly shows how this vulnerability is linked with eroticism, not always through explicitly "sex-ual" poses—as in *Untitled #103* (fig. 11) and some of the earlier much publicized "Film Stills"—but through performing femininity at their intersection. In the earlier work, particularly, there always seems to be a

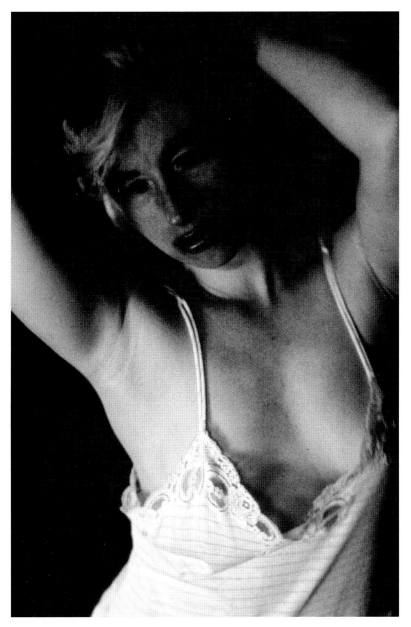

11 *Untitled #103,* 1982
color photograph
30 × 19³/₄ inches

A Piece of the Action

sense of menace, the woman is under threat. And her vulnerability is always erotic, rather in the way that many horror movies which involve no explicit sex at all give an erotic spin-off just through having a terrified woman constantly in vulnerable positions. So strongly is femininity evoked in these situations that they have to be *sexual*—is there any definition of femininity that isn't? That's why, in so many of Sherman's images, simply the distress or passivity of the women figures feels faintly pornographic—I say that to be descriptive rather than pejorative. I feel Sherman simply brings to the surface very clearly that same whiff of the pornographic that I personally feel about so many of Hitchcock's heroines, frightened, blonde, and vulnerable; or Godard's use of Anna Karina and other women stars as fathomless icons of femininity, passive repositories of desire. Sherman's women with their parted lips and their stories in their eyes (very Bob Dylan) are something to get off on in their very uncertainty. And in linking the erotic and the vulnerable she has hit a raw nerve of "femininity." I don't by this mean women (though we do experience it) but the *image* of Woman, an imaginary, fragmentary identity found not only in photos and films but in the social fabric of our thoughts and feelings.

It is so important to stress the difference not because "femininity" is a bad, false, two-dimensional construct that is forced upon us (even if it feels that way) but precisely because, ultimately, it isn't any one thing at all. It can only exist in opposition to something else, like one half of a see-saw. In Sherman's pictures, the way the woman is *affected* by something makes her like an *effect,* her face stamped by events, and I have tried to argue that this produces the feminine sexual identity which comes across. But what is crucial to the reading of Sherman's work is also the opposition between the images. "Essentially feminine" as they all are, they are all different. This not only rules out the idea that any one of them *is* the "essentially feminine," but also shows, since each *seems* to be it, that there can be no such thing. Yet so tenacious is the wish for this set of psychic garments to turn out to be actual skin, that almost every time Sherman's work is written about the issue of Cindy Sherman "herself" comes into it. She has often been thought of as *indulging* in self-images, wishing secretly to be like Marilyn Monroe, posing as a sexy heroine. From the notion that her work springs from a desire to be more glamorous, follows the idea that she is not "really" as attractive as her heroines, the glamour is not allowed to be hers.

The best example of such an approach is Waldemar Januszczak's review of her retrospective at Bristol in the *Guardian:* "You see her as she sees her-

self, a small, scrawny girl from Buffalo, a mousey blond who dreams of becoming a peroxide starlet. Her wigs don't always fit and her bra has to be padded." What a combination of put-down and turn-on! "Behind the Marilyn Monroe character you finally find Cindy Sherman." How? Does he know her? "She is at her best looking intense, staring into the distance as intently as if it were her own past—which of course it is . . ." and finally, "Several times she appears to be recoiling from the harsh stare of her own camera, like a scared animal trapped in a car's headlights. This too, you sense, is the real Cindy Sherman."[3] This all reads like a patently sexual fantasy, as if she were at somebody's mercy (his). If she were a man he would not even continue using her first name as well as surname beyond the first paragraph; and this detail of language might make him have to treat her as an artist, in control of her work. As it was, even the image selected to illustrate the article was one of the most sexually provocative. I have quoted this review in detail first to show that it is a possible response to the work (basically for men) but second, because I think that this false search for the "real" her is exactly what the work is about, and it leads people like Waldemar Januszczak right up the garden path. The attempt to find the "real" Cindy Sherman is unfulfillable, just as it is for anyone, but what's so interesting is the obsessive *drive* to find that identity.

This comes out particularly in comments on the later photos. Almost every critic has felt the recent work is in some way moving closer to Sherman "herself." Els Barents, in a catalogue introduction, calls it "free of references to archetypes" and says that "dressed in today's clothes . . . the[se] portraits seem more refined, natural, and closer to Cindy Sherman herself."[4] But in the more recent photos there seem to me to be sets of contrasts that function in the same way as the earlier "Film Stills," only even more pointedly. For some reason most critics have seen *Untitled #103* (fig. 11) but somehow gone blind to *Untitled #104* (fig. 12), which immediately follows it and would stand beside it in a gallery. There, right next to the sexy Monroe-type image is a different one—not necessarily unsexy or unsexual but very boyish, much more alert, wearing an old teeshirt—and, most important, they are both her. The fact that it *is* Cindy Sherman performing each time is precisely what undermines the idea that any one image is "her." It reminds me of the Cachet ad: "It won't be the same on any two women . . . the perfume as individual as *you* are." This promise is followed by a bunch of images of different "femininities," each of which is meant to be a different *woman* (using Cachet); whereas what Sherman shows is that anyone can "be" all of them, and none.

12 *Untitled #104,* 1982
color photograph
30 × 19³/₄ inches

In the recent photos the issue seems to be pushed still farther, beyond different femininities and across the border of femininity/masculinity. This is particularly powerful because the later images do appear more "realistic," though of course they are nothing of the sort. *Untitled #116* and *#112* (fig. 13) both seem very straightforward, "natural" poses compared with the earlier set-ups. Both are "dressed in today's clothes," yet it is the subtlety in the difference between the clothes that makes one image very feminine, the other masculine. In *#116* the lighting, pose, expression, gaze, hair, skin, all spell femininity; subtly, but as clearly as in *Film Still #40*. But *#112* is sharper: the pointed collar, the shorts, the "harder" gaze, less unfixed than the other, all produce a "masculine" reading. The way the later images move towards, not simply sexual ambiguity (as if that were an identity) but a juxtaposing of "feminine" and "masculine" identities, seems to demolish once and for all the idea that either of these is something that can be fully inhabited (and also puts paid to the wet dream of Sherman as frightened animal or girl in padded bra).

For the identities elusively suggested, and so obsessively sought, are trapped, not in a car's headlights (for goodness sake) but, literally, in the light of the photographic print: the lighting which makes the image possible on that surface which is ultimately nothing more than a flattened reaction to light. In *Untitled #110* no face is even visible in the darkness, all that the lighting lets us see is an arm, a sleeve, some soft fabric, glowing as golden as an advertisement. There is only just enough photographic information for us to recognize what the image is of at all, and here again we are forced to realize how these effects on their own (as in so many ads) conjure up a feminine presence. The viewer is pushed as far as possible, to search in shadows for what isn't there on the page, but which the few shapes of light suggest *is* there. Femininity is trapped in the image—but the viewer is snared too. A similar and very witty rebuffing of our "reading in" is found in *Untitled Film Still #46* (fig. 14), where all that's visible of the woman is a diving mask looking up from the sea. We can't even see the face, and barely the eyes, yet the joke is, it *still* seems full of meaning.

In images like this one, in the whole range of work, in the juxtapositions made, there seems to me an enormous amount of wit. The conflation of Cindy Sherman as the imagined character in her performance, and Sherman as artist, always ends up with some idea of "her" as her heroines, frightened, vulnerable, threatened, and uncertain. But clearly as an artist Sherman is sharp, controlled, intelligent, witty. Couldn't these qualities of the work itself, rather than being swamped by that femininity she exposes,

13 *Untitled #112*, 1982
color photograph
45$^{1}/_{4}$ × 30 inches

14 *Untitled Film Still #46, 1979*
black-and-white photograph
8 × 10 inches

reflect back on it as a biting comment? Obviously the dialectic between Sherman as performer and photographer is important; after all, she *does* choose to present *herself* (in disguise) in her pictures. The identities she acts out may be passive and fearful. But look what she *does* with them, what she *makes:* she is in control. In its very last line, Barents's catalogue blurb turns on some of Sherman's critics: "the women she represents, they say, are too artificial to be experienced as real people" and ends by asking poignantly, "Is vulnerability as unreal as all that?"[5] Well, no, obviously not. But both the critics referred to, and the writer of the commentary, are opposing "artificial" and "real" in a way that has no meaning where femininity is concerned, which is why I started this piece with the wardrobe syndrome. Femininity is multiple, fractured, and yet each of its infinite surfaces gives the illusion of depth and wholeness. Realizing this means that we as women don't have to get trapped trying to "be" the depth behind a *surface,* and men just might bang their heads up against it and stop believing in that reflected space. Sherman's work is more than either a

witty parody of media images of women, or a series of self-portraits in a search for identity. The two are completely mixed up, as are the imagery and experience of femininity for all of us. Others might try to break open that web of mirrors, but Sherman's way of revealing it is just to keep on skillfully turning the kaleidoscope where a few fragments of fantasy go a long way.

Notes

1. Jean-Louis Baudry, "The Mask" in "Writing, Fiction, Ideology," *Afterimage* UK (Spring 1974), pp. 22–39.

2. Michael Starenko, "What's an Artist To Do?" *Afterimage* US (January 1983), pp. 4–5.

3. Waldemar Januszczak, "Here's Looking at You, Kid," *Guardian,* May 19, 1983.

4. Els Barents, Introduction to *Cindy Sherman* (Amsterdam: Stedelijk Museum, 1982), p. 10.

5. Ibid., p. 14.

Suitable for Framing: The Critical Recasting of Cindy Sherman

Abigail Solomon-Godeau

In a celebrated essay on Henry James's novella *The Turn of the Screw,* the literary theorist Shoshana Felman demonstrated how much of the critical commentary about the work unconsciously echoes, parallels, or even re-enacts the narrative problems and psychological questions it poses. In this regard, a number of recent laudatory essays on the work of Cindy Sherman evidence similar but, as I will suggest, revisionary relations to their subject. For unlike the mirroring tendencies of Jamesian commentary, the criticism of Sherman features a form of mirrored reversal, such that given elements of Sherman's work are effectively transposed into precisely what they put in question.[1] Thus, for example, if Sherman's pictures have struck many viewers as centrally concerned with the problematics of femininity (as role, as image, as spectacle), more recent interpretation now finds them redolent with allusion to "our common humanity,"[2] revealing "a progression through the deserts of human condition [sic]."[3]

Such readings might well be characterized as inverted insofar as the most prominent and denaturalizing aspects of Sherman's pictures are either altogether elided and denied (thus enabling far more anodyne interpretations), or, more interestingly—if not perversely—metamorphosed into precisely what they aren't, as when Thomas Kellein closes his essay with the biblical quotation, "Skin for skin, yea, all that a man hath will he give for his life!" The work of a woman artist, whose work has long been preoccupied with constructions of femininity, is here textually dispatched with an exclamatory invocation to the masculine.

Of course one might well respond to such criticism by demonstrating how the authors have somehow gotten it wrong. Surely if there is anything

15 *Untitled Film Still #82,* 1980
black-and-white photograph
10 × 8 inches

unambiguous about Sherman's work in its entirety it is the refusal of the equation man = human. Nevertheless, I prefer to see, as did Felman, a certain method in the madness. Accordingly, I want to consider what stakes—psychological, aesthetic, material—might conceivably underpin these celebratory recastings. To do so, however, it is useful to recall that the major critical writing on Cindy Sherman from, say, 1978 to the early eighties had two primary axes. On the one hand, a corpus of explicitly feminist texts, exemplified by Judith Williamson's 1983 "Images of 'Woman'."[4] For feminists, Sherman's work was not only immediately recognizable as major art whose motifs and thematics converged with those which feminist theory was addressing, but perhaps more importantly, it could also be seen as a tributary to that project. In this respect, it is clear that artists whose principle themes devolved on questions of difference, sexuality, and gender (whether self-proclaimed feminists or not, whether male or female, whether essentialist or anti-essentialist) were—and are—part of a collective project in which artist, critic, theorist, and feminist are discursively joined. Furthermore, while mass culture (as image bank, as ideology, and as cultural problematic) had been the stock in trade of much contemporary art at least since Pop, from the beginning Sherman grasped the particular density and specificity of relations between mass culture and femininity. For many, Sherman's importance was therefore inseparable from the analyses—and the challenge—of feminist work on representation.

On the other hand, the earliest serious consideration of Sherman's work was animated by the most rigorous formulations of a deconstructive and oppositional postmodernism; I refer here specifically to the texts of Douglas Crimp, especially the essay "Pictures" which accompanied the exhibition of the same title that he curated in 1977.[5] There were, as well, critics such as the late Craig Owens, who incorporated both approaches, acknowledging those aspects of Sherman's production that dealt with issues of femininity for feminism and those aspects of her work that raised the kind of questions so provocative to Crimp; the epistemological status of photography and its dialectic of presence and absence, narrative, the politics of representation, the rejection of painting, the death of the author, the conditions of postmodernism, and so on.[6] It is not my intention to argue for the primacy of one approach over the other, but rather, to reinstate the terms by which Sherman's work was initially made critically visible, which is to say, within theoretical frameworks that insisted on its aesthetic and its sexual politics.

16 *Untitled #138,* 1984
color photograph
77 × 48¹/₂ inches

By the time of her 1987 one person show at the Whitney Museum, if not before, Sherman was firmly established as a central figure in the art world, having, *mutatis mutandis,* decisively escaped the marginality of a category such as "critical or oppositional postmodernism," much less "feminist art." This escape was effected not because her work had become in any way less potent or highly charged; on the contrary, her work could be, and frequently was, even more uncompromising, more assaultive, more disturbing than the justly famous *Film Stills* of 1977–1980. Rather, within the interlocking activities and discourses that propelled Sherman to major artist status, a new critical framework was galvanized; a second tier, as it were, of critical commentary. Produced, for the most part, by art journalists such as Gerald Marzorati, newspaper critics such as Andy Grundberg, and museum curators such as Lisa Phillips, an apparatus of publicity replaced an apparatus of criticism. More to the point, these successive approaches to Sherman's pictures were as much invested in Sherman's not being perceived as concerned with aesthetic or sexual politics as earlier commentators had been invested in affirming the opposite. The Whitney Museum catalogue is in this respect an interesting gauge of the degree to which Sherman's work had, by 1987, already been substantially recast. While it is hardly surprising to discover that neither Peter Schjeldahl nor Lisa Phillips have a single word to say about feminism (might not this have been, as well as T.V. and movies, an influence on the artist?), feminist art practice, or the specific issues involved in the mass media's representations of femininity, one is nonetheless struck by the very force of this avoidance. It is, for example, nowhere stated in either essay that Sherman's pictures were at that date exclusively concerned with what might be termed woman-as-image, as though the act of exhaustively restaging an image repertoire of feminine types was an entirely adventitious or arbitrary aspect of Sherman's project.[7] It is in Schjeldahl's essay, however, where one encounters the tendency to inversely mirror the terms that Sherman's work sets up. Thus, if Sherman's heroines (with or without elaborate mise-en-scènes) function like psychic lures, soliciting subjective mechanisms of narrative, psychological, or sexual projection, it is surely because the point is to make those projections available to conscious analysis. Without this critical dimension, one might just as well be Helmut Newton. Schjeldahl's essay, however, enacts the projection as though it were real:

> I am interested to note that I automatically assume, without knowing, that the photographer of the 'film frames' was always male. As a

male, I also find these pictures sentimentally, charmingly, and some-
times pretty fiercely erotic: I'm in love again with every look at the
insecure blonde in the nighttime city. . . . I am responding to Sher-
man's knack, shared with many movie actresses, of projecting female
vulnerability, thereby triggering (masculine) urges to ravish and/or
protect.[8]

This more or less eroticized relation to the image is frequently to be
encountered in Sherman's male critics; for example, Thomas Kellein and
Arthur C. Danto both include in their essays rather feverish descriptive
litanies of their preferred Sherman characters in which projection is given
free reign, but where critical analysis is nowhere in evidence. This form
of reverse mirroring is particularly evident in Danto's discussion of what
he is pleased to call "The Girl"—the *dramatis persona* within the stills. Un-
noticed or in any case unremarked is the fact that Sherman does not just
"do" the girl. Also populating the stills are middle-aged matrons, squalid
Hausfrauen, and—patriarchal euphemism par excellence—women of a
certain age. That such types become critically invisible grimly parallels
their invisibility in real life. But the enthusiasm that "The Girl" prompts
in Danto's essay, and analogous passages in Schjeldahl and Kellein, suggests
that when confronted with a deconstruction of mythic femininity, these
writers must compensate by shoring up or recuperating precisely the
fantasies which Sherman's stills attempt to destabilize.

If the phantasmatic femininity that Sherman exhaustively stages is
renaturalized in such texts, it is no doubt a foregone conclusion that a re-
lated critical move will be to minimize, if not deny, any feminist intent in
the work. Hence, the availability of Sherman's pictures for feminist read-
ings is glossed in the glass darkly of Danto's text with the baffling proviso,
"her work has had a special interest for feminists who subscribe to the
view that women do not hold theories but tell stories, whose way of
representing the world is essentially narrativistic."[9] While Sherman's use of
narrative is, in fact, profoundly connected to feminist theory (one thinks
here, for example, of Laura Mulvey's observation that "sadism demands
a story") it is also significant that Danto feels compelled to caution the
reader that "Even so, the stills are not in my view merely feminist parables."

If one aspect of Sherman's critical recasting mandates the repression
of feminism as a term in criticism, this must be understood as the neces-
sary cost of making Sherman a universal artist whose very stature requires
that her work transcend the particularity or specificity of femininity.

Hence, the critical investment in claiming her work for a nondifferentiated human condition: "The hypnotic women of the 'horizontals' strike beneath the personality and gender, almost beneath humanity. Their reveries are like so many viewpoints on the darkest sensations, and the terror, of existing."[10] It is in Danto's essay, however, that the mechanisms by which femininity becomes humanity are most clearly displayed. Here, the specificity of Sherman's subject (the image of femininity within the visual codes of B films of *film noir*) is magisterially subsumed under the rubric of universalism:

> And with her breakthrough to the still, everything came together for Sherman: a oneness with a set of narrative structures instantly legible to everyone who lives in this culture, and so a oneness with her presumed audience. . . . The still has given her a way into the common cultural mind, obliterating the distances between her self and our selves, and between self and self among us.[11]

The Family of Man rhetoric which Danto employs operates quite clearly to obscure the salient fact that it is femininity, and not humanity, that is Sherman's chosen domain. After all, it is not anxious or apparently menaced men that Sherman photographed on dark streets, nor did she depict men lying, tearful and distressed, on various floors or beds. And these pious humanist evocations of oneness, (for example, "the common cultural mind," "self and self among us") and the concomitant assertion that Sherman's work fosters a communal closeness between "her self" and "our selves" are equally predicated on an interpretive reversal. For if, as Danto elsewhere acknowledges, one of Sherman's tactics in the stills (and indeed in all her work) is the consistent withholding of an authentic "self," a perpetual denial of autobiographic presence, on what basis is this communion of selves taking place? While Sherman is equally adept at exposing masculine masquerade—masculinity as masquerade—as in her Masterpiece Theater excursus on the history of Western portraiture, the bulk of her work until now has been constructed as a theater of femininity as it is formed and informed by mass culture. Far from sustaining a sentimental notion of human collectivity and oneness, Sherman's pictures insist on the aporia of feminine identity, indeed, of identity *tout court,* represented in her pictures as a potentially limitless range of masquerades, roles, projections. Danto's text is additionally concerned to sanitize the mass cultural forms that Sherman exploits; another wish-fulfilling reversal. Sherman's

appropriation of mass media forms is anything but confirming or parodic; they rarely induce laughter. To interpret her use of the film still as a salutory embrace of a medium that "obliterat[es] the distance between her self and our selves, and between self and self among us" is to effectively deny any possibility of conflict, alienation, or opposition in either Sherman's (or our) relation to "her culture."

If Schjeldahl's and Danto's essays can discover and celebrate a humanism that Sherman's work categorically denies, and project an affirmative relation to the media that she investigates, another example of mirror reversal can be found in Ingrid Sischy's startling perception that Sherman's pictures exist on a continuum with Victorian art photography. Her specific example is Lady Clementina Hawarden, who for a period of time (1857–1865) took photographs of her daughters in "fancy dress" (not masquerade). Sischy's meandering *New Yorker* essay, entitled "Let's Pretend," is implicitly concerned to ratify the major status of both women as photographers. Such an argument must therefore repress the antithetical terms that underpin, on the one hand, the ethos of Victorian art photography, and on the other, postmodern uses of the medium. The critical revision at work here is rooted in the desire for a tradition, albeit one that can be claimed for women. Despite the fact that Hawarden employed models for her pictures, and Sherman employs herself; despite the fact that Hawarden's pictures fetishize the entirely conventional femininity that they stage while Sherman's, if anything, are relentlessly de-fetishizing; despite the fact that Hawarden's photographs are moored in pictorialist aestheticism, and Sherman's in the cultural landscape of postmodernism. Sischy's text, confronting rupture, reflects back continuity, a commonality of vision and experience—derived from "dressing up."

> But the similarities between the photography of Sherman and Hawarden raised questions. Is it the dressing up that makes the pictures by both these women so powerful? Is that what's so haunting about what they do? And in the idea of dressing up is there something especially meaningful to women? . . . To take away the specificity of what Sherman and Hawarden have created with dressing up is to drain their work of its impact, and to miss what is perhaps the most meaningful implication of their connection. Together, they suggest how dressing up could be used as a thread to weave in and out of the history of photography in order to help find what has been missing: the presence of women.[12]

While the absence of women from photographic history is certainly to be deplored and if possible, rectified, such a linkage is nonetheless entirely spurious. What is at stake in Sischy's text is the desire to imagine a tradition (female "authors," feminine preoccupation with dressing up as a transhistorical and unifying thematic, the shared photographic medium as itself a guarantee of filiation) that collapses the oppositions, ruptures, and contestations that Sherman's work poses with respect to, variously, the ideology of art photography, conventionalized notions of femininity, and last but hardly least, the integrity and authenticity of photographic images of the feminine. To read out from Hawarden's and Sherman's work a thematic connection is to invert quite literally the historic (and political) distinction between the visual production of romantic notions of femininity and their active subversion. Not for nothing has Sherman employed carapace-like simulacra of breasts and buttocks in her pictures, and not for nothing do so many of her series batten on those forms of mass culture in which femininity has been most problematically figured. Just as Danto's essay duly registers an inventory of feminine types but reflects back "a deep human essence," so too does Sischy's acknowledge that Hawarden's and Sherman's pictures are "like images you find in 'before' and 'after' narratives"—in this case, the narrative of women before and after they publicly took the matter of their lives into their own hands, but immediately concludes, "There's a tie between their photographs which connects them as surely as an umbilical cord."[13]

As Sischy herself concludes elsewhere in her essay, for good or for ill, art works do not speak for themselves. Art objects enter the world embedded in and subsequently subject to a dense matrix of discourses and determinations, including, but not limited to, art criticism. Works of art are also "framed" in myriad ways: literally (or not) on the wall, architecturally, institutionally, and discursively. That Sherman and her pictures should now be critically framed in terms that cast her either as Universal Artist plumbing the trackless wastes of the "human condition," or as art-world Madonna (re)purveying femininity as spectacle, depends on the distortion or repression of the most destabilizing, denaturalizing, and subversive elements of her work. In this regard, it is significant that the nastiest and most aggressive of her series have received proportionally the least commentary. That Cindy Sherman has achieved, *mirabile dictu,* Major Artist Status, is certainly to be celebrated by all those, like myself, for whom her work has been of immense importance and continued fascination. Nevertheless, the terms of this recent critical revision are hardly cause for rejoicing. In ascending to

17 *Untitled #155*, 1985
color photograph
72^1/$_2$ × 49^1/$_4$ inches

18 *Untitled #222*, 1990
color photograph
60 × 44 inches

that pantheon where, as we all know, genius has no gender, what gets deflected in the criticism, when not relegated to critical oblivion altogether, are all those elements in the work that constitute its difference. Only then it seems is an art so integrally bound to devalued secondary terms (masculine/feminine, high culture/mass culture, painting/photography, appearance/essence, and last, but hardly least, presence/absence) deemed definitely, and triumphantly, suitable for framing.

Notes

1. A conspicuous exception to the critical revisions discussed here is Laura Mulvey's essay on Sherman, "A Phantasmagoria of the Female Body: The Work of Cindy Sherman" (1991). Included in this volume under the title "Cosmetics and Abjection: Cindy Sherman 1977–87."

2. Arthur C. Danto, "Photography and Performance: Cindy Sherman's Stills," in *Untitled Film Stills: Cindy Sherman* (Munich: Schirmer/Mosel and New York: Rizzoli, 1990).

3. Thomas Kellein, "How difficult are portraits? How difficult are people!" in *Cindy Sherman,* exhibition catalogue (Kunsthalle Basel: 28 March–20 May, 1991).

4. Judith Williamson, "Images of 'Woman'—The Photographs of Cindy Sherman" (1983). Reprinted in this volume as "A Piece of the Action: Images of 'Woman' in the Photography of Cindy Sherman."

5. A revised version of Douglas Crimp's catalogue essay appeared as "Pictures," *October* 8 (Spring 1979); See also his "The Photographic Activity of Postmodernism" (1981), reprinted in this volume; and "Appropriating Appropriation," in *Image Scavengers,* exhibition catalogue (Philadelphia: Institute of Contemporary Art, 1982).

6. Craig Owens, "The Discourse of Others," in Hal Foster, ed. *The Anti-Aesthetic* (Port Townsend: Bay Press, 1983); "From Work to Frame," in *Implosion,* exhibition catalogue (Stockholm: Moderna Museet, 1987).

7. The important distinction between an analysis of images of women as opposed to an analysis of woman as image was first made by the British art historian Griselda Pollock.

8. Peter Schjeldahl, "The Oracle of Images," *Cindy Sherman,* exhibition catalogue (New York: The Whitney Museum of American Art, 1987), p. 7.

9. Danto, p. 10.

10. Schjeldahl, p. 9.

11. Danto, p. 13.

12. Ingrid Sischy, "Let's Pretend," *The New Yorker,* May 6, 1991, p. 96.

13. Ibid., p. 87.

Cosmetics and Abjection: Cindy Sherman 1977–87

Laura Mulvey

When I was in school I was getting disgusted with the attitude of art being so religious or sacred, so I wanted to make something which people could relate to without having read a book about it first. So that anybody off the street could appreciate it, even if they couldn't fully understand it; they could still get something out of it. That's the reason why I wanted to imitate something out of the culture, and also make fun of the culture as I was doing it.

—Cindy Sherman[1]

Cindy Sherman's works are photographs. She is not a photographer but an artist who uses photography. Each image is built around a photographic depiction of a woman. And each of the women is Sherman herself, si-multaneously artist and model, transformed, chameleon-like, into a glos-sary of pose, gesture, and facial expression. As her work developed, between 1977 and 1987, a strange process of metamorphosis took place. Apparently easy and accessible postmodern pastiche underwent a gradual transformation into difficult, but still accessible, images that raise serious and challenging questions for contemporary feminist aesthetics. And the metamorphosis provides a new perspective that then alters, with hind-sight, the significance of her early work. In order to work through the critical implications of this altered perspective, it is necessary to fly in the face of her own expressly non-theoretical, even anti-theoretical stance. Paradoxically, it is because there is no explicit citation of theory in the work, no explanatory words, no linguistic signposts, that theory can then

come into its own. Sherman's work stays on the side of enigma, but as a critical challenge, not an insoluble mystery. Figuring out the enigma, deciphering its pictographic clues, applying the theoretical tools associated with feminist aesthetics, is, to use one of her favorite words, fun, and draws attention to the way that, through feminist aesthetics, theory, decipherment and the entertainment of riddle or puzzle solving may be connected.

During the '70s, feminist aesthetics and women artists contributed greatly to questioning two great cultural boundary divisions. Throughout the 20th century, inexorably but discontinuously, pressure had been building up against the separation between art theory and art practice on the one hand, and between high culture and low culture on the other. The collapse of these divisions was crucial to the many and varied components of post-modernism, and also to feminist art. Women artists made use of both theory and popular culture through reference and quotation. Cindy Sherman, first showing work in the late '70s, used popular culture as her source material without using theory as commentary and distanciation device. When her photographs were first shown, their insistent reiteration of representations of the feminine, and her use of herself, as model, in infinite varieties of masquerade, won immediate attention from critics who welcomed her as a counterpoint to feminist theoretical and conceptual art. The success of her early work, its acceptance by the center (art market and institutions) at a time when many artists were arguing for a politics of the margins, helped to obscure both that the work has intrinsic interest for feminist aesthetics and that the ideas raised by the work could not have been formulated without a prehistory of feminism and feminist theorization of the body and representation. Her arrival on the art scene certainly marks the beginning of the end of that era in which the female body had become, if not quite unrepresentable, only representable if refracted through theory. But rather than sidestepping, Sherman reacts and shifts the agenda. She brings a different perspective to the "images of women question" and brings back a politics of the body that had, perhaps, been lost or neglected in the twists and turns of '70s feminism.

In the early '70s, the Women's Movement claimed the female body as a site for political struggle, mobilizing around abortion rights above all, but with other ancillary issues spiraling out into agitation over medical marginalization and sexuality itself as a source of women's oppression. A politics of the body led logically to a politics of representation of the body. It was only a small step to include the question of images of women in the debates and campaigns around the body, but it was a step that also moved

feminism out of familiar terrains of political action into a terrain of po-
litical aesthetics. And this small step, from one terrain to another, called
for a new conceptual vocabulary, and opened the way for the influence
that semiotics and psychoanalysis have had on feminist theory. The initial
idea that images contributed to women's alienation from their bodies and
from their sexuality, with an attendant hope of liberation and recupera-
tion, gave way to theories of representation as symptom and signifier of
the way that problems posed by sexual difference under patriarchy could
be displaced onto the feminine.

Not surprisingly, this kind of theoretical/political aesthetics also
affected artists working in the climate of '70s feminism, and the repre-
sentability of the female body underwent a crisis. At an extreme, the film-
maker Peter Gidal said in 1978: "I have had a vehement refusal over the
last decade, with one or two minor aberrations, to allow images of women
into my films at all, since I do not see how those images can be separated
from the dominant meanings."[2]

Women artists and filmmakers, while rejecting this wholesale banish-
ment, were extremely wary about the investment of "dominant mean-
ings" in images of women and while feminist theorists turned to popular
culture to analyze these meanings, artists turned to theory, juxtaposing
images and ideas, to negate dominant meanings and, slowly and polemi-
cally, to invent different ones. Although in this climate, Cindy Sherman's
concentration on the female body seemed almost shocking, her represen-
tations of femininity were not a sign of regression, but a re-representation,
a making strange.

<p style="text-align:center">★</p>

A visitor to a Cindy Sherman retrospective, who moves through the work
in its chronological order, must be almost as struck by the dramatic nature
of its development, as by the individual, very striking, works themselves. It
is not only a question of observing an increasing maturity, a changed style,
or new directions, but of following a certain narrative of the feminine from
an initial premise to the very end of its road. And this development takes
place over ten years, between 1977 and 1987. The journey through time,
through the work's chronological development, is also a journey into
space. Sherman dissects the phantasmagoric space conjured up by the fe-
male body, from its exteriority to its interiority. The visitor who reaches
the final images and then returns, reversing the order, finds that with the
hindsight of what was to come, the early images are transformed. The first

process of discovery, amusement, and amazement is complemented by the discovery of curiosity, reverie, and decipherment. And then, once the process of bodily disintegration is established in later work, the early, innocent, images acquire a retrospective uncanniness.

The first series of photographs, which also established Sherman's reputation, are called *Untitled Film Stills*. In each photograph Sherman poses for the camera, as though in a scene from a movie. Each photograph has its own *mise en scène,* evoking a style of film-making that is highly connotative but elusive. The black and white photographs seem to refer to the '50s, to the New Wave, to neo-realism, to Hitchcock, or Hollywood B-pictures. This use of an amorphous connotation places them in a nostalgia genre, comparable to the American movies of the '80s that Fredric Jameson describes as having the postmodern characteristic of evoking the past while denying the reference of history.[3] They have the Barthesian quality of "fifties-ness," that American collective fantasy of the '50s as the time of everyone's youth in a white and mainly middle America setting, in the last moment of calm before the storms of civil rights, Vietnam, and finally feminism. Nostalgia is selective memory and its effect is often to draw attention to its repressions, to the fact that it always conceals more than it records. And the '50s saw a last flowering of a particular culture of appearances and, particularly, the feminine appearance. The accoutrements of the feminine struggle to conform to a façade of desirability haunt Sherman's iconography. Makeup, high heels, back-combed hair, respectable but eroticized clothes are all carefully "put on" and "done." Sherman, the model, dresses up into character while Sherman, the artist, reveals her character's masquerade. The juxtaposition begins to refer to a "surfaceness," so that nostalgia begins to dissolve into unease. Sherman accentuates the uneasiness by inscribing vulnerability into both the *mise en scène* of the photographs and the women's poses and expressions.

These *Film Still* scenes are set mainly in exteriors. Their fascination is derived from their quality as *trompe l'oeil*. The viewer is subjected to a series of doubletakes, estrangements and recognitions. The camera looks; it "captures" the female character in a parody of different voyeurisms. It intrudes into moments in which she is unguarded, sometimes undressed, absorbed into her own world in the privacy of her own environment. Or it witnesses a moment in which her guard drops as she is suddenly startled by a presence, unseen and off screen, watching her. Or it observes her composed, simultaneously demure and alluring, for the outside world and its intrusive gaze. The viewer is immediately caught by the voyeurisms on

19 *Untitled Film Still #54*, 1980
black-and-white photograph
8 × 10 inches

offer. But the obvious fact that each character is Sherman herself, disguised, introduces a sense of wonder at the illusion and its credibility. And, as is well known in the cinema, any moment of marveling at an illusion immediately destroys its credibility. The lure of voyeurism turns around like a trap, and the viewer ends up aware that Sherman, the artist, has set up a machine for making the gaze materialize uncomfortably in alliance with Sherman, the model. Then the viewer's curiosity may be attracted to the surrounding narrative. But any speculation about a story, about actual events and the character depicted, quickly reaches a dead end. The visitor at a Cindy Sherman show must be well aware that the *Film Still* is constructed for this one image only, and that nothing exists either before or after the moment shown. Each pregnant moment is a cutout, a tableau suggesting and denying the presence of a story. As they pretend to be something more, the *Film Stills* parody the stillness of the photograph and they ironically enact the poignancy of a "frozen moment." The women in the photographs are almost always in stasis, halted by something more than photography, like surprise, reverie, decorum, anxiety, or just waiting.

The viewer's voyeurism is uncomfortable. There is no complementary exhibitionism on the part of the female figures and the sense of looking on, unobserved, provokes a mixture of curiosity and anxiety. The images are, however, erotic. Sexuality pervades the figures and their implied narratives. Sherman performs femininity as an appearance, in which the insistent sexualization of woman hovers in oscillation with respectability. Because Sherman uses cosmetics literally as a mask she makes visible the feminine as masquerade. And it is this culture of appearance, a homogeneity of look that characterizes "fifties-ness," that Sherman makes use of to adopt such a variety of similar, but different, figurations. Identity, she seems to say, lies in looks for white femininity at the time. But just as she is artist and model, voyeur and looked at, active and passive, subject and object, the photographs set up a comparable variety of positions and responses for the viewer. There is no stable subject position in her work, no resting point that does not quickly shift into something else. So the *Film Stills'* initial sense of homogeneity and credibility breaks up into the kind of heterogeneity of subject position that feminist aesthetics espoused in advance of post-modernisms proper.

In 1980 Sherman made her first series of color photographs, using back projections of exteriors rather than actual locations, moving into a closer concentration on the face, and flattening the space of the photograph. Then, in 1981, she made a series of color photographs that start to suggest an interiority to the figure's exterior appearance. These photographs initiate her exploration inside the masquerade of femininity's interior/exterior binary opposition. The photographs all have the same format, horizontal like a cinemascope screen, so most of the figures lie on sofas or beds or on the floor. As the series originated as a "centerfold" for *Artforum,* they parody soft-core pastiche. These photographs concentrate on the sphere of feminine emotion, longing and reverie, and are set in private spaces that reduplicate the privacy of emotion. But, once again, an exact sensation is impossible to pin down. The young women that Sherman impersonates may be daydreaming about a future romance or they may be mourning a lost one. They may be waiting, in enforced passivity, for a letter or telephone call. Their eyes gaze into the distance. They are not aware of their clothes which are sometimes carelessly rumpled, so that, safe alone with their thoughts, their bodies are, slightly, revealed to the viewer. They exude vulnerability and sexual availability like lovesick heroines/victims in a romantic melodrama. There are some precedents in the *Untitled Film Stills* for this series, but the use of color, the horizontal format, and the

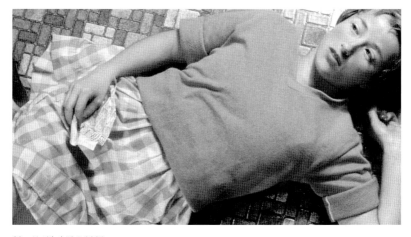

20 *Untitled #96*, 1981
color photograph
24 × 48 inches

repeated pose create a double theme of inside space and of reverie. The intimate space of a bedroom provides an appropriate setting for daydream or reverie, and combines with Sherman's erotic, suggestive poses to accumulate connotations of sexuality. These photographs reiterate the "to-be-looked-at-ness" of femininity. The *Untitled Film Stills* fake a surrounding narrative, so the camera should not draw undue attention to its presence and the "to-be-looked-at-ness" is a matter of social and cultural conformity. The 1981 *Untitleds,* on the other hand, announce themselves as photographs and, as in a pinup, the model's eroticism, and her pose, are directed towards the camera, and ultimately towards the spectator.

In most of the *Untitled Film Stills,* the female figure stands out in sharp contrast to her surroundings, exaggerating her vulnerability in an exterior world. In some, however, a visible grain merges the figure with the texture and material of the photograph. In the 1981 series, Sherman's use of color and light and shade merges the female figure and her surroundings into a continuum, without hard edges. Pools of light illuminate patches of skin or bathe the picture in a soft glow. Above all, the photographs have a glossy, high-quality finish in keeping with the codes and conventions of commercial photographs. While the poses are soft and limp, polar opposites of a popular idea of fetishized femininity (high-heeled and corseted, erect, flamboyant, and exhibitionist), fetishism returns in the formal qualities of the photography. The sense of surface now resides, not in the female

figure's attempt to save her face in a masquerade of femininity, but in the model's subordination to, and imbrication with, the texture of the photographic medium itself.

Sherman's next important phase, the *Untitleds* of 1983, first manifests the darkness of mood that will, from then on, increasingly overwhelm her work. This turn was, in the first place, a reaction against the fashion industry that had invited her to design photographs for them and then tried to modify and tone down the results:

> From the beginning there was something that didn't work with me, like there was friction. I picked out some clothes I wanted to use. I was sent completely different clothes that I found boring to use. I really started to make fun, not of the clothes, but much more of the fashion. I was starting to put scar tissue on my face to become really ugly.[4]

These photographs use bright, harsh light and high-contrast color. The characters are theatrical and ham up their roles. A new Sherman body is beginning to emerge. She grotesquely parodies the kind of feminine image that is geared to erotic consumption and she turns upside down conventional codes of female allure and elegance. Whereas the language of fashion photography gives great emphasis to lightness, so that its models seem to defy gravity, Sherman's figures are heavy in body and groundedness. Their lack of self-consciousness verges on the exhibitionist, and they strike professional poses to display costumes which exaggerate their awkward physiques, which are then exaggerated again by camera angle and lighting. There is absolutely nothing to do with nature or the natural in this response to the cosmetic svelteness of fashion. Rather, they suggest that the binary opposition to the perfect body of the fashion model is the grotesque, and that the smooth glossy body, polished by photography, is a defense against an anxiety-provoking, uneasy, and uncanny body. From this perspective the surface of the body, so carefully conveyed in the early photographs, seems to be dissolving to reveal a monstrous otherness behind the cosmetic façade. The "something" that had seemed to be lurking somewhere in the phantasmatic topography of femininity begins, as it were, to congeal.

After the *Untitleds* of 1983, the anti-fashion series, the metamorphoses become more acute and disturbing. The series *Untitled 1984* is like a reversal of Dorian Gray, as though the pain, anger, and stupidity of

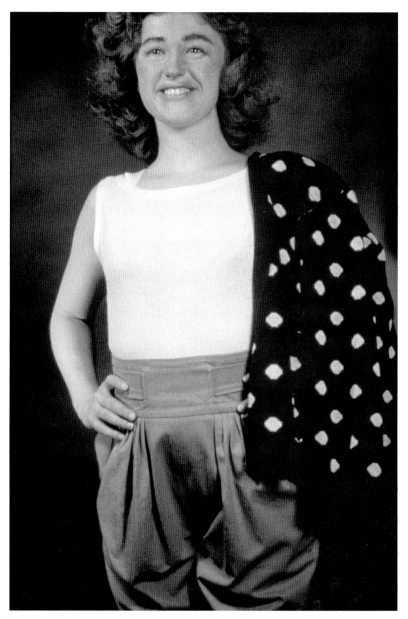

21 *Untitled #118,* 1983
color photograph
34^1/$_2$ × 23^1/$_4$ inches

human nature left their traces clearly on human features, as though the surface was failing in its task of masking. In the next series, inspired by the monsters of fairy stories, the figures become supernatural, and, rather like animistic personifications, they tower above or return to the elements. By this time the figures seem to be the emanations of irrational fears, verging on terror, relics of childhood nightmares. If the "centerfold" series conveyed, through pose and facial expression, the interiority of secret thoughts, now Sherman seems to personify the stuff of the unconscious itself. While the earlier interiority suggested soft, erotic reverie, these are materializations of anxiety and dread. Sherman seems to have moved from suggesting the presence of a hidden otherness to representing its inhabitants. Increasingly grotesque and deforming makeup blurs gender identity, and some figures are horned or snouted, like horrific mythological hybrids. If the earlier iconography suggested a passive aspiration to please, deformation and distortion seem to erupt in some kind of ratio to repression. These figures are active and threatening.

Finally, in the last phase, the figure disappears completely. Sometimes body bits are replaced by prostheses, such as false breasts or buttocks, but, in the last resort, nothing is left but disgust; the disgust of sexual detritus, decaying food, vomit, slime, menstrual blood, hair. These traces represent the end of the road, the secret stuff of bodily fluids that the cosmetic is designed to conceal. The topography of exterior/interior is exhausted. Previously, all Sherman's work had been centered and structured around a portrait, so that a single figure had provided a focus for the viewer's gaze. Surrounding *mise en scènes* had gradually vanished as though Sherman was denying the viewer any distraction or mitigation from the viewers themselves as they gradually became more and more grotesque. Around 1985, settings make a comeback in the photographs, but diffused into textures. Natural elements, pebbles, sand, or soil, for instance, develop expressive and threatening connotations. Color, lighting, and the texture of the figures make them merge visually into their settings. The camera angle now looks down onto the ground where the figures lie lifeless or, perhaps, trapped in their own materiality.

The shift in perspective, to downward camera angle, heralds Sherman's last phase. When the body, in any homogeneous or cohesive form, disappears from the scene, its traces and detritus are spread out on the ground, on pebbles or sand or submerged in water. With the disintegration of the body, the photographs also lose any homogeneous and cohesive formal organization, and the sense of physical fragmentation is echoed

22 *Untitled #175,* 1987
color photograph
47¹/₂ × 71¹/₂ inches

in the fragmentation of the images. Now the edge of the image may be as significant as any other section of its space. At the same time the photographs have become enormously enlarged. The early series, *Untitled Film Stills,* were all 8 by 10 inches, while the late series have grown to dimensions such as 72 by 49 inches. The viewer could take in the early work with a glance and sense of command over the image; the late photographs overwhelm the viewer and force the eye to scan the surface, searching for a specific shape or pattern that might offer some formal reassurance against the disturbing content.

This narrative of disintegration, horror, and finally disgust raises, first and foremost, the question of the source, or origin, of this phantasmagoria of the female body, and, second, how it might be analyzed. Woman becomes "the favored vehicle of the metaphor" once she is inscribed into the regime of castration anxiety, so the question of origin returns, once again, to the question of the male unconscious. A cosmetic, artificial surface covers, like a carapace, the wound or void left in the male psyche when it perceives the mark of sexual difference on the female body as an absence, a void, a castration. In this sense, the topography of the feminine masquerade echoes the topography of the fetish itself. But whereas, for instance,

the Pandora phenomenon remains, in the last resort, a symptom of these anxieties and disavowals, Sherman has slowly stripped the symptom away from its disavowal mechanisms, at the same time revealing the mechanisms for what they are. Sherman's ironic "unveiling" also "unveils" the use of the female body as a metaphor for division between surface allure and concealed decay, as though the stuff that has been projected for so long into a mythic space "behind" the mask of femininity had suddenly broken through the delicately painted veil. The female body's metamorphoses, in Sherman's "narrative trajectory," trace a gradual collapse of surface. In parodying the metaphor, she returns to the "literal," to the bodily fluids and wastes that become inseparable from the castrated body in the iconography of misogyny. But she also dramatically draws attention to the regime of representational and mythological contradiction lived by women under patriarchy. Although the origin of the image may be in the unconscious and although the image may be a phantasm, these collective fantasies also have an impact in reality, and produce symptoms that mediate between the two. The late photographs are a reminder that the female psyche may well identify with misogynist revulsion against the female body and attempt to erase signs that mark her physically as feminine. The images of decaying food and vomit raise the specter of the anorexic girl, who tragically acts out the fashion fetish of the female as an eviscerated, cosmetic, and artificial construction designed to ward off the "otherness" hidden in the "interior."

It is hard to trace the female body's collapse as successful fetish without re-representing the anxieties and dreads that give rise to the fetish in the first place, and Sherman might be open to the accusation that she reproduces the narrative without a sufficiently critical context. It is here that the *Untitled Film Stills* may be reread with the hindsight of the future development of Sherman's work in mind. To return to the early photographs, with hindsight, is to see how the female body can become a conduit for different ideas condensed into a single image. For instance, the uncanniness of the women characters, behind their cosmetic façades, starts to merge with the instability of the photograph as object of belief. The structure of fetishism indicates a homology between these different ideas, and the theory of fetishism helps to unravel the process of condensation.

For Freud, fetishism (apart, that is, from his view that it "confirmed the castration complex") demonstrates that the psyche can sustain incompatible ideas at one and the same time through a process of disavowal. Fetishistic disavowal acknowledges the woman's castration and simulta-

neously constructs a substitute to deny it and replace the missing object. Freud saw the coexistence of these two contradictory ideas, maintained in a single psyche, as a model for the ego's relation to reality, the "splitting of the ego," which allowed two parallel, but opposed, attitudes to be maintained with uneasy balance. Switching back and forth between visual duping, followed by perception of the duping mechanism, a willing suspension of disbelief followed by a wave of disillusion, "I know . . . but all the same," the viewer of Sherman's *Film Stills* can feel almost physically, and almost relish, the splitting open of the gap between knowledge and belief.

An "oscillation effect" contributes to postmodern aesthetics. The viewer looks, recognizes a style or trope, doubts, does a doubletake, recognizes the citation; and meanings shift and change their reference like shifting perceptions of perspective from an optical illusion. This effect is, perhaps, particularly exciting because it dices with the credibility of the fetish. In this sense, Cindy Sherman pushes postmodern play to its limits in the contested terrain of the female body. When the viewer reaches the final photographs of disintegration and only reluctantly recognizes the content for what it is, the art aspect of Sherman's work returns. It is not so much that the colors of the detritus images are more "painterly" and their reference is more to the shape of the frame than the figure, but that their place on the gallery wall affirms their status, just as the viewer is about to turn away in revolted disbelief. In this sense, they, too, create an "oscillation effect," this time between reverence and revulsion. This kind of theme is present in Sherman's latest works,[5] which are outside the 1977–87 "narrative" and return to the figuration of the human body, now refracted through art itself. She reproduces Old Masters, putting herself in the role of the central figure, or impersonating a portrait. Again, she distorts the body with false additions, such as the breast in a Virgin and Child. Although these images lack the inexorability and complexity of her previous phase, she still plays on the structures of disavowal and draws attention to the art-historical fetishization of great works and their value.

For Freud, the structure of fetishism was not the same as the structure of repression. While providing a substitute and a replacement and literally a screen against a traumatic memory, the fetish is also a memento of loss and substitution. And in these circumstances, how the female body, the original provoker of castration anxiety, is represented may be symptomatic and revealing. When Sherman depicts femininity as a masquerade in her succession of "dressings-up," the female body asserts itself as a site of anxiety that it must, at all costs, conceal. And it acquires a self-conscious

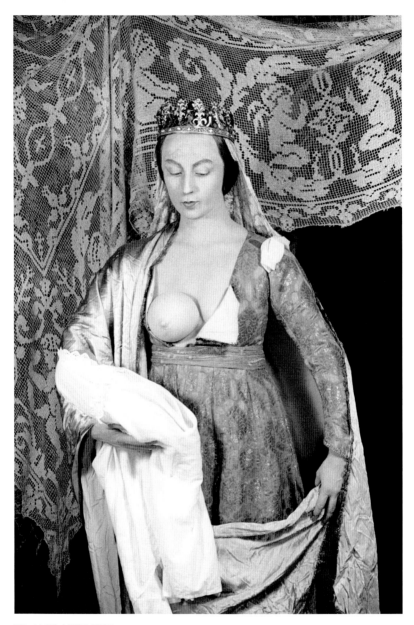

23 *Untitled #216,* 1989
color photograph
67 × 56 inches

vulnerability that seems to exude tension between an exterior appearance and its interiority. In this way, Sherman plays with a "topography" of the female body. But the early photographs illustrate the extent to which this "topography" has been integrated into a culture of the feminine. In order to create a "cosmetic" body, a cosmetics industry has come into being, so that the psychic investment the patriarchy makes in feminine appearance is echoed by an investment on the part of capitalism. And cosmetics are also, of course, the tools of Sherman's trade.

Fetishism depends on a phantasmatic topography, setting up a screen and shield, closely linked to the ego's defense mechanism, as Freud pointed out. At the same time, fetishism is the most semiotic of perversions, screening and shielding by means of an object that is, unavoidably, also a sign of loss and substitution. But its semiotic enterprise is invested in an acknowledgement of artifice. The fetish is, as Nietzsche said of woman, "so artistic." And, for instance, in Godard's representations of women, the female body reduplicates the surface that covers over a mysterious void, but it can incarnate the fetish object itself. This syndrome came into its own with the Hollywood star system, the mass production of pinups, and the equation, in contemporary consumer culture, between the feminine and glamour.

Cindy Sherman traces the abyss or morass that overwhelms the defetishized body, deprived of the fetish's semiotic, reduced to being "unspeakable" and devoid of significance. Her late work, as I suggested in the Pandora myth,[6] raises the question of Julia Kristeva's concept of the abject.[7] Barbara Creed's argument that abjection is central to the recurring image of the "monstrous feminine" in horror movies[8] is also applicable to the monstrous in Sherman. Although her figures materialize the stuff of irrational terror, they also have pathos and could easily be understood in terms of "the monster as victim." Her photographs of atrophied figures, for instance the corpse that lies like a soiled wax work, eyes staring and blending with color tones into the grass, could be collected into a lexicon of horror and the uncanny, just as the Untitled Film Stills are like a lexicon of poses and gestures typical of respectable, but still uncanny, femininity. Just as the development of individual subjectivity depends on marking out a boundary between the self, the mother, and subsequently anything reminiscent of the boundarilessness of infancy, so Sherman's photographs work in reverse. Starting off with Untitled Film Stills, mounted within a white border and enclosed in a black frame, the images gradually lose their definite outlines, both in relation to the frame and the depiction of the figures themselves.

By referring to the '50s in her early work, Sherman joins many others in identifying Eisenhower's America as the mythic birthplace of postmodern culture. Reference to the '50s invokes the aftermath of the Korean War and the success of the Marshall Plan, American mass consumption, the "society of the spectacle," and, indeed, the Hollywood melodrama. It was a time when, in the context of the cold war, advertising, movies, and the actual packaging and seductiveness of commodities all marketed glamour. Glamour proclaimed the desirability of American capitalism to the outside world and, inside, secured Americanness as an aspiration for the newly suburbanized white population as it buried incompatible memories of immigrant origins. In Sherman's early photographs, connotations of vulnerability and instability flow over onto the construction and credibility of the wider social masquerade. The image of "fifties-ness" as a particular emblem of Americanness also masks the fact that it was a decade of social and political repression while profound change gathered on the horizon, the transition, that is, from Joe McCarthy to James Dean, from Governor Maddox to Martin Luther King. Rather than simply referring to "fifties-ness" in nostalgia mode, Sherman hints at a world ingesting the seeds of its own decay.

In 1982 Cindy Sherman appeared on the cover of the Anglo-American avant-garde magazine *ZG*. She is immediately recognizable as Marilyn Monroe in a cover girl pose. She is not the Marilyn of bright lights and diamonds, but the other equally familiar Marilyn in slacks and a shirt, still epitomizing the glamour of the period, hand held to thrown-back head, eyes halfclosed, lips open. But refracted through Sherman's masquerade, Marilyn's masquerade fails to mask her interior anxiety, and unhappiness seems to seep through the cracks. America's favorite fetish never fully succeeded in papering over her interiority and the veil of sexual allure now seems, in retrospect, to be haunted by death. While American postmodernism cites the '50s, Marilyn Monroe is its emblem, as an icon in her own right, and as source of all the subsequent Marilyn iconography, kept alive by gay subculture, surfacing with Debbie Harry in the late '70s and recycled by Madonna in the '80s.

Cindy Sherman's impersonations predate, and in some ways prefigure, those of Madonna. Madonna's performances make full use of the potential of cosmetics. As well as fast changing her own chameleonlike appearance on a day-to-day basis, she performs homages to the cosmetic perfection of the movie stars and also integrates the "oscillation effect" into the rhythm of her videos, synchronizing editing, personality change, and sexual role

reversals. Although Madonna, obviously, does not follow the Cindy Sherman narrative of disintegration, her awareness of this, other, side of the topography of feminine masquerade is evidenced in her well-known admiration for Frida Kahlo. Frida depicted her face as a mask in a large number of self-portraits, and veiled her body in elaborate Tehuana dresses. Sometimes the veil falls, and her wounded body comes to the surface, condensing her real, physical, wounds with both the imaginary wound of castration and the literal interior space of the female body, the womb, bleeding, in her autobiographical paintings, from miscarriage. Frida Kahlo's mask was always her own. Marilyn's was like a trademark. While Cindy Sherman and Madonna shift appearance into a fascinating debunking of stable identity, Marilyn's masquerade had to be always absolutely identical. Her features were able to accept cosmetic modeling into an instantly recognizable sign of "Marilyn-ness." But here, too, the mask is taut, threatened by the gap between public stardom and private pressures (as was the case for everyone caught in the Hollywood Babylon of the studio system's double standards) and also by the logic of the topography itself.

In refusing the word/image juxtaposition, so prevalent in the art of the '70s and '80s, Sherman may draw the accusation that she is, herself, stuck in the topographic double bind of the fetish and its collapse. She would thus be unable to inscribe the means of decipherment into the work itself. Her use of "Untitled" to describe her works turns inability into refusal. Her work vividly illustrates the way that images are able to address their spectator, and are completely available to the process of deciphering, through *mise en scène*, connotations, juxtapositions, and so on. In this sense, the iconicity of a photograph, its meaning through resemblance to what it represents, may be an illusion. Like children's puzzle pictures which have objects concealed in other objects, like the *double entendre* of a *trompe l'oeil*, like the adjustment of vision needed to see a holographic image, Sherman's work bears witness to the photograph's ability to mean more than what it seems to represent.

Furthermore, the human psyche thrives on the division between surface and secret, which, as a metaphor for repression of all kinds, cannot be swept away. Topographies of the female body are formed out of the uncertainty inscribed into femininity by misogynist culture and this kind of imbrication between a psychic (social) order and the culture that reflects it will necessarily exist. But the wordlessness and despair in Sherman's work represents the wordlessness and despair that ensue when a fetishistic

structure, the means of erasing history and memory, collapses, either as a result of individual trauma or social repression. The fetish necessarily wants history to be overlooked. That is its function. The fetish is also a symptom and, as such, has a history which may be deciphered, but only by refusing its phantasmatic topography. Freud described his first concept of the unconscious as a topography to convey the burying action of repression, but he analyzed the language of the unconscious, its formal expression in condensation and displacement, in terms of signification and decipherment. In the last resort, decipherment is dependent on language and the analysand's exegesis, which transforms the symptom into language and traces its displaced history. The complete lack of verbal clues and signifiers in Cindy Sherman's work draws attention to the semiotic that precedes a successful translation of the symptom into language, the semiotic of displacements and fetishism, desperately attempting to disguise unconscious ideas from the conscious mind. She uses iconography, connotation or the sliding of the signifier in a trajectory that ends by stripping away all accrued meaning to the limit of bodily matter. However, even this bedrock, the vomit and the blood for instance, return to cultural significance, that is to the difficulty of the body, and above all the female body, while it is subjected to the icons and narratives of fetishism.

Notes

1. Cindy Sherman quoted in Sandy Nairne, *The State of the Art: Ideas and Images in the 1980s* (London: Chatto & Windus, 1987), p. 132.

2. Peter Gidal in Teresa de Lauretis and Stephen Heath (eds.), *The Cinematic Apparatus* (New York: St. Martins's Press, 1980), p. 169.

3. Fredric Jameson, *Postmodernism or The Logic of Late Capitalism* (London: Verso, 1991), p. 19.

4. Cindy Sherman quoted in Nairne, p. 136.

5. At the moment Mulvey wrote this essay, Sherman's most recent work was the 1989–90 series commonly referred to as the "old masters"—Ed.

6. A reference to another essay by Mulvey, titled "Pandora's Box: Topographies of Curiosity," also in her book *Fetishism and Curiosity* (London: British Film Institute, 1996), pp. 53–64.—Ed.

7. Julia Kristeva, *Powers of Horror: An Essay on Abjection* (New York: Columbia University Press, 1982).

8. Barbara Creed, *The Monstrous Feminine* (London: Routledge, 1993).

House of Wax

Norman Bryson

A first image, from the late nineteenth century. Visitors coming into the Musée Grévin in Paris must have felt it was rather like making their entrance to an embassy ball or the Opéra. The large antechamber, a plush salon in the style of Louis XV with a magnificent central chandelier and mock-rococo panel paintings on the walls, led to the first tableau, *Le Foyer de la Danse*.[1] Here a life-sized mannequin of the great star Mme Rose Caron, in the costume she had worn for the ballet *Faust,* was seen taking her curtain call center-stage, surrounded by a host of other, lesser stars whom enthusiasts would have recognized as Mlle Sandrini (as Cleopatra), Mlle Chabot (as Psyche), Mlle Invernizzi (as the queen of Nubia). Passing on, visitors came to an installation showing the recent reception of the tsar and tsarina on board the French vessel *Marengo* at Cronstadt in 1891, with a large cast of assorted admirals, naval officers, and cabinet ministers greeting the imperial entourage. The next scene commemorated the Paris Exposition of 1889, including a display of the sensational dancers from Java in authentic costume and the replica of an entire street in Cairo, complete with gesticulating merchants before their shop fronts, café boys, and beggars.

From the Cairo street it was a few paces to the next, even more exotic waxwork scene: the "Human Sacrifices at Dahomey," in which the native king Behanzin, surrounded by his wives, was shown ordering the ritual death of one of his slaves (reconstructed from eyewitness accounts). In the episodes that followed, the horrors banished to Africa moved rather closer to home, gravitating toward the historical trauma of the French Revolution: Louis XVI, in prison with Marie Antoinette, being shown by

the Revolutionary mob the severed head of the Princesse de Lamballe (in a gory blonde wig); the political martyr Marat in his bath, his leprous skin condition perfectly captured in wax, with Charlotte Corday about to plunge the dagger home; and, not to forget, death's-head effigies of the politicians Bailly, Robespierre, and Mirabeau.

Spectators were now prepared for the Musée Grévin's main attraction. Descending to a lower level (*les souterrains*), they first reached the torture chamber, with executioner, rack, and assorted implements of pain; then, a display of an actual guillotine, alongside "an execution by electricity in New York." Next came a narrative tableau in several episodes showing a bank robbery (the young guard fatally stabbed in the chest), the murderer's arrest, trial, last meal, and finally (just before the exit) his climb up the scaffold ("*Une seconde plus tard, il aura expié son forfait et payé son tribut à la justice des hommes*").[2]

From the glittering stage at the Opéra to the body mangled and mutilated, from the image-theater of a world already rapidly transforming into the society of spectacle down the stairs to the body on the rack—what kind of sequence is this, so sudden, so quick to move from allure to abjection? What is the relation between the body of glamour, the visual repertoire of beauty, and the chamber of horrors, chamber of the body in humiliation, the body excoriated in pain?

A second image, from David Lynch's *Wild at Heart*—or rather two images (the ones I can't seem to shake from my memory): the face of a man being held as the barrel of a colossal elephant gun is placed, just out of sight, against the back of his head; and the repeated close-up of a cigarette being lit and turning into a tornado of fire.

What is the nature of the transition, in the postmodern image universe, that seems to go in one move from everything-is-representation to the body-as-horror? From the proposition that what is real is the simulacrum to the collapse of the simulacrum in a Sadeian meltdown? From the *Untitled Film Stills* to Cindy Sherman's present take on the body as house of horrors and house of wax?

<div align="center">★</div>

One crucial difference between the waxwork museum and the *Untitled Film Stills* concerns the kind of representational regime within which each operates. The waxwork museum is among other things an extreme product of the post-Renaissance aesthetic of representation as the duplicate of a physically stable referent, a body that stands before it as its original:

"Faithful reproduction of nature and respect for truth down to the last details, such are the principles that preside over the execution of every work at the Musée Grévin."[3] The body is presumed simply to exist out there in the world, and then through the skill of the copyist its forms are faithfully repeated in the wax. With the *Untitled Film Stills* this structure of representation is precisely reversed: the nominal referent exists only by means of representation and the complex cultural codes it activates.

Sherman alters her image so radically from picture to picture that it becomes impossible to locate the consistent term that ought to bind the series together; the body disappears into its representations. Or rather, what in a commonsense way we take to be the body, this given thing, is elaborated across the series in such a way that it appears to have been worked by the codes and conventions of representation to a point of saturation; the body is modeled by those codes as completely as the wax is modeled by the Musée Grévin's craftsmen. Sherman convinces the viewer that her various images are indeed different presences, but that "behind" those there stands no central core of identity. The sense of identity—of each image as bodying forth a different presence—becomes manifestly a product of a manipulation of the complex social codes of appearance, a pure surface.

Which is to say that identity—the interior depths supposed to stand behind or within the surface of appearance—is only an identity-effect, the semihallucinatory transformation of a material surface into imaginary profundity. Alter the lighting, focus, or grain of the print, and there are immediate consequences in the sense of "identity" being fabricated. Sherman exposes the material underpinnings of identity-production, not only the theatrical codes of costume and gesture, but the photographic codes that come to join them. If graininess in the print makes the figure seem different (distanced or mysterious or disfigured), that proves beyond a doubt that what we had taken to be the source of the presence to which we respond—the figure, the referent, with its/her inwardness and depth—actually emanates from the materiality of the signifying work, from the photographic paper and the way it has been processed, from the apparatus of representation itself.

The "constructionist" view of the body—that the body is not an anatomical constant but a historical variable, a social construction—ought by rights to be serene. If the body consists only in and through its representations, across all the discourses in which it is invoked (medical, aesthetic, erotic, sartorial, legal, historical), if it truly evaporates into representation,

becoming weightless, losing its old opacity and density, then in a sense the body should cease to be any kind of a problem, for anyone. Entirely subsumed into the sphere of cultural work, indeed apparently becoming the principle arena of cultural activity, it sheds at last its primitive character and is fully assimilated and civilized. In this sense the constructionist attitude consummates the whole project of making the body disappear that characterizes the Enlightenment. As J. S. Mill wrote: "It is in keeping as far as possible out of sight, not only actual pain, but all that can be offensive or disagreeable to the most sensible persons, that refinement exists."[4] From the eighteenth century on, practices in which the body possessed any kind of insistence are designated barbarous and hidden from view: executions can no longer be conducted before the crowd and vanish behind prison gates; animals are not to be killed in courtyards by local butchers but in abattoirs on the outskirts of the city where no one goes; the display of meat as something frankly carved up from an actual beast (viz. the Mercato Centrale in Florence, to this day), with a head, with internal organs, with a recognizable cadaverous form, is rethought so that meat can cease to appear as recently living flesh and becomes instead a hygienic, quasiindustrial product obtained who knows where or how; urination in public view is thought unbearable and the venerable *pissoirs* are torn down; the dying, no longer spending their last days and hours at home with their families and friends, their death continuous with the rest of their life and with their surroundings, but instead are sequestered behind white walls and hospital screens.[5]

And further down the line, in our own time, the body will be made to disappear entirely: said to consist solely in its representations, it will eventually be viewed as never having existed any other way. For Foucault, the body's history is that of its construction through the myriad discourses that act to produce the body "positively," i.e. for the first time. It is by virtue of being built by culture that the body comes to be an object of historical inquiry, that it comes to exist at all. And in Foucault the agency of its sublimation is discourse-as-sight: the medical gaze that penetrates past the barrier of skin to the body's secret interior, probing every recess with panoptic clarity, mapping and charting, claiming this newfound land as the last outpost of the discursive empire. The medical gaze—and photography: it is through the photograph that the last taxonomies will be made, of the criminal and deviant physiognomies, the superior and inferior ethnic groups, eventually of entire populations. It is photography that will, in the hands of the authorities, illuminate and set down for the record even the grizzliest murder and finally enable the announcement to be generally

circulated that the body has at last been caught within representation's net: it is only representations, always was.

Yet the constructionist understanding of the body has always had a problem with—pain. Wittgenstein's interest in the existence of pain is emblematic of what can happen once it is granted that everything that exists, exists in discourse ("The limits of my language are the limits of my world"). When meaning is identified with cultural convention, when it arises only in the interactive space between persons and is no longer to be located in anyone's head, paradoxically the body returns with an urgency it never before possessed. For pain marks the threshold at which the signifying contract and the language games that compose social reality come up against some kind of absolute limit: there is no *sign* I can exchange for my pain, it cannot be channeled into words (only cries), it exists beyond my powers to represent it before others. Others, in turn, who know of me only through what I can do and be within the world of representation I share with them, are unable to know this pain of mine, which belongs to me alone and cannot be converted into signifying currency of any kind. At the very moment when the claim is eventually staked that the body is built exclusively in and as representations, instead of the body's becoming weightless, translucent, illuminated through and through by the pure light of discursive reason, the body instead establishes itself as discourse's unpassable limit.

What therefore comes into play is the reverse of the body's subsumption into discourse: the perception of the body as symbolically recalcitrant, as underground resistance from the boundary of the discursive empire. The discourse that officially carries the body off—abduction as much as subsumption—stumbles, falters, as it is experienced as running up against something that eludes the contractual exchange of signifiers: a density, a gravity, a standing-outside of discourse; an ecstasy of the body as that which cannot, will not, be sublimated into signifying space. Henceforth the body is exactly the place where something *falls out* of the signifying order—or cannot get inside it. At once residue and resistance, it becomes that which cannot be symbolized: the site, in fact, of the real.

The body is everything that cannot be turned into representation, and for this reason is never directly recognizable: if, in our minds, we were to picture this body-outside-discourse, it would not *resemble* a body at all, since the body-as-resemblance is precisely that into which it may not be converted. Even depictions of the body in abjection only approximate what is at stake here, substituting the mere forms of the horrible for what

24 *Untitled #157,* 1986
color photograph
60 × 40 inches

is essentially incommensurable with form, is *informe*. Language can only point toward this aspect of the body, cannot grasp its fleshiness and dampness, its excess beyond signification. As Lacan described the throat of Freud's patient Irma:

> The flesh one never sees, the foundation of things, the other side of the head, of the face, the secretory glands par excellence, the flesh from which everything exudes, at the very heart of mystery, the flesh in as much as it is suffering, is formless, in as much as its form in itself is something which provokes anxiety.[6]

Like language, visual representation can only find analogues and comparants for this body: it is *like* this or that (*Untitled #175* (fig. 22), of 1987, and *Untitled #157* (fig. 24), of 1986). At the edges of representation or behind it hovers a body you will know about only because these inadequate stand-ins, which are there simply to mark a limit or boundary to representation, are able to conjure up a penumbra of something lying beyond representability. The penumbra indicates that discourse-as-sight cannot quite detect this region or bring it into focus. Yet insofar as the spectator has the sense that sight is not able comfortably to scan the penumbra (the gaze bouncing off from the image, like an arrow hitting a shield), a certain nausea arises that unmistakably announces the advent of the real. Not because the image shows this or that horrible thing—the repellent appearance of the image's content is only a momentary obstacle to discourse, since as soon as the discourses of horror move in on their target, they at once neutralize it and absorb it back inside the repertoire of the conventions. On the contrary, the object of horror (of *enjoyment*) shown in the picture will always be inadequate to the affective charge it carries with it: the horror is never *in* the representation, but around it, like a glow or a scent. In the *Sex Pictures* series, Sherman manages to play with exactly this gap between the body as the ecstasy-of-discourse and that body's inadequate stand-ins on the representational stage. Hence their comedy of the macabre, their gallows humor: the medical-student mannequins and body parts and Halloween masks and prostheses cannot live up to, cannot *match,* the affect they induce. But in a sense the horror object need not even aim to be adequate, since it is only a decoy, not the real thing, only a herald of the real, a warning that horror is in the air.

Once the world is declared to have become representation, and the real drops out of the system, the cultural sphere should be at peace,

25 *Untitled #256,* 1992
color photograph
68 × 45 inches

orbiting in the serene spaces of virtual reality. But the surprising consequence of the conversion of reality into spectacle is its obverse: a tremulous sensitivity to the real, an acute awareness of the moments when the virtual reality is disturbed, when it comes up against and hits that which it has notionally expelled from its system. Precisely because the system of discursive representation is supposed to have embraced everything there is, the body included, the subject's brushes with the real have a force they never possessed prior to the totalization of representation into "reality." Like a magnet held to a television screen, the encounters with the real cause the entire image to buckle. To the subject of the world-as-representation (or commodity/spectacle) the approach of the real induces a special kind of fear that may, historically, be something new in the world: an anxiety or nausea that is the unlooked-for spin-off from the system's own success.

The primary action of the real is never, of course, to appear: when it dons a form (monster, alien, vampire, corpse), it is already safely within the space of the representational. The action of the real is simply that it moves close, moves *too* close. The hard nucleus of that which resists symbolization comes toward the subject as a curvature in the space of representation itself, as a dread that infiltrates the image and seems to shimmer outside and behind it.

Perhaps this is what subtends the strain of Gothic Revival in the postmodern, whose key practitioners are (for me, at least) Sherman, David Lynch, and Joel-Peter Witkin. The structure on which each thinks about the image and the body is less the sign than the *symptom*. The symptom is what stands permanently on the threshold of symbolization but cannot cross over; it is a cyphered message, on the verge of passing into signification and culture yet permanently held back, as a bodily cryptogram. What makes it recognizable (insofar as this is possible) is its affect of dread, as the whole edifice of personal and cultural intelligibility is shaken by what it has excluded—the object-cause of the subject's fear and desire. Strictly speaking, the affect of panic that comes with the overproximity or imminence of the real is about all that can be known here, since what induces the dread is precisely unnameable. Certainly its locus is the body, but not the body that emerges in Foucault, the Enlightenment product of discipline, knowledge, and technique. What the theory of the disciplinary body passes over in methodological silence is the body precisely as the disciplinary's stumbling block, the dense and wayward Thing that escapes absorption into the panoptic theater of power. Dark, hidden, it is the price

that is paid for the very idea of the body as disciplined and tamed; its monstrosity is that of all the amorphous secretions that fall back into the subject as rejects from the disciplinary arena.

Which is already to speak of its *necessity* to the symbolic order. The structure of the symptom is only partially understood if we think of it as the true speech of the body, welling up from inside it and hammering at the door of culture. Rather it is the whole mass of residues created as waste products from the theater of the cultural imaginary, where the subject assumes and internalizes its repertoire of sanctioned and conventional appearances. It comes into being *with* and *out of* that theater of representations. And the greater scope and range of the imaginary theater (the closer the latter comes to making the declaration that "everything that exists has been absorbed into culture and symbolization"), the greater the menace that the symptom poses to the subject's internal stability. Its core is an elementary axiom, incapable of further elaboration: simply that "something has gone wrong with the body." Hence the emphasis, which with Witkin ventures into the terrain of the abominable—farther even than Sherman or Lynch—of the body as *unfathomably* afflicted.[7] With Lynch, the bodies of the stars in the main plot ("normal," even glamourized) are shunted aside as figures from a lower narrative level invade the screen, bringing with them the de-formation of the wholesome bodily outline enjoyed by the principal characters: in *Dune,* the Witkinesque figures of barely-functioning bodies decomposing from the unknown diseases of the planetary future; in *Wild at Heart,* the central image of the body exploded, its disconnected parts flying up into the sky or carried off by a dog or on the point of facial obliteration (the elephant gun behind the head).

In both Lynch's and Sherman's work what intensifies the symptom's dread is that nothing from the available "reality" seems strong enough to ward off or drive back the fearful incursion from the real. In a classical order of representation (like that of the Musée Grévin), based on the two terms *original::copy,* the representation of horror—however ghastly—was never any more than a phantom or a temporary nightmare, since no matter how bad the dream one could always wake up and shift away from the unsettling zone of representation back to the safe haven of a real world and a waking state. But in the postmodern visual regime, built around the idea of the breakdown of the classical opposition between real and copy and on the absorption of reality within representation, there is no space outside of the theater of representation into which the subject might run. An apparently enclosed order, representation now has no exit point, no fire escape. Its space is like that of the Tibetan *bardo,* a zone in which after death

26 *Untitled Film Still #48,* 1979
black-and-white photograph
8 × 10 inches

the subject is said to witness the playing-out of all its fantasies of desire and fear, but from a viewpoint of total entrapment and inability to swerve away from the object-cause of dread. In the *Untitled Film Stills* all that remains of a reality largely swallowed up inside representation is narrative and visual shards from old cinema genres (*film noir,* Hitchcock, New Wave, Neo-Realism, etc). None of these flimsy screens has the force to keep at bay the advance of the real toward the subject (the same can be said of Lynch: the quotations from older cinema—from musicals, road-movies, comedies, science fiction—serve only to weaken still further the narrative space, leaving it powerless before the real's encroachment).[8]

Two images from Sherman, a song of innocence and one of experience, *Untitled Film Still, #48* (fig. 26) of 1979, and *Untitled, #274,* (fig. 27) of 1992. They could hardly be more different. At what point did Sherman go over to the dark side? Turning back the pages of the "complete works," one sees with hindsight that despite the earlier image's optimism, its upbeat quality of "setting out" (one might recall the title of a review from 1983: "Here's Looking at You, Kid"),[9] the symptomatic structure is already

27 *Untitled #274*, 1992
color photograph
$26^{1}/_{2} \times 40$ inches

fully in place: the first proposition, that the real is now being thoroughly assimilated into representation (in this case, across the codes of cinema); and the second, its consequence, that this very absorption secretes at its edges an atmosphere of dread, off-screen and at the fringes of the representation, a fear *for* and *of* the body at the very moment of its sublimation or disappearance into the representational theater. In the later image (*Untitled, #274*) the real moves in much closer, and Sherman's own body has physically vanished from the scene, sign of its assumption into the visual equivalent to the "social text," the image stream. What reemerges from that very disappearance is everything about the body that the image stream throws out in order to maintain the ideas of the body as socialized, clean, representable: the body's material density, its internal drives and pulsions, the convulsiveness of its pain and pleasure, the thickness of its enjoyment.

Which in a sense was what the Musée Grévin was already exploring a century earlier, in the context of a society as yet only halfway toward a thorough-going conversion of reality into spectacle. Elsewhere in Paris, in the Salon, were to be found the official representations of the body, the academic idealizations by the Gérômes, the Bouguereaus, the Carolus Durans, Cabanels, Viberts. In the margins of the official culture stood the waxworks, still pretending to be respectable and correct, still bowing to the higher powers of religion and national history (the Pope, Napoleon, the tsar of Russia). But all these are presented as simulacra, in some sense entering into an emergent modern image-stream, while a staircase leads abruptly down to everything that exceeds the acceptable repertoire of images: murder, torture, electrocution, with the state in its guise of pure violence (guillotine, electric chair) and the civil subject addressed as a kind of bundle of darkly desiring flesh. With Sherman we see the same (or a related) culture one century later. The stakes are higher, and representation is in the process of putting the finishing touches to its colonization of the real. At its margins, coeval with that colonizing project and consequent upon it, stands the symptomatic body of pain and pleasure, of *enjoyment.* The movement from the ideal to the abject is now a single sweep, an arc: the trajectory, indeed, of Sherman's career to date.

Notes

1. This account of the museum is taken from the *Catalogue Illustré: Musée Grévin,* 98th edition (Paris, n.d.). The museum opened its doors in June 1882.

2. Ibid., p. 44.

3. Ibid., p. 2.

4. Cited in Thomas Laqueur, "Clio Looks at Corporal Politics," in *Corporal Politics* (Cambridge: MIT, List Visual Arts Center, 1992), p. 14.

5. Ibid.

6. *The Seminar of Jacques Lacan. Book II: The Ego in Freud's Theory and in the Technique of Psychoanalysis* (Cambridge, England: Cambridge University Press, 1988), pp. 154–155.

7. See *Joel-Peter Witkin* (Amsterdam: Stedelijk Museum, 1983); *Joel Peter Witkin: Forty Photographs* (San Francisco: San Francisco Museum of Modern Art, 1985); Joel-Peter Witkin, *Gods of Earth and Heaven* (Altadena: Twelvetree Press, 1989); and especially *Masterpieces of Medical Photography: Selections from the Burns Archive*, ed. J.-P. Witkin (Pasadena: Twelvetree Press, 1987).

8. See Slavoj Žižek, *Enjoy Your Symptom! Jacques Lacan in Hollywood and Out* (London and New York: Routledge, 1992), p. 129.

9. Waldemar Januszczak, "Here's Looking at You, Kid," *Guardian*, May 19, 1983.

Cindy Sherman: Untitled

Rosalind Krauss

The Film Stills

Some people have told me they remember the film that one of my images is derived from, but in fact I had no film in mind at all.

—Cindy Sherman[1]

Here is a curious story: an art critic writes an account of Cindy Sherman presenting her work to an art school audience. She shows slides of her "film stills"—the black and white photographs in which as both director and actress she projects a range of 1950s screen images—and next to each, he reports, she presents the real movie stills on which her own images were based. What emerges through this comparison, he says, is that "virtually every detail seemed to be accounted for: right down to the buttons on the blouses, the cropping of the image, even the depth of field of the camera."[2]

Although he is upset by what this comparison reveals about the slavishness of Sherman's procedure—the stroke-for-stroke meticulousness of the copy, so to speak—he is certain that what Sherman is after when we encounter these *Stills* is in any case a recognition of the original, although not as a source waiting to be replicated, but rather as a memory waiting to be summoned. So he speaks about the viewer of the normally unaccompanied Sherman *Still* "starting to recall the original film image." And, he says, "if it wasn't the actual film" the viewer recalled, "then it was an ad for it; and if not that, then it was a picture from a review in a newspaper."

On its face this story is amazing. Because in a Sherman *Film Still* there is no "original." Not in the "actual film," nor in a publicity shot or "ad," nor in any other published "picture." The condition of Sherman's work in the *Stills*—and part of their point, we could say—is the simulacral nature of what they contain, its condition of being a copy *without* an original.

The structure of the simulacrum, then, along with Sherman's exploration of it, is something that needs to be examined. But even before doing so, it is worth staying with the story of the slide show and its putative unveiling of an "original," which is to say the story's blatant, screaming, *Rashomon*-like, misrecognition.

Did Sherman ever show real movie stills next to her own work? And if so, to what end? Since her own images manage their projection of a whole array of stereotypical Hollywood or New Wave heroines, along with the very atmospheres through which they are cast—the *film noir*'s hard-bitten denizen of the night, one of Hitchcock's plucky but vulnerable career girls, the B-movie's small-town innocent swamped by Metropolis, a New Wave vehicle of alienated despair, and so on—and yet do all of this from within a kind of intense, generalized memory, what would a comparison of, say, a still from a Douglas Sirk film and a Cindy Sherman mean? Could it indicate that the sense that the two images intersect—no matter how distant their actual details might be—derives from the way *both* Sherman and Sirk (in addition to Sirk's actress) are each imaginatively focused on a remembered fantasy—of a character, who is "herself" not only fictional, but, like Emma Bovary, the creature as well of fiction, a character woven from the tissue of all the romances she has ever consumed? Could it mean that with the stereotypes projected by these fictions, with regard to the creatures of this fantasized romance, could it mean that these boxes-within-boxes of seeming "memory" always produce what appears to be an authentic copy, even though there is no "real" original to be found? So that Sirk's copy and Sherman's copy uncannily overlap like two searchlights probing through the night toward the same vaguely perceived target? Let's speculate that this is why Sherman would show her own image and, say, Sirk's.

Why, then, would the critic misrecognize the comparison, making one a copy and the other an original: Sherman, the artist, copying the "real" of the Hollywood film? Roland Barthes, the structuralist critic, would have a word with which to explain this strange hallucination; and that word would be *myth:* the art critic who "saw" the comparison as repli-

cation—*Untitled Film Still* = image taken from real film—was in the grip of myth, consuming it, Barthes would say.

Barthes would, of course, be using the term *myth* in a somewhat limited, rather technical way. And if it is useful to explain how he deploys the term, it's because myth is also what Sherman herself is analyzing and projecting in the *Untitled Film Stills*. Although not as a myth consumer, like the critic; but rather as a mythographer, like Barthes—a demystifier of myth, a de-myth-ifier.

To consume a myth is to buy a package along with the salesman's pitch. The salesman's pitch names it, and the buyer, never looking under the hood, accepts the name, is satisfied (or suckered) by the pitch. The somewhat more technical analysis involves the terms *signified* and *signifier,* or form and content. It goes like this: a schoolchild reads in a grammar book *quia ego nominor leo.*[3] The signifiers of this string of words are the letters—the material component of the composite through which each sign (as here, each word) is made up; the signified is the lion and its name—the ideational content that is articulated by the units cut out by the signifiers: "because my name is lion." At the level of the individual sign the relation between signifier—letter—and signified—idea—and their conjunction would look like this: S^d/S^r = Sign.

But this sign, or string of signs, is found in a grammar book and thus "because my name is lion" is not left at what could be called the denotational level where it is pointing to lions, to their habitats, to their strength, as in, let us say: "If I have taken the prey from my weaker fellow animals, it is, among other things, because my name is lion." Rather the Latin phrase is being used as an example, a mere instance of the grammatical agreement between subject and predicate. And as such an instance, the richness of the sign—the lion, its strength, its habitat, etc.—is itself divided from within. And a second layer, parasitical on the first meaning, is installed.

This second layer is formal; it is the subject/predicate structure of the sentence in which grammatical agreement is at stake—*any* instance of agreement, lions, snakes, butterflies, no matter. This formal layer constituting the phrase as "mere" example is thus empty. But it preys on the fullness of the layer of the sentence understood as meaning. And Barthes's argument is that for myth to work, it *must* prey on it.

So what is myth? Myth is depoliticized speech. Myth is ideology. Myth is the act of draining history out of signs and reconstructing these

signs instead as "instances," in particular, instances of universal truths or of natural law, of things that have no history, no specific embeddedness, no territory of contestation. Myth steals into the heart of the sign to convert the historical into the "natural"—something that is uncontested, that is simply "the way things are." In the case of "because my name is lion," the myth is the combination of meaning and form into the content that reads: "this is the principle of agreement in Latin." But beyond that the mythical content conveys the importance of order and regularity in the structure of Latin, as well as one's sense, as reader, of belonging to a system of schooling in which many children like oneself are also learning this principle, and the idea that this principle is addressed to oneself, meant for oneself: "See! This is what 'grammatical agreement' looks like." This is what Barthes calls the *interpellant* aspect of mythical speech.[4] It is addressed to its readers, calling out to them, asking them to see and agree to the way this example confirms this principle, at one and the same time fading before the principle's authority—this is just an example—and filling that authority with a kind of subservient but needed specificity—see! nature is brimming with just the thing this means: "because my name is lion."

The more famous example Barthes uses in his analysis of mythical speech is one that is closer to Sherman's *Film Stills,* since it is not composed of letters and words but of a photograph and its depictions. It is a magazine cover of *Paris Match* in which a black soldier is shown giving the French salute. The photograph—as physical object, with its areas of dark and light—is the signifier; the depicted elements are the signified. They combine into the sign: a black soldier giving the French salute. That combination then becomes the support for the mythical content that is not just a message about French imperialism—"France is a global nation; there are black subjects who also serve it"—but a message about its *naturalness,* as the signified of the first order of the mythic support is called up as an example to fill up and instance its mythic contention: "Imperialism is not oppressive; it is natural, because we are all one humanity; you see! examples of how it works and the loyalty it engages can be found everywhere, anywhere, for example, in this photograph where a black soldier gives the French salute." The "you see!" part of the message is, of course, the interpellant part. It is the myth summoning its consumer to grasp the meaningfulness of the first order sign—the photograph-as-signified—and then to project his or her conviction in that unitary, simple meaning, onto the more complex, hazy, insinuating level of the contents of the myth.

So let's go back to Sherman and the *Rashomon*-factor: the critic sitting there in the darkened auditorium of the School of Visual Arts, looking at a set of slide comparisons and believing something about their replicative relationship, believing this to be the case because after all Sherman's work, he is certain, takes us back in any event to the real film we remember. What is crucial here is that he has bought the pitch and never thought to look under the hood. He has taken the first order sign as a composite, a signifier and signified already congealed into a finished meaning—actress X in film Y—and he has completed the mythical content. Here it would be something like: Cindy Sherman is an artist and artists imitate reality (Universal Truth No. 1), doing so through their own sensibilities, and thus adding something of themselves to it (Universal Truth No. 2). The formula we come out with was penned by Emile Zola. It goes: Art is important; it gives us a piece of nature seen through a temperament. Nature in the Sherman case would be of a somewhat technological kind, namely, the original film role, which Sherman would pass through the temperament of her own memory and projection; she would externalize this observed and felt bit of the world, and her work of art—the externalization of these emotions—will be her expression, with which we as viewers can empathize. Art = Emotion relayed through nature. That's the myth and that's why the critic has to produce—no matter through what process of self-deception or hallucination—the "original," the bit of nature, the filmic heroine in her role. That's what it's like to be a myth consumer. To buy the pitch. To fail to look under the hood.

What, then, is under the hood?

What is always under the hood is the signifier, the material whose very articulation conditions the signified. And further, working away under the hood, either *on* or *with* the signifier, is the effort perhaps to limit the possibility that it might produce a multiplicity of unstable signifieds and promote a sliding among them or, on the other hand, to do the reverse and welcome, even facilitate such sliding. Limitation is the work of realism in novels and films: to every signifier one and only one signified.[5] Conversely, sliding and proliferation has always interested the antirealist (what used to be called the *avant-garde*) artist.[6]

Work on the signifier is perfectly available for observation in Sherman's *Untitled Film Stills*. Take the group of images that includes *#21* (fig. 28), *#22,* and *#23* (1978). In all three, Sherman wears the same costume, a dark, tailored suit with a white collar and a small straw cloche

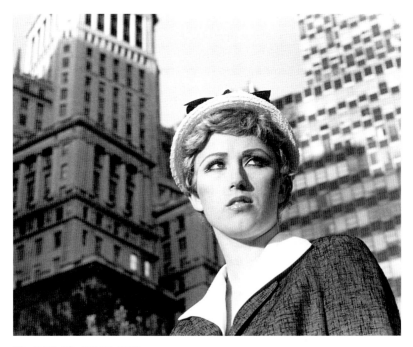

28 *Untitled Film Still #21,* 1978
black-and-white photograph
8 × 10 inches

pulled onto a mop of short blond curls. But everything else changes from
one still to the next: as in the first, *#21,* the register is close-up taken at a
low angle; in the second, *#22,* a long shot intricates the character amid a
complication of architectural detail and the cross fire of sun and shadow;
and the last, *#23,* frames the figure in medium shot at the far right side of
the image against the darkened emptiness of an undefined city street and
flattened by the use of a wide-angle lens. And with each reframing and
each new depth-of-field and each new condition of luminosity, "the char-
acter" transmogrifies, moving from type to type and from movie to movie.
From *#21* and the Hitchcock heroine to *#23* and the hardened *film noir*
dame, there is no "acting" involved.[7] Almost every single bit of the char-
acter—which is to say, of each of the three different characters—is a func-
tion of work on the signifier: the various things that in film go to make up
a photographic style.

It was just this that Judith Williamson, one of the early feminist writ-
ers on Sherman's work, described when she said that in the stills, "we are

constantly forced to recognize a visual style (often you could name the di-
rector) simultaneously with a type of femininity. The two cannot be
pulled apart. The image suggests that there is a particular kind of femi-
ninity in the *woman* we see, whereas in fact the femininity is in the image
itself, it *is* the image."[8]

This fact that there is no free-standing character, so to speak, but only
a concatenation of signifiers so that the persona is released—conceived,
embodied, established—by the very act of cutting out the signifiers, mak-
ing "her" a pure function of framing, lighting, distance, camera angle, and
so forth, is what you find when you look under the hood. And Sherman
as de-myth-ifier is specifically allowing us, encouraging us to look under
the hood, even as she is also showing us the tremendous pull to buy into
the myth—which is to say, to accept the signifier as finished fact, as free-
standing figure, as "character." Thus there is the tendency when speaking
of the *Film Stills* to enumerate their personae, either as the roles—"a
woman walking down a dark street at night; another, scantily clad, with
martini in hand, peering out the sliding glass door of a cheap motel"[9]—
or as the actresses who project them: Gina Lollobrigida, Monica Vitti,
Barbara Bel Geddes, Lana Turner . . .

That neither the roles nor the actresses are free-standing, that all are,
within representation, effects—outcomes, functions—of the signifiers
that body them forth is what Barthes labored to demonstrate in his extra-
ordinary book *S/Z*, an analysis of the inner workings of literary realism.
Showing that each "character" is produced through a concatenation of
separate codes—some the signifiers or operators of difference, whether of
gender (male/female) or age (young/old) or position (rich/poor); others
the operators of references to general knowledge keyed into the text by the
merest aside ("as in the Arabian Nights"); still others the operators of the
puzzle that drives the narrative forward toward its Truth (who is? what
is?)—what Barthes makes clear is that when a name finally arrives to refer
to or denote a character, that name is buoyed up, carried along, by the
underlying babble of the codes.[10] The name is thus the signified—the
character—that the author slides onto the codes to produce realism's ap-
pearance that for every name there is a referent, a denotation, a unified
empirical fact. What is being masked is that the name, rather than point-
ing to a primary entity in the "real," is an effect of the vast already-written,
already-heard, already-read of the codes; it, the denotation, is merely the
last of these codes to be slipped into place. The consumer of realist fiction,
however, buys the pitch and believes in the "character," believes in the

substance of the person from whom all the rest seems to follow as a set of necessary attributes, believes, that is, in the myth.

Most of those who write about the *Film Stills* acknowledge that Sherman is manipulating stereotypes and that though these are being relayed through a generalized matrix of filmic portrayals and projections, there is of course no real film, no "original," to which any one of them is actually referring. So the myth consumer of my opening anecdote is something of an exception and in that sense a straw man. And yet we have not far to look to find other versions of myth consumption, or the direct connection to the signified-as-instance.

One form of this that can be found in the mountainous literature on Sherman's work is to assume that each of these signifieds is being offered as an instance of Sherman's own deeper self—the artist (as in Universal Truth No. 2, above) becoming the vehicle through which the fullness of humanity might be both projected and embraced in all its aspects. Peter Schjeldahl, for example, understands the individual *Film Still*'s signified to be Sherman's "fantasy of herself in a certain role, redolent usually of some movie memory," with all the different characters resonating together to form the totality of the artist's selfhood in her oracular role as "our" representative: "Sherman's special genius has been to locate the oracle not in the 'out there' of media bombardment but in the 'in here' of her own partly conditioned, partly original mind—a dense, rich sediment of half-remembered, half-dreamed image tones and fragments. . . . She has mined this sediment for ideas, creating an array of new, transpersonal images that spark across the gap between self and culture."[11] The mythic content Schjeldahl then consumes from these instances of the self-as-oracle is that it is in the nature of the artist to organize "messages that seem to tell us our nature and our fate."

Another form of myth consumption is to continue to buy into the finished signified of the role, the "character," but to see the multiplicity of these as various forms of what Arthur Danto seems to like to call The Girl. He provides his own roll call of these variants: The Girl in Trouble, The Girl Detective, The Girl We Left Behind, Daddy's Brave Girl, Somebody's Stenog, Girl Friday, The Girl Next Door, The Whore with the Golden Heart . . . But his point is that "The Girl is an allegory for something deeper and darker, in the mythic unconscious of everyone, regardless of sex. . . . Each of the stills is about The Girl in Trouble, but in the aggregate they touch the myth we each carry out of childhood, of danger, love, and security that defines the human condition."[12] Although Danto

turns here to the term *myth,* he uses it not in the manner of the de-myth-ifier, but as the unsuspicious myth consumer: buying into the signified of every variant of The Girl as an instance of the myth that there is a shared space of fantasy, or what he himself provides by way of mythic content as "the common cultural mind."

<center>★</center>

. . . it is necessary to fly in the face of Sherman's own expressly non-, even anti-, theoretical stance.

—Laura Mulvey[13]

Not surprisingly, given the fact that Sherman's *Film Stills* focus exclusively on women, on the roles women play in films, on the nature of those roles as preset, congealed, cultural clichés—hence their designation as "stereotype"—and by implication, on the pall that the real-world pressure to fill these roles casts over the fates of individual women, feminist writers have embraced Sherman's art, seeing it as "inseparable from the analyses—and the challenge—of feminist work on representation." But even as they have done so, they have been disgusted by its consumption as myth. For such consumption, they point out, inverts the terms of Sherman's work, taking the very thing she is holding up for critical inspection and transposing it into the grounds of praise.[14]

Arguing that there is, however, a logic—no matter how perverse—behind such a transposition, Abigail Solomon-Godeau sees a mechanism at work there to recut Sherman's art by exchanging what is dismissed as the narrow, somewhat threadbare cloth of feminist investigation for the more noble garments that drape the artist who addresses the humanity-in-general of "the common cultural mind." This, she reasons, is necessary to the art world's promotion of Sherman to the status of major artist, something incompatible with a feminist understanding of her enterprise. Therefore, as an apparatus of promotion (in both the media and museums) has supplanted other kinds of writing about Sherman, the mythical reading of the meaning of her work has followed. And thus it is no accident that Danto would need to recast the import of the *Film Stills* by insisting that they "are not in my view merely feminist parables."[15]

But it must be said that within feminism itself the import of the *Stills* has also been recast, a recasting that is articulated in Solomon-Godeau's essay, although buried in its footnotes. For if Judith Williamson's early

treatment of the *Film Stills* appeared under the title "Images of 'Woman,'"
Solomon-Godeau, eight years later, transposed this to "woman-as-
image," and signaled to the reader the importance of the distinction.[16]

Indeed, almost two decades of work on the place of the woman
within representation has put this shift into effect, so that a whole domain
of discourse no longer conceives of stereotype as a kind of mass-media
mistake, a set of cheap costumes women might put on or cast-aside.
Rather stereotype—itself rebaptized now as "masquerade," and here un-
derstood as a psychoanalytic term—is thought of as the phenomenon to
which all women are submitted both inside and outside representation, so
that as far as femininity goes, there is nothing *but* costume. Representa-
tion itself—films, advertisements, novels, and so forth—would thus be
part of a far more absolute set of mechanisms by which characters are
constructed: constructed equally in life as in film, or rather, equally in film
because as in life. And in this logic woman is nothing but masquerade,
nothing but image. As Laura Mulvey has described this shift: "The initial
idea that images contributed to women's alienation from their bodies and
from their sexuality, with an attendant hope of liberation and recupera-
tion, gave way to theories of representation as symptom and signifier of
the way problems posed by sexual difference under patriarchy could be
displaced onto the feminine."[17]

It was Mulvey's own 1975 text, "Visual Pleasure and Narrative Cin-
ema," that most formatively set out that latter argument in which woman
is constructed as spectacle and symptom, becoming the passive object of a
male gaze. Which is to say that in her essay a relation is set up among three
terms: (1) the observation that there are gender distinctions between the
roles that men and women play in films—males being the agents of the nar-
rative's action; females being the passive objects or targets of that narrative,
often interrupting the (masculine) action by the stasis of a moment of for-
mal (feminine) opulence; (2) the conception that there is a gender assign-
ment for the viewers of films, one that is unrelentingly male since the very
situation of filmic viewing is structured as voyeuristic and fetishistic, its
source of pleasure being essentially an eroticization of fetishism: "the de-
termining male gaze projects its fantasy onto the female figure, which is
styled accordingly," she writes; and (3) that these assignments of role are a
function of the psychic underpinnings of all men and women, since they
reflect the truths about the unconscious construction of gendered identity
that psychoanalysis has brought to light: "Woman . . . stands in patriarchal
culture as signifier for the male other, bound by a symbolic order in which

man can live out his fantasies and obsessions through linguistic command, by imposing them on the silent image of woman still tied to her place as bearer of meaning, not maker of meaning."[18]

In that last sentence, which slides from the domain of filmic representations to the universal condition of how "woman stands in patriarchal culture," there are packed a large number of theoretical assumptions that knot together around concepts about the unconscious, castration, and the import of structural linguistics for psychoanalysis. Insofar as Sherman's work is implicated in those assumptions and the analysis about woman-as-image that flows from them—the *Film Stills,* for example, repeatedly presented as either a text to be explained by this analysis and/or a consequence of it—it is necessary to unpack these assumptions, no matter how schematically.

The psychic economy that drives men to activity and speech and women to passivity and silence is an economy that also separates looking from being looked at, spectator from spectacle. And that economy is organized, according to this reading of psychoanalysis, around castration anxiety, which is to say in terms of an event through which the child is made aware of sexual difference and, in one and the same moment, socialized by being subordinated to parental law. And if difference and law converge in a single psychic configuration, they do so in relation to a visual event in which the possibility of absence is verified in the body of the "castrated" mother, the woman from whose genitals the phallus can be seen to be absent.[19] Siding with the paternal law, the child chooses speech, for which the master signifier is now the emblem of difference itself: the phallic signifier, the signifier as phallus.

It is in this sense that Mulvey refers to the male as maker of meaning in contrast to woman as bearer of meaning, a bearer now because the lack she is seen as manifesting on her own body, insofar as it sets up the phallus as signifier—which is to say a differential function through which the play of meaning now operates—this lack is necessary to the social system of order and sense to which Mulvey gives, following Jacques Lacan, the name Symbolic.[20] Thus she writes, "An idea of woman stands as linchpin to the system: it is her lack that produces the phallus as a symbolic presence, it is her desire to make good the lack that the phallus signifies."[21]

If the economy of sexual difference sets up a division of labor in relation to language, it also produces a separation of roles, it is argued, in relation to vision. On the one hand cinematic pleasure is scopophilic, voyeuristic: it wants to see and to control its objects of sight—but at a

distance, protected by its own remove in the dark and at a point of van-
tage that perspective triangulates for it, the occupant of this point guaran-
teed, through this visually unified position of control, a sense of its own
(phallic) mastery. On the other hand this pleasure is put in jeopardy by the
very image of the woman it wishes to master insofar as that woman is
marked as well as the bearer of the threat of castration. Thus it is necessary
for this spectator to convoke the psychic mechanism of denial, for which
the classic psychoanalytic instance is fetishism: the male child entering a
perversion in which he sees the proof of sexual difference but continues
nonetheless to believe in the woman as "whole," not-castrated: the phallic
mother. The fetish constructed through this mechanism of denial thus
restores to her body what is known to be "missing."

If film works constantly to re-create woman as a symptom of man's
castration anxiety—thus silencing her—it also works, and here even
harder, to situate her as eroticized fetish: the image of lack papered over,
the emblem of wholeness restored. Woman is in this sense skewered in
place as an image that simultaneously establishes her as other than man—
the Truth that it is he who possesses the phallus—and at the same time the
fetishized image of the whole body from which nothing is missing.

Stephen Heath describes this visual scenario from the point of view
of the gazing male subject—"Everything turns on the castration complex
and the central phallus, its visibility and the spectacle of lack; the subject,
as Lacan puts it at one point, 'looks at itself in its sexual member'"—and
then for the consequences for the woman secured as spectacle:

> What the voyeur seeks, poses, is not the phallus on the body of the
> other but its absence as the definition of the mastering presence,
> the security, of his position, his seeing, his phallus; the desire is for the
> other to be spectacle not subject, or only the subject of that same
> desire, its exact echo. . . . Fetishism too, which often involves the
> scopophilic drive, has its scenario of the spectacle of castration; and
> where what is at stake is not to assert that the woman has the penis-
> phallus but to believe in the intact, to hold that the woman is not cas-
> trated, that nothing is lost, that his representation, and of him, works.
> Always, from voyeurism to fetishism, the eroticization of castration.[22]

It is with this theoretical armature in place, then, that Laura Mulvey
herself looks at the *Film Stills,* understanding them to be rehearsing this

structure of the male gaze, of the voyeurist constructing the woman in endless repetitions of her vulnerability and his control: "The camera looks; it 'captures' the female character in a parody of different voyeurisms. It intrudes into moments in which she is unguarded, sometimes undressed, absorbed into her own world in the privacy of her own environment. Or it witnesses a moment in which her guard drops as she is suddenly startled by a presence, unseen and off-screen, watching her."[23]

And yet, we could say, it is this very theoretical armature that operates in such a description to put a mythic reading of the *Film Stills* in place, one that is not taking the trouble, indeed, to look under the hood. Judith Williamson had seen the constructed role emerge in the *Stills* as a consequence of the signifiers through which any filmic image must be built— "the two cannot be pulled apart," she had said; Laura Mulvey, on the other hand, is buying into a signified-as-instance, a congealed sign, the semantic totality that reads "woman-as-image," or again, "woman as object of the male gaze."

Sherman, of course, has a whole repertory of women being watched and of the camera's concomitant construction of the watcher for whom it is proxy. From the very outset of her project, in *Untitled Film Still #2* (1977) (fig. 44), she sets up the sign of the unseen intruder. A young girl draped in a towel stands before her bathroom mirror, touching her shoulder and following her own gesture in its reflected image. A doorjamb to the left of the frame places the "viewer" outside this room. But what is far more significant is that this viewer is constructed as a hidden watcher by means of the signifier that reads as graininess, a diffusion of the image that constructs the signified /distance/, a severing of the psychic space of the watcher from that of the watched. In *Untitled Film Still #39* (1979), it is not so much the grain of the emulsion that establishes the voyeuristic remove, with its sense that one is stealing up on the woman, as it is a kind of nimbus that washes around the frame of the image, repeating in the register of light the sense of barrier that the door frame constructs in the world of physical objects.

But in *Untitled Film Still #81* (1979) (fig. 29) there is a remarkably sharp depth of field, so that such /distance/ is gone, despite the fact that doorways are once again an obtrusive part of the image, implying that the viewer is gazing at the woman from outside the space she physically occupies. As in the other cases, the woman appears to be in a bathroom and once again she is scantily dressed, wearing only a thin nightgown. Yet the

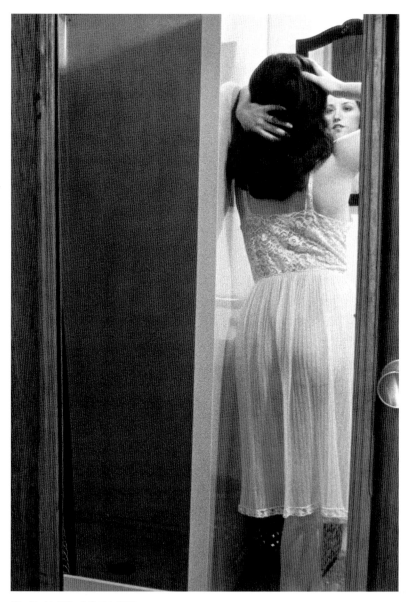

29 *Untitled Film Still #81,* 1980
black-and-white photograph
10 × 8 inches

continuity established by the focal length of the lens creates an un-impeachable sense that her look at herself in the mirror reaches past her reflection to include the viewer as well. Which is to say that as opposed to the idea of /distance/, there is here the signified /connection/, and what is further cut out as the signified at the level of narrative is a woman chatting to someone (perhaps another woman) in the room outside her bathroom as she is preparing for bed.

The narrative impact of these images tends to submerge the elements through which it is constructed, elements such as depth-of-field, grain, light, etc. which, it would seem, are too easy to dismiss as merely "formal" integers, whereas they function as signifiers crucial to the semantic effect. That Sherman is concentrated on these aspects is made very palpable in the one *Film Still* that seems inexplicable within the series as a whole: *#36* (1979) (fig. 30). Of all the *Stills* this one is so severely backlit that nothing can be seen of the character's face and almost nothing of her body beyond its silhouette. Standing in front of a curtain through which the powerful backlighting is dramatically diffused, she extends one of her arms upward almost out of frame; the other bends to grasp the elbow of the first in what could be a gesture of washing but remains radically ambiguous. As pattern her body reads black on the white of the ground, and her garments—the bodice of her slip and the stiffened film of a crinoline—parted slightly from her body, create the only area of modulation or middle tone in the image. To a far greater degree than almost any other in the series, this work is deprived of narrative implication.

A few months prior to the making of this *Still,* an image—or rather two images—remarkably like it were published: two photographs by Edgar Degas, of a ballerina dressed in a low-cut bodice, her skirt a diaphanous crinoline, standing in front of a luminous curtain and reaching with one arm upward, her other arm bent inward at the elbow. These photographs, published by a critic who just a few months later would launch Sherman in an essay called "Pictures," an article providing the first serious critical context for her work (Sherman's first solo exhibition was still one year away), are related to one another through an extraordinary ambiguity with regard to light.[24] For having solarized the negative of his photograph to create reversals between negative and positive areas within the image, Degas then created both a negative and a positive print. And the dark/light reversals that arise from this treatment constitute the dancer as a phantom whose existence can be located nowhere. As Douglas Crimp described it:

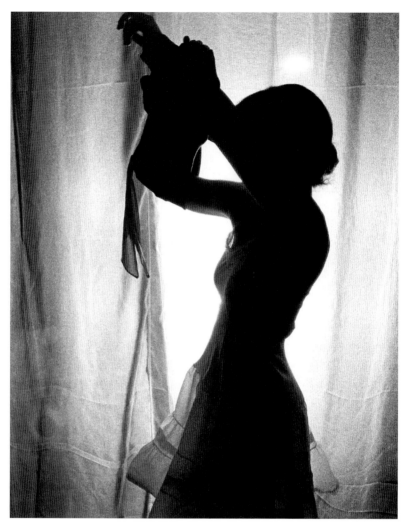

30 *Untitled Film Still #36*, 1979
black-and-white photograph
10 × 8 inches

In the print in which the right arm and torso of the dancer appears to be normally positive, the shadow of the arm on the wall she grasps appears as a streak of light. Her face, also apparently in shadow, and her "dark" hair are registered as light. At this point, obviously, language begins to fail. How can we any longer speak of light and dark? How can we speak of a white shadow? a dark highlight? a translucent shoulder blade? When light and dark, transparency and opacity, are reversed, when negative becomes positive and positive, negative, the referents of our descriptive language are dissolved. We are left with a language germane only to the photographic, in which the manipulation of light generates its own, exclusive logic.[25]

And in the publication of the twinned Degas photographs, the same dancer turns to confront her own mirror image as, flipped from negative to positive, she is also flipped left and right. Folded in a way almost impossible to imagine around the axis of her own body, that body is folded as well around a ghostly condition of luminosity that produces it now as solid, now as if in X-ray.

Sherman's *Untitled Film Still #36,* in its condition of being *hors série,* has also the aura of this impossibly folded Degas dancer, turning in a light that has no focus, and indeed no possible external point of view. Perhaps the *Still* was addressed, imaginatively, to Crimp; but such an address has nothing in it of the theorization of the male gaze and the psycho-politics of sadistic control. Further, as we will see, this kind of backlighting, and all that it does to fragment the gaze, will emerge as a crucial element—or signifier—in Sherman's work of the early 1980s. But that is to anticipate somewhat, getting ahead of our story.

The Horizontals

The only thing cinemascope is good for is to film snakes and funerals.

—Jean-Luc Godard[26]

The *Film Stills* had been a laboratory for exploring the range of signifiers that go together to produce the look of a given filmic genre or director and thereby to construct a "character," sealing it as the "real" of denotation, which in Barthes's terms, as we've seen, is only the last of the cinematic, connotational codes to be slipped into place. It was from this

various testing ground that Sherman then began to select out a single sig-
nifier, so as to concentrate on it.

First, in 1980, this signifier was the special effect of backscreen pro-
jection with its resultant fissure in the image field, the split it sets up in the
experience of density and substance between the three-dimensional char-
acter and her flattened, fictitious-looking scenic surrounds. Color, which
entered Sherman's work at this moment, heightened the sense of this
difference.

Then, in 1981, a different signifier, put in place in the series triggered
by a commission for a centerfold for *Artforum* magazine, emerged as the
central concern. That signifier is point of view. And in this group of images
that viewpoint, consistent through most of the series and stridently
adopted by the camera, is from above, looking down. It is as though the
extreme horizontality of the image's format had suggested a corresponding
horizontality in the image field. From being a projection of the viewer
looking outward toward a visual field imagined as parallel to the vertical of
the upright body of the beholder and his or her plane of vision, the view
now slides floorward to declare the field of vision itself as horizontal.

But if this in fact has happened, it has never been registered in the
writing that greeted this phase of Sherman's work. Still firmly fixed on the
signified, the projected roles—"In several of these, a girl is seen in a state
of reverie, daydreaming—we automatically presume since we sublimi-
nally recall so many scenes like these from movies and television—about
her prospects for romance"[27]—the accounts of the series go straight for
the mythic content: Sherman's ability to get inside her characters. "What
is instantly recognizable in Sherman's new pictures is the universal state of
daydream or reverie, the moments of harmless, necessary psychosis that
are a recurring mechanism in anyone's mental economy. These are
moments when consciousness dissolves back into itself, when wish and
reality, personal and collective memory are one and the physical world
ceases to exist."[28]

Mulvey, also, focuses on the characters and their interiors: "The
young women that Sherman impersonates may be daydreaming about a
future romance, or they may be mourning a lost one. They may be wait-
ing, in enforced passivity, for a letter or telephone call. Their eyes gaze into
the distance. They are not aware of their clothes, which are sometimes
carelessly rumpled, so that, safe alone with their thoughts, their bodies are,
slightly, revealed to the viewer." Referring to this effect as "soft-core pas-
tiche" and associating the horizontal format of the images to the shape of

a cinemascope screen, Mulvey's reading returns to the woman-as-image question, the construction of the eroticized fetish. "These photographs reiterate the 'to-be-looked-at-ness' of femininity," she writes, pointing to the way the connotations of intimacy both at the level of emotion—daydream, fantasy—and of setting—the bedroom—combine to exude a strong sense of sexuality. And even though the voyeuristic place of the spectator is not marked here, as it has been in the *Film Stills,* she says, the issue of woman-as-spectacle, woman-as-symptom has not changed. It has merely been reconditioned to concentrate on the mechanism of masquerade: the posturing projected outward from an empty center. It is in this series, she writes, that the works "start to suggest an interior space, and initiate [Sherman's] exploration inside the masquerade of femininity's interior/exterior binary opposition."[29]

It was in his essay "The Meaning of the Phallus" that Jacques Lacan had formulated masquerade as this desperate binary, pronouncing: "Paradoxical as this formulation might seem, I would say that it is in order to be the phallus, that is to say the signifier of the desire of the Other, that a woman will reject an essential part of femininity, namely all its attributes via masquerade."[30] Thus, if femininity is unconsciously constructed—insofar as it is projected as lack, as what is missing, and in this sense as symptom of the man—as an essential absence, Lacan describes the woman as rejecting that absence, and thus her own "essence," in order to assume the masquerade of wholeness, of the nothing-missing of the fetish. The dance of her "to-be-looked-at-ness" is a veil covering over this nothing, which Lacan elsewhere designates as "not-all"—*pas tout.*

It is in this same text that Lacan had cautioned that the phallus in being a signifier could not be seen as either a phantasmatic object or a physical organ: "Nor is it as such an object (part, internal, good, bad, etc. . . .) in so far as this term tends to accentuate the reality involved in a relationship. It is even less the organ, penis or clitoris, which it symbolizes."[31] Instead, as signifier it opposes the signified, and—as in the relationship described by structural linguistics—it "has an active function in determining the effects in which the signifiable appears as submitting to its mark, becoming through that passion the signified."

It is, of course, the human subject who in this sense emerges as "submitting to its mark," emerging as the material through which language itself speaks, "his nature woven by effects in which we can find the structure of language." Spoken thus by this chain of signifiers that operate to cut him out as their effect, their signified, the human subject is, then, the subject

of this system. In another essay Lacan formulated the rule of this linguistic subject as $\chi_\Phi \chi_A$, which read *all x is a function of the phallus,* with phallus understood here as the master signifier in the linguistic chain.[32] It is a formulation that announces once again the sense in which the human subject is not its own master but is organized elsewhere, in the place Lacan designates as Other and is occupied by the unconscious, by language, by social law.

But it is also the case that every human subject has an ego, or sense of (autonomous) self, that wants to hold out against that formula and would instead organize itself in other, directly opposing terms: $\exists \chi \overline{\Phi} \chi$, which reads *there is an x that is not a function of the phallus.* This protest is an insistence that there is something that "I really am"—"beneath my surfaces and roles and socialization, beyond my sex and my childhood, away from everything that conspires to keep me from saying what" it is.[33] For Stephen Melville, writing on Lacanian notions of the subject, the combination (or rather the togetherness-in-opposition) of these two formulations "seems to capture something of the primordial and constitutive alienation that Lacan takes to characterize human being."

Now if the ego can insist that "there is an *x*—me!—that is not a function of the phallus," it is because, Lacan argues, that ego has first constituted itself in relation to an image of wholeness, a unitary figure or gestalt, that it has seen in a mirror. And that ego will continue to find instances of wholeness with which to reconstitute the "there is . . ." throughout its existence, one example of which is, of course, the setting up of the woman as fetish, as *pas-tout.* In a certain way this securing of the ego in relation to the instance takes a form that is very like what Barthes had called the interpellant function of myth, the "you see! here is . . ." Which is to say that if the subject is no longer the *source* of his own meanings in the field of the symbolic (the chain of signifiers), the very production of meaning out there in the field of representation will itself project an image of wholeness (the sign as unit) that will be mirrored back to him as an interpellant fiction. And this will set him up as the unified, although imaginary, recipient of the "you see! . . ."

Now, if I have been rehearsing these theories, so central for the feminist theorization of woman-as-image, it is in order to get a sense of what the mechanisms are that prevent a critic like Mulvey from looking under the hood. It is to be able to speculate on why a certain meaning of Sherman's "horizontals" would have remained invisible, namely, the one marked /horizontal/.

Yet all we have to do is focus on the insistent verticalization inscribed by all the metaphors that circulate through the Lacanian universe of the subject—the vertical of the mirror, the vertical of the veil, the vertical of the phallus as instance of wholeness, the vertical of the field of the fetish, the vertical of the plane of beauty—to sense why the horizontal is forced to recede from view when one's eyes are fixed on this theory.

Wherever Sherman's eyes are in relation to this or any theory, they are certainly attuned to the givens of her own field of operations, which is to say both high art and mass media. And in that field vertical and horizontal are exceedingly overdetermined. If the vertical is the axis of painting, the axis in which the picture orients itself to the wall, it is also, as we have seen, the axis of the plane of vision. That plane, which the Gestalt psychologists characterize as insistently "fronto-parallel" to the upright body of the viewer, is as well, they tell us, the plane of *Prägnanz,* by which they mean the hanging together or coherence of form. Thus the very drive of vision to formulate form, to project coherence in a mirroring of the body's own shape, will already mark even the empty vertical plane as a reflection of that body, heavier at the bottom, lighter at the top, and with a different orientation from right side to left. And conversely any location of form—of shape or of figure—will assume its place in an axis that is imaginatively vertical, even if we confront it on the page of the magazine we hold on our laps or in the tiles of the mosaic that lies under our feet.

Further, this vertical dimension, in being the axis of form, is also the axis of beauty. That is what Freud adds to the Gestaltists' picture: in that period in his evolution when man finally stood up, he left the world of sniffing and pawing, with nose pressed to genitals, and entered the world of vision in which objects were now experienced as being at a distance. And in this distancing his carnal instincts were *sublimated,* Freud writes, reorganized away from the organ world of the horizontal and into the formal world of the vertical, which is to say, of the beautiful.[34]

It was not just modernist painting, which formed part of Sherman's heritage as an artist, that insisted on this verticality—and its effect of sublimation; it was also the media universe of movies and television and advertising that declared it. And these two fields, so seemingly inimical to one another, had a bizarrely complementary relation to this effect of sublimation. If the media's fetish occupied the axis of the vertical, that very axis had itself become the fetish of high art.

During the 1960s and 1970s, however, a series of blows had been struck against this fetish. There were, to take only one example, a group

of readings of the work of Jackson Pollock—itself a dominant emblem of the sublimatory condition of the vertical, optically conditioned, pictorial field—that defiantly reinterpreted Pollock's painting as horizontal. This was true of Andy Warhol's *Oxidation* paintings through which he read Pollock's dripped pictures as the work of a urinary trace (as though made by a man standing over a supine field and peeing), thus insisting on the way Pollock's canvases are permanently marked by the horizontality of their making. It was also true of Robert Morris's felts and scatter pieces, through which he reinterpreted Pollock's enterprise as "anti-form," by which he meant its condition of having yielded to gravity in assuming the axis of the horizontal. It can also be said that it was true of Ed Ruscha's *Liquid Word* pictures, with their reading of the significance of the drip technique as opening onto the dimension of entropy and "base materialism."[35]

If this sequence is invoked here it is to give one a sense of the connotations of the /horizontal/ within the field of the avant-garde of the 1960s and 1970s as certain artists opposed the /vertical/ within which is inscribed all forms of sublimation, whether that be of *the beautiful* or of *the fetish*. It is to see the work already in place on the pictorial signifier once it operates in terms of the failure to resist the pull of gravity, of the pivoting out of the axis of form.

In the "horizontals" Sherman's work is joined to this tradition. That desublimation is part of what she is encoding by means of the /horizontal/ will become unmistakably clear by the end of the 1980s with what are sometimes politely referred to as the "bulemia" pictures, namely, images in which the horizontal plane occupied by the point of view is forcibly associated with vomit, mold, and all forms of the excremental—"base materialism," indeed. But in these works of 1981 it is already clear that the view downward is desublimatory. In *Untitled #92* (fig. 31) the narrative operated by this signifier is not that of "vulnerability" via a pose that is "soft and limp," but rather of animality, the body clenched in a kind of subhuman fixation. And in *Untitled #91* the network of cast shadows that grids the body and face of the woman projects over the image a sense of decay and of death. It is as though something were working against the forces of form and life, attacking them, dissolving them, disseminating them into the field of the horizontal.

The theory of the male gaze, even as it moves from an analysis of the operations of a representational field—movies, paintings—to a generalization about the structure of human consciousness, has had to blind itself to its own fetishization of the vertical. Which is to say that it has had to

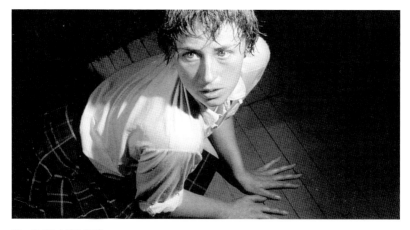

31 *Untitled #92,* 1981
color photograph
24 × 48 inches

blind itself to anything outside the vertical register of the image/form.[36] It is because of this that the theorists of the gaze repeat, at the level of analysis, the very fixity they are describing as operating the male gaze at the level of its social effects. And the symptom of this repetition is the constant submission to the meaning-effect the system generates, a submission to be found in Mulvey's steady consumption of Sherman's work as myth.

Gleams and Reflections

> In short, the point of the gaze always participates in the ambiguity of the jewel.
>
> —Jacques Lacan[37]

In the view of its theorists, the male gaze can do its work of continually putting the fetish/form in place even in the absence of any identifiable image. Victor Burgin, for example, argues that the effect of the gestalt's delineation and boundary can be generated by the very surfaces of media artifacts, such as the glossiness of the photographic print, with its high resolution and its glazed finish.

And Mulvey follows Burgin in this argument. For even while she reads the "horizontals" in terms of "the 'to-be-looked-at-ness' of femininity," she also admits that there is a contradiction between the limpness

she sees in the poses—"polar opposites of a popular idea of fetishized fem-
ininity (high-heeled and corseted erect, flamboyant, and exhibition-
ist)"—as well as the limpness of the image—"Sherman's use of color and
of light and shade merges the female figure and her surroundings into a
continuum, without hard edges"—and the sharp definition characteristic
of the fetish. But fetishism, she argues, "returns in the formal qualities of
the photography. The sense of surface now resides, not in the female
figure's attempt to save her face in a masquerade of femininity, but in the
model's subordination to, and imbrication with, the texture of the photo-
graphic medium itself."[38]

This texture, "in keeping," as Mulvey writes, "with the codes and
conventions of commercial photography," is glossiness, the product of a
kind of reflective veneer. It is this shiny surface that Burgin in his turn had
related to the fetishized *glanz*, or gleam, that Freud had described in his
essay outlining the unconscious mechanics of the construction of the
fetish.[39]

Now while it is true that shininess functions as a certain kind of sup-
port for media images—and not just those of photography but even more
insistently of backlit advertising panels and film and television screens—it
is also true that Sherman performs specific work on this phenomenon. Just
as she had taken a horizontal format—borrowed both from centerfold
photographs and from cinemascope screens—and worked on it to pro-
duce a signifier that (in opposition to the meaning of the /vertical/) would
cut out a specific signified—the /horizontal-as-lowness, -as-baseness/—
so, here as well, the gleam is submitted to sustained investigation.

One of the last of the horizontals, *Untitled #95* (1981) (fig. 32), had
announced this attention to the gleam. It is of a woman sitting upright on
a bed (and thus no longer aligned with the horizontal axis of the format),
caught in a strong glow of backlighting, so that her hair, now reconfigured
as an intensely luminous nimbus, displaces the focus away from her face.
As Sherman's work advances into the 1980s it repeats this kind of back-
lighting, forcing a glow to emerge from the ground of the image to ad-
vance outward at the viewer and thus to disrupt conditions of viewing,
producing the figure herself as a kind of blind spot. We find it again, for
example, in *Untitled #139* (1984).

But although backlighting is a very direct signifier for this sense of a
diffracted and dispersed visual field, it is not the only means to produce it.
Indeed it could be said that a certain effect of "wild light," the scattering
of gleams around the otherwise darkened image as though refracting it
through the facets of an elaborate jewel, will also create this corrosive vi-

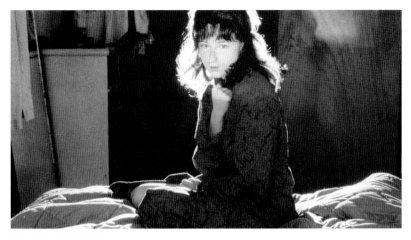

32　*Untitled #95,* 1981
color photograph
24 × 48 inches

sual dispersal. An early example of such wild light immediately followed the last of the horizontals, in *Untitled #110* (1982), where Sherman has concentrated on creating a sense of the completely aleatory quality of the illumination. For while the lighting plunges three quarters of the field into total blackness, it picks out the arm and draped edge of the figure's garment to create a glowing, knotted complex of near unintelligibility.

Another instance of wild light is *Untitled #147* (1985), where head and upper torso given in enormous close-up are plunged into a darkness only violated by the backlit fragments of a bit of hair and one shoulder, and—building the eerie significance of the work—the reflected gleam of a pupil that emerges from the obscurity of the rest of the face like an utterly opaque, black marble.[40] This contrast between the opacity of the figure's look and the quality of light beaming outward at the viewer from dispersed parts of the rest of the image sets up a condition that can be generalized to other parts of this series I am calling Gleams and Reflections. It is a condition that I would like, now in my own turn, to use the work of Lacan to illuminate; although unlike the theory of the male gaze, this condition of the uncanny gaze, which Lacan qualifies as "the gaze as *objet a,*" works against the effects of sublimation.

In setting up the model of this gaze as *objet a,* Lacan specifically contrasts it to the ego-model, itself linked to the vantage point of the perspective diagram, through which the "it's me!" of the subject, escaping from the dispersed condition of the Symbolic (the chain of signifiers) into the unified

gestalt of the Imaginary, projects itself as whole. This projection, as we re-member, is used in the male gaze theory to link the institution of the fetish to the very conditions of vision, understood as mapped by perspective's optical pyramid.

In the four lectures devoted to the question of the gaze, Lacan, how-ever, is intent on restricting this optico-visual model, which he terms "geometral," to the realm of an idealized, abstracted, Cartesian conception of space. In the place of this spatial conception, he wishes to set a more fundamental condition of visuality, namely, that of light. Contrasting this luminous surround to the model of linear perspective, he says that we en-counter the visual "not in the straight line, but in the point of light—the point of irradiation, the play of light, fire, the source from which reflec-tions pour forth."[41]

Such an irradiation beaming at the subject from everywhere in space, bathing and surrounding him or her, cannot, then, be assimilated to the mirror image in which a gaze looks back at the subject in an imitation of the single point from which the subject sees himself seeing. Instead, to de-pict this luminous gaze, which makes of the subject a *speculum mundi,* Lacan turns to the model of animal mimicry, which his old friend Roger Caillois had described back in the 1930s as the effect of space at large on a subject (-insect) who, yielding to the force of this space's generalized gaze, loses its own organic boundaries and merges with its surrounds in an almost psychotic act of imitation.[42] Making itself into a kind of shapeless camouflage, this mimetic subject now becomes a part of the "picture" of space in general: "It becomes a stain, it becomes a picture, it is inscribed in the picture," Lacan insists.[43] But if Caillois had been describing animal behavior, Lacan elaborates this effect for the human subject as well. Telling an anecdote about himself caught in an indefinable beam of light reflected off a sardine can, Lacan draws the conclusion:

> I am taking the structure at the level of the subject here, and it reflects something that is already to be found in the natural relation that the eye inscribes with regard to light. I am not simply that punctiform being located at the geometral point from which the perspective is grasped. No doubt, in the depths of my eye, the picture is painted. The picture, certainly, is in my eye. But I, I am in the picture.[44]

The sliding back and forth between Caillois's insect and Lacan's "I" in this discussion of mimicry is important to what Lacan wants to get at by

this notion of gaze. For Caillois had insisted that the insect cannot be shown to assume its camouflage for purposes of adaptation—and thus what could be seen as coming from an intentional, subjective ground (no matter how instinctual or unconscious)—but simply as matter flowing into other matter, a mere body yielding to the call of space. Lacan joins this same position when he says, "Mimicry reveals something insofar as it is distinct from what might be called an *itself* that is behind," which is to say, distinct from a subjective ground of the subject.[45] Rather, we pass into the "picture" as mere "stain," which is to say as physical matter, as body. And here Lacan also refers to Merleau-Ponty's position in *The Phenomenology of Perception* that our relation to space—insofar as it is the target of the gaze constituted by the luminous surround, a light that catches us in its beam from behind as well as from in front—founds our perception not in the transparency of a conceptual grasp of space (as in the "geometral") but in the thickness and density of the body that simply intercepts the light.[46]

It is in this sense that to be "in the picture" is not to feel interpellated by society's *meaning*—"it's me!"—is not to feel, that is, whole; it is to feel dispersed, subject to a picture organized not by form but by formlessness. The desire awakened by the impossibility of occupying all those multiple points of the luminous projection of the gaze is a desire that founds the subject in the realization of a point of view that is withheld, one(s) that he or she cannot occupy. And it is the very fragmentation of that "point" of view that prevents this invisible, unlocatable gaze from being the site of coherence, meaning, unity, gestalt, *eidos*. Desire is thus not mapped here as the desire for form, and thus for sublimation (the vertical, the gestalt, the law); desire is modeled in terms of a transgression against form. It is the force invested in desublimation.[47]

Nowhere is the notion of having become "the picture" more searingly evoked than in Sherman's *Untitled #167* (1986) (fig. 33), where the camouflage effect is in full flower. The figure, now absorbed and dispersed within the background, can only be picked out by a few remnants still visible, though only barely, in the mottled surface of the darkened detritus that fills the image. We make out the tip of a nose, the emergence of a finger with painted nail, the detached grimace of a set of teeth. Horizontalized, the view downward mapped by the image puts the signifier of the dissolution of the gestalt in place. But as it reaches the bottom edge of the image, the spectator's view encounters a gaze that projects toward it from within this matrix of near-invisibility. Reflected in the tiny mirror of a discarded compact, this gaze cannot be identified with any source in the

33 *Untitled #167*, 1985
color photograph
60 × 90 inches

image. Instead, it seems to join all the other gleams and reflected points of light in the image to constellate the signifier for the /unlocatable/, and thus for the transgression of the gestalt.

Throughout the late 1980s Sherman continued to figure this field of the unlocatable gaze by means of Gleams and Reflections. And now the bouncing light of these opaquely slippery, arborescent signifiers is more consistently married to the /horizontal/, both combining in a drive toward the desublimation of the image. In *Untitled #168* (1987) a glowing but imageless television screen joins the repertory of gleams. In *Untitled #176* (1987) the refractive surface of water sparkling upward to meet the downwardly focused view of the spectator projects the multiple points of light with all the ambiguity of the jewel that produces not the beautiful of sublimation but the formless pulsation of desire.

The Old Masters

The core of [Leonardo's] nature, and the secret of it, would appear to be that after his curiosity had been activated in infancy in the service

of sexual interests he succeeded in sublimating the greater part of his libido into an urge for research.

—Sigmund Freud[48]

In his *Three Essays on the Theory of Sexuality* Freud speaks of the sexual instincts of children as relentlessly and repetitively driving them toward what they want to know but dare not ask, and what they want to see but dare not uncover behind the garments that conceal it. This drive, which is sexual, does not cause pleasure for the child, but to the contrary, nonpleasure "in view of the direction of the subject's development." Therefore to ward off this nonpleasure, a defense against the drive sets in, in the form of disgust, shame, and morality. This defense Freud calls reaction-formation.

But parallel to this is another defense against the force of the drive, namely that of sublimation. This occurs when the drive is forced to change its course by shifting its object. Thus the sexual instinct can be "diverted ('sublimated') in the direction of art, if its interest can be shifted away from the genitals on to the shape of the body as a whole." This shift is, as we know, away from the libidinal and on to the beautiful form.[49]

In 1989 and 1990 Sherman turned her own attention to Art, which is to say, firmly and steadily toward the most overt and pronounced version of the scene of sublimation. The very term *high* that modifies *art* (either explicitly or implicitly) announces this sublimatory effect as having had its origin in a gesture of raising one's eyes to the plane of the vertical and of thereby acceding to the field of the gestalt. And Sherman's "Old Master" pictures revel in forming again and again the signifiers of the form that high art celebrates, signifiers of verticality meshing with signifiers of the unitariness of the gestalt.

Premiere among these, of course, is the signifier constellated by the frame. For the frame is what produces the boundary of the work of art as something secreted away from ordinary space-at-large, thereby securing the work of art's autonomy; and at the same time the frame's contour echoes the conditions of boundary and closure that are the very foundations of form.

Sometimes the frame enters the field of the aesthetic image through nothing more complex than the black background that cushions and cradles the figure, emphasizing its shape by contrast, a shape that in its turn is often constructed as a set of miniaturized echoes of the larger, enclosing frame. These internalized echoes might appear in the encircling oval

formed by the figure's arms, meeting in a gesture of self-embrace. Or they may be the result of the U of a bodice that frames the head and upper torso, or the encircling O of a turban that frames the face. Sometimes the frame is projected by more scenographic elements: painted curtains that part to make a space for the figure; or even the depiction of an actual frame behind the figure—the ornate frame of a mirror, perhaps, in which the figure can now be doubly enfolded, first by the actual frame of the painting as a whole, and second by the depicted frame that captures and embraces the figure's double.

Two of the very famous Old Master images that Sherman stages represent the extremes of these possibilities, from most simple to most elaborate. Her version of *La Fornarina,* the portrait of Raphael's mistress (*Untitled #205* [1989]), presents us with the first alternative, while her strangely composite projection of several of Ingres's most celebrated sitters—Madame Rivière, Madame de Senonines, and Madame Moitessier (*Untitled #204* [1989] [fig. 34])—confronts us with the second. In this last the signifiers of internal framing are piled one upon the other as drapery, gesture, and mirror encircle the projected body in a giddy enactment of frames-within-frames.

Further, another rather disturbing signifier enters this theater of the /vertical/ to point to still one more meaning of *high* in the conception of high art. This signifier, a function of the way these Old Master personages are constructed by Sherman thanks to fake body parts that are strapped onto her torso or applied to her head, marks the surface of the image as a mask or veil, one that can supposedly be removed, pushed aside, seen behind. In their very detachability, these elements point thus to the hermeneutic dimension of the work of art: the idea that it possesses an inner truth or meaning to which the interpreter might penetrate. In being a hermeneutic object the work of art thus occupies the "high" position not as vertical to horizontal but as ideal to material, or as mind to body.

And yet it is also in the obviousness of the condition of these body parts as prostheses that they work against the conception of the veil with its hidden Truth, at the very same time that they burrow into the /vertical/ to oppose and topple it. Conniving against the sublimatory energy of Art, the body parts constitute signifiers that mark a yield to gravity, both because of the weight of the physical elements they model, and the sense they promote of these pendulous forms already sliding down the surface of the body. In this capacity they elaborate the field of a desublimatory, horizontal axis that erodes the facade of the vertical, bearing witness to the fact

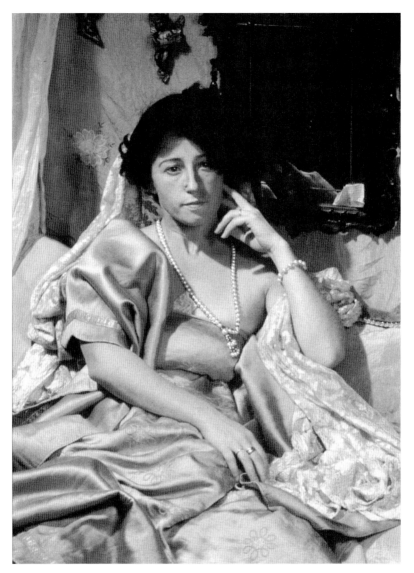

34 *Untitled #204,* 1989
color photograph
59³/₄ × 53¹/₄ inches

that behind that facade there lies not the transparency of Truth, of meaning, but the opacity of the body's matter, which is to say, the formless.

It is as though Sherman's own earlier work with the /horizontal/ has now led her back to the vertical, sublimated image, but only to disbelieve it. Greeting the vertical axis with total skepticism, the Old Master images work to discorroborate it, to deflate it, to stand in the way of its interpellant effect.

The Vomit Pictures

> However, even this bedrock—the vomit and the blood for instance—returns to cultural significance: that is, to the difficulty of the body, and above all the female body, while it is subjected to the icons and narratives of fetishism.
>
> —Laura Mulvey[50]

Nothing, it would seem, could be less alike than Sherman's impersonation of various Raphaels and Davids and Ingres and the series she worked on over roughly the same time period (1987–91), to which various descriptive rubrics have been given, among them "bulimia" and "vomit." And yet the notion of the veil can operate for both series: either in the manner of a hermeneutics of the work of art, as described above; or, for the bulimia pictures, in the manner of what Mulvey has called the "phantasmagoria of the female body."

Indeed, as has often been pointed out, the female body itself has been made to serve as a metaphor for hermeneutics, which is to say as the Truth to which one might penetrate upon lifting the veil of the work. But Mulvey's "phantasmagoria" recasts this Truth into its psychoanalytic dimension and shows it as yet one more avatar of fetishism. For the truth that was sought behind the veil, the truth for which the woman-as-fetish now functions as symptom, is the truth of the wound inflicted by a phantasmatic castration. Thus the interior of the female body is projected as a kind of lining of bodily disgust—of blood, of excreta, of mucous membranes. If the woman-as-fetish/image is the cosmetic facade erected against this wound, the imagined penetration of the facade produces a revulsion against the "bodily fluids and wastes that become condensed with the wounded body in the iconography of misogyny." And women themselves, Mulvey points out, participate in this notion of exterior/interior,

of veiled and unveiled. Speaking of how women identify with misogynistic revulsion, not only in adopting the cosmetics of the masquerade but in pathologically attempting to expunge the physical marks of the feminine, she says: "The images of decaying food and vomit raise the specter of the anorexic girl, who tragically acts out the fashion fetish of the female as an eviscerated, cosmetic, and artificial construction designed to ward off the 'otherness' hidden in the 'interior.'"[51]

Now, the contrast between interior and exterior, which Mulvey had consumed as the mythic content of Sherman's horizontals, continues to be the thematics she reads into Sherman's work throughout its progression. Moving from the horizontals to the parodically violent fashion images Sherman made in 1983, Mulvey sees these as a protest against the smooth, glossy body of the fashion model, a protest registered by a surface that seems to drop away "to reveal a monstrous otherness behind the cosmetic facade." Or, in the subsequent series inspired by fairy tales she sees the revelation of the very stuff of the unconscious that lines the interior: "While the earlier interiority suggested soft, erotic, reverie, these are materializations of anxiety and dread." Finally in the body's disappearance into the spread of waste and detritus from the late eighties, "the topography of exterior/interior is exhausted," since "these traces represent the end of the road, the secret stuff of bodily fluids that the cosmetic is designed to conceal." With the removal of this final veil and the confrontation of the wound—"the disgust of sexual detritus, decaying food, vomit, slime, menstrual blood, hair"—the fetish fails and with it the very possibility of meaning: "Cindy Sherman traces the abyss or morass that overwhelms the defetishized body, deprived of the fetish's semiotic, reduced to being 'unspeakable' and devoid of significance."[52]

And yet, no sooner is it imagined that the "vomit pictures" have produced the "unspeakable," defetishized body than that body is reprogrammed as the body of the woman: the mother's body from which the child must separate itself in order to achieve autonomy, a separation founded on feelings of disgust against the unclean and the undifferentiated. Using Julia Kristeva's term "abjection" for this preverbal cut into the amorphous and the continuous in order to erect the boundaries between an inside and an outside, a self and an other, Mulvey writes:

> Barbara Creed's argument that abjection is central to the recurring image of the "monstrous feminine" in horror movies is also applicable to the monstrous in Sherman. Although her figures materialize the

stuff of irrational terror, they also have pathos and could easily be un-
derstood in terms of "the monster as victim." . . . The 1987 series sug-
gests that, although both sexes are subject to abjection, it is women
who can explore and analyze the phenomenon with greater equa-
nimity, as it is the female body that has come, not exclusively but pre-
dominantly, to represent the shudder aroused by liquidity and decay.[53]

At the very moment, then, when the veil is lifted, when the fetish is
stripped away, the mythic content of a packaged signified—"the mon-
strous feminine"—nonetheless rises into place to occupy the vertical field
of the image/form. The truth of the wound is thus revealed. Decoded at
last, it reads: the truth of the wound.

But under the hood of the image all the signifiers of the "vomit pic-
tures" are at work to desublimate the visual field. Not only the insistent
construction of the /horizontal/ but the sense in which the random glit-
ter of wild light is leering up at the viewer to configure the /unlocatable/
work together to produce a displacement of the body "into the picture"
and to install it there as *formless.* This is a field without truth, one that re-
sists being organized in order to produce /the wound/ as its signified. And
of course its signifiers are at work, as always, completely in the open, ready
for inspection without a safety net or a veil.

The notion of unveiling what is veiled, of penetrating from exterior
to interior is hermeneutical of course, but it is also tied to the psychoan-
alytic distinction between manifest and latent content. The manifest con-
tent of a dream, Freud explained, was its secondary revision, its plausible
surface meant to paper over its latent thoughts, the ones that needed to be
censored or repressed. The secondary revision is a disguise, a concealment,
a veil. In *The Interpretation of Dreams* Freud gives as an example dreams of
embarrassment at appearing in public improperly dressed. These he says
are veils that cover the dreamer's desire for nakedness, a nakedness that
would not produce shame.

Jacques Derrida points to this peculiar slippage between the analytic
metaphor of the veil removed to reveal the naked truth and the semantic
content in which the dreamer dreams of a veil that threatens to reveal his
nakedness. He turns to Freud's use of the story of "The Emperor's New
Clothes" in this connection. For Freud is illustrating his theory of unveil-
ing the latent contents by revealing that the hidden theme of the fairy tale
is the dream of nakedness, which is to say, the dream of veiling/unveiling.
Objecting that "The Emperor's New Clothes" is not latently about the

dream of nakedness, but manifestly so, and into the bargain about the act of revelation—staged by the child who calls out, "But he's naked!"—that itself performs, within the text, the act of veiling/unveiling, Derrida writes:

> Freud's text is staged when he explains to us that the text, e.g. that of the fairy tale, is an *Einkleidung* [disguise] of the nakedness of the dream of nakedness. What Freud states about secondary revision (Freud's explaining text) is already staged and represented in advance in the text explained (Andersen's fairy tale). This text, *too,* described the scene of analysis, the position of the analyst, the forms of his language, the metaphorico-conceptual structures of what he seeks and what he finds. The locus of one text is in the other.[54]

With this model of the way the form of the inquiry will produce the semantic version, or the thematization, of that very form—veiling/un-veiling—as its *answer,* in an act of finding that always finds itself, Derrida looks at Lacan's use of a story by Edgar Allan Poe to illustrate his own psychoanalytic theories of the operations of the signifier. Turning to Lacan's "Seminar on 'The Purloined Letter,'" Derrida says: "If the critique of a certain sort of semanticism constitutes an indispensable phase in the elaboration of a theory of the text, the Seminar exemplifies a clear progress beyond any post-Freudian psychoanalytic critique. It takes into account the organization, material as well as formal, of the signifier without throwing itself upon any semantic, not to say thematic, content of the text."[55]

And yet Derrida will progress from this point toward a demonstration that for Lacan, too, despite his insistence on the materiality of the signifier and on its condition as the mere marker or operator of difference—a differential function that cannot accept the assignment of a fixed meaning—his interpretation of Poe's "Purloined Letter" will constantly move toward an unveiling that will find what it seeks in the place where it expects to find it. It will find, that is, that the letter—the phallic signifier—constructs the fetish: "It is, woman, a place unveiled as that of the lack of the penis, as the truth of the phallus, i.e. of castration. The truth of the purloined letter is the truth itself, its meaning is meaning, its law is law, the contract of truth with itself in the logos."[56]

If Lacan wants to show that in Poe's story the incriminating letter, which the Minister steals from the Queen only, once it is in his possession,

to have it ravished from him in turn by Dupin, is the phallus—signifier of the pact that links Queen to King, and signifier as well of castration—so that anyone who possesses it is "feminized," this letter-as-phallus, he insists is a signifier, the circulating operator of meaning, cutting out each character in turn as he or she is submitted to its course. But Derrida argues that far from being the mere differential function of structural linguistics, this letter functions, in fact, as a *transcendental* signifier, which is to say as the term in a series whose ideal and idealizing privilege comes from the fact that it makes the series possible. For Lacan insists not only that the letter-as-phallic-signifier is indivisible and indestructible, but that it has a certain and proper place, the two taken together producing the very truth of the letter: that it will always arrive at its destination, namely, on or at the body of the woman.

The slippage Derrida is interested in is thus a version of the same slippage that had occurred in "The Emperor's New Clothes." For here the notion of pure difference continually returns to the same signified, and the signifying chain with its endless play of signifiers is in fact rooted in place. Thus the analyst is trapped by the very lure of meaningfulness—"it's me!"—that he wishes to analyze. The ideality of the letter-as-phallic-signifier derives from the interpellant system, the one that produces meaning as points of stability between signifiers and signifieds:

> The idealism which resides in [this system] is not a theoretical position of the analyst, it is a structure-effect of *signification* in general, whatever transformations or adjustments are practiced on the space of *semiosis*. It is understandable that Lacan finds this "materiality" "unique": he retains only its ideality. He considers the letter only at the point where, determined (whatever he says about it) by its meaning-content, by the ideality of the message which it "vehiculates,". . . it can circulate, intact, from its place of detachment to the place of its re-attachment, that is to say, to the same place. In fact, this letter does not elude only partition, it eludes movement, it does not change place.[57]

We have seen this before, this result of "the structure-effect of *signification* in general," which the analyst wants to reveal or unveil but which the analysis itself repeats by continually setting up the fetish—the Truth of the veil/unveiled—in the place of meaning. We have seen this in the analysis of Sherman's art through all types of mythic consumption, in-

cluding that of the theory of the male gaze as production of the eroticized fetish. In all of these there is the continual rush toward the signified, the refusal to follow the signifiers, the steady consumption of the mythic production of meaning.

The Sex Dolls

> When I did those horizontal pictures of me lying down, I got a lot of criticism for being "anti-feminist" and "turning the clock back" by showing these "victims," and these new pictures [the 1985 fairy tale characters] show me just how wrong I think those people really were.

—Cindy Sherman[58]

There may have been reasons why, in the series she made in 1993, Sherman turned away from her own body as support for the image and began to use dolls instead, or more specifically, plastic mannequins acquired from a medical supply house. She had spoken in interviews of trying to imagine breaking away from her own constant presence in front of the camera and possibly using models, although she would always end by saying why it didn't seem feasible.[59] Perhaps she finally found a way to make it feasible; perhaps the decision to stage the display of the genitals and the performance of "sexual acts" was in fact a way of forcing her own body out of the image, giving her an excuse to engage a substitute.

But there are many perhapses. Another has to do with how artists locate themselves in a universe of discourse. Some of the criticism of Sherman that has come from feminists who, unlike Mulvey or Solomon-Godeau, see her not as deconstructing the eroticized fetish but as merely reinstalling it—"Her images are successful partly because they do not threaten phallocracy, they reiterate and confirm it"[60]—has focused on Sherman's silence. By calling every one of her works *Untitled,* they argue, Sherman has taken refuge in a stolid muteness, refusing to speak out on the subject of her art's relation to the issues of domination and submission that are central to feminism. Avoiding interviews as well, it is maintained, Sherman further refuses to take responsibility for the interpretation of her work.

The idea that an artist has a responsibility to come forward with an explicit reading of her or his work seems just as peculiar as the idea that the only way to produce such a reading—should the visual artist wish to

do so—would be through words. It is far more usual for artists to construct the interpretive frames within which they are producing and understanding their work by situating themselves in relation to what the critic Mikhail Bakhtin called a discursive horizon. Which is to say that the work an artist makes inevitably enters a field that is structured by other works and their interpretation: the artist can reinforce the dominant interpretation—as when, say, Morris Louis acknowledged the understanding of Pollock's drip paintings as "optical mirages" by painting his own series of *Veils;* or the artist can resist, and by implication, critique that interpretation—which was the case of Warhol and Morris when they transgressed the optical, modernist reading and, as we saw, produced their own in the form of the horizontalized, urinary trace on the one hand and "antiform" on the other.

Now the same discursive horizon that is encircling Sherman's work, demanding that it either acknowledge or disconfirm its commitments to feminism, has also held up for criticism, much of it virulent, the work of another artist whose major support is the photographic image. This artist is Hans Bellmer, who spent the years 1934–49, that is, from the rise of the Nazi Party through World War II, in Germany making work to which he gave the series title *La Poupée.* Photographs of dolls that he assembled out of dismountable parts, placing the newly configured body fragments in various situations, mainly domestic, in an early version of installation art, and then disassembling them to start anew, Bellmer's work has been accused of endlessly staging scenes of rape and of violence on the bodies of women.

It thus would seem, within the present discursive horizon, that the act of choosing to make one's art by means of photographing suggestively positioned dolls is, itself, a decision that speaks volumes. Sherman can continue to call these works *Untitled* but they nevertheless produce their own reading through a connection to the *Poupées* of Bellmer.

And this is to say that among other things, they are a statement of what it means to refuse to an artist the work that he or she has done—which is always work on the signifier—and to rush headlong for the signified, the content, the constructed meaning, which one then proceeds to consume as myth. Bellmer's signifiers are—among other things—doll parts. They are not real bodies and they are not even whole bodies. And these signifiers are operated in a way that allows them to slide along the signifying chain, creating the kind of slippage that is meant, precisely, to blur their meaning, rather than to reify it, or better, to create meaning itself as blurred.

35 *Untitled #253,* 1992
color photograph
75 × 50 inches

Nowhere is this more evident than in an image of four legs attached to a swivel joint that radiate outward along a hay-strewn ground. Unmistakably swastika-like in their configuration, these legs present the viewer with a representation that constructs the Nazi emblem in relation to the scenario of the part-object, in which the body is experienced as being threatened and invaded by dismembering objects. As has been pointed out by Hal Foster in his reading of Bellmer's project, the fascist subject's embrace of the perfect body of the trained soldier and of a hardened neoclassicism has itself been read as a defense against its own sense of menace. That fear of invasion—by a group of others who threaten its borders both geographically (Jews, homosexuals, gypsies, Bolsheviks) and psychically (the unconscious, sexuality, the "feminine")—has been seen in its turn as a projection of a fantasized bodily chaos, the result of a ruined ego construction, a chaos against which the fascist subject armors himself, seeking a defense by means "of the human body."[61]

Seeing Bellmer's project as one that submits itself to sadomasochistic fantasies in order to explore the convulsive tension between binding and shattering and thus to assume a complicity with the fascist subject "only to expose it most effectively," Foster writes: "For in the *poupées* this fear of the destructive and the defusive is made manifest and reflexive, as is the attempt to overcome it in violence against the feminine other—that is a scandal but also a lesson of the dolls."[62]

Bellmer, himself the son of a hated authoritarian father who was indeed a Party member and against whom the *Poupées* can be seen to stage their most flagrant transgression, had written, "If the origin of my work is scandalous, it is because, for me, the world is a scandal." The failure to observe the configuration of the swastika as the ground of reflexiveness from which Bellmer can strike against the father's armor is a failure that allows the semantic naiveté of a description of the work's signified as: a victim of rape.

Just as I would like to think of Sherman in a dialogue with Crimp in the production of *Untitled Film Still #36,* I imagine her reflecting on Foster's argument in the course of producing *Untitled #263* (1992) (fig. 36). This is certainly not because I picture her sitting around and reading works of criticism. It is rather because she fully inhabits a discursive space vectored by, among other things, her friends. So that many voices circulate within this space, the supports of many arguments and theories, among them those of Hal Foster.

36 *Untitled #263,* 1992
color photograph
40 × 60 inches

But the coherence of Sherman's work, something that comes out in retrospect as each succeeding series seems to double back and comment on the earliest ones, will probably do as much as anything to interpret these images and resolve these "perhapses." Laura Mulvey comments on this effect of Sherman's retrojective meaning: "The visitor [of a Sherman retrospective exhibition] who reaches the final images and then returns, reversing the order, finds that with the hindsight of what was to come, the early images are transformed."[63]

Thus even as this text is going to press,[64] Sherman is undoubtedly making new work. And in that series, or perhaps the next one, we will encounter signifiers that will cut across the discursive horizon and the plane of the image to reinforce and thus to clarify what is even now going on under the hood.

Notes

1. Lisbet Nilson, "Q & A: Cindy Sherman," *American Photographer* (September 1983), p. 77.
2. Richard Rhodes, "Cindy Sherman's 'Film Stills,'" *Parachute* (September 1982), p. 92.

3. Roland Barthes, *Mythologies,* trans. Annette Lavers (New York: Hill and Wang, 1972), pp. 109–159.

4. Ibid., p. 125.

5. Rosalind Coward and John Elis, *Language and Materialism* (London: Routledge and Kegan Paul, 1977), pp. 43–44, 47.

6. In invoking the metaphor of the used car salesman and the buyer who does or doesn't look under the hood, I am perhaps implying that the myth's manipulation of signifiers and signifieds is somehow concealed. But it is important to emphasize that it is wholly visible, out in the open. As Barthes says, "This is why myth is experienced as innocent speech: not because its intentions are hidden—if they were hidden, they could not be efficacious—but because they are naturalized" (Roland Barthes, *Mythologies,* p. 131).

7. Another similar series—not sequential in a narrative sense but simply grouped around the same costume—is comprised of *Stills #17–20.*

8. Judith Williamson, "Images of 'Woman'—the Photographs of Cindy Sherman" (1983), reprinted in this volume as "A Piece of the Action: Images of 'Woman' in the Photography of Cindy Sherman." She quotes Jean-Louis Baudry, "The Mask," *Afterimage* 5 (Spring 1974), p. 27.

9. Lisa Phillips, "Cindy Sherman's Cindy Shermans," in *Cindy Sherman* (New York: Whitney Museum of American Art, 1987), p. 14.

10. Roland Barthes, *S/Z,* trans. Richard Howard (New York: Hill and Wang, 1974): "What gives the illusion that the sum is supplemented by a precious remainder (something like *individuality,* in that, qualitative and ineffable, it may escape the vulgar bookkeeping of compositional characters) is the Proper Name, the difference completed by what is *proper* to it. The proper name enables the person to exist outside the semes, whose sum nonetheless constitutes it entirely" (p. 191).

11. Peter Schjeldahl, "The Oracle of Images," in *Cindy Sherman* (New York: Whitney Museum of American Art, 1987), p. 8.

12. Arthur Danto, *Untitled Film Stills: Cindy Sherman* (New York: Rizzoli, 1990), p. 14.

13. Laura Mulvey, "A Phantasmagoria of the Female Body: The Work of Cindy Sherman" (1991), reprinted in this volume as "Cosmetics and Abjection: Cindy Sherman 1977–87," p. 65. [Please note slight changes to this passage in Mulvey's 1996 version of the essay. —Ed.]

14. Abigail Solomon-Godeau, "Suitable for Framing: The Critical Recasting of Cindy Sherman" (1991), reprinted in this volume, p. 55.

15. Danto, *Untitled Film Stills,* p. 14.

16. Solomon-Godeau, "Suitable for Framing," p. 57.

17. Mulvey, "Cosmetics and Abjection," p. 67.

18. Laura Mulvey, "Visual Pleasure and Narrative Cinema," *Screen* 13 (Autumn 1975), pp. 6–18; republished in Laura Mulvey, *Visual and Other Pleasures* (Bloomington: University of Indiana Press, 1989), p. 15.

19. The sequence of texts in which Freud develops this scenario begins with "Infantile Genital Organization of the Libido" (1923), "The Passing of the Oedipus-Complex" (1924), and "Female Sexuality" (1931). In the 1925 essay, "Some Psychological Consequences of the Anatomical Differences between the Sexes," the scenario takes a different form; it stresses the sense in which meaning does not arise in the presence of the visual field but is only retrojected on it as a result of a verbal prohibition: "When a little boy first catches

sight of a girl's genital region, he begins by showing irresolution and lack of interest; he sees nothing or disowns what he has seen . . . It is not until later, when some threat of castration has obtained a hold upon him, that the observation becomes important to him: if he then recollects or repeats it, it arouses a terrible storm of emotion in him and forces him to believe in the reality of the threat."

20. In their introductory essays, Juliet Mitchell and Jacqueline Rose present the development from the scenic event described by Freud to its subsequent semiological elaboration by Lacan. See Mitchell and Rose, eds., *Feminine Sexuality: Jacques Lacan and the Ecole Freudienne* (New York: Norton, 1982).

21. Mulvey, "Visual Pleasure," p. 14.

22. Stephen Heath, "Difference," *Screen* 19 (Autumn 1978), p. 89.

23. Mulvey, "Cosmetics and Abjection," p. 68.

24. *Pictures* was the title of an exhibition organized in the fall of 1977 by Douglas Crimp for Artists Space, New York, which focused on work structured around the issue of replication, work that thereby could bring notions of representation into question. The five artists included Troy Brauntuch, Jack Goldstein, Sherrie Levine, Robert Longo, and Philip Smith. Crimp's connection to these issues continued and led to an essay that enlarged the circle of "pictures" artists to include Cindy Sherman. See Douglas Crimp, "Pictures," *October* 8 (Spring 1979), pp. 75–88.

25. Douglas Crimp, "A Note on Degas's Photographs," *October* 5 (Summer 1978), p. 99.

26. Godard puts this in the mouth of Fritz Lang, in the film *Contempt*.

27. Ken Johnson, "Cindy Sherman and the Anti-Self: An Interpretation of Her Imagery," *Arts* (November 1987), p. 49.

28. Peter Schjeldahl, "Shermanettes," *Art in America* (March 1982), p. 110.

29. Mulvey, "Cosmetics and Abjection," pp. 70–71. [Please note slight changes to this passage in Mulvey's 1996 version of the essay. —Ed.]

30. Jacques Lacan, *Ecrits,* trans. Alan Sheridan (New York: Norton, 1977), p. 290. Translation modified.

31. Ibid., p. 285.

32. These Lacanian "mathemes" appear in *Encore,* Lacan's 1972 seminar, and are published in *Feminine Sexuality: Jacques Lacan and the Ecole Freudienne,* p. 149. Here the mathemes for the female subject are also given: $\overline{\exists x}\,\overline{\Phi x}$ (there is no x that is not submitted to the phallus); and $\overline{\forall x}\,\Phi x$ (not all x are submitted to the phallus.) As Stephen Melville points out, it is from this matheme, which says the "same" thing as the mathemes for the male subject (there is an x that is not submitted to the phallus), but does so indirectly, without the same existential insistence, that Lacan derives the definition of the woman as "not-all": *pas-tout* (see n. 33 below, p. 355).

33. Stephen Melville, "Psychoanalysis and the Place of *Jouissance,*" *Critical Inquiry* 13 (Winter 1987), p. 353.

34. Freud's discussions of man's assumption of an erect posture as the first step toward culture and as making possible a sublimated visuality are in "Civilization and Its Discontents" (1930), *Standard Edition* 21, pp. 99–100; and "Three Essays on the Theory of Sexuality" (1905), *Standard Edition* 7, pp. 156–157. The Gestalt psychological interpretation of the upright posture is from Erwin Straus, "Born to See, Bound to Behold: Reflections on the Function of Upright Posture in the Aesthetic Attitude," in Stuart Spicker, ed., *The Philosophy of the Body* (New York: Quadrangle, 1970), pp. 334–359.

35. For the argument about Warhol's and Morris's reading of the horizontality of Pollock's mark, see my *The Optical Unconscious* (Cambridge: MIT Press, 1993); for the discussion of Ruscha's *Liquid Words,* see Yve-Alain Bois, "Thermometers Should Last Forever," in *Edward Ruscha: Romance with Liquids* (New York: Rizzoli, 1993). Both these readings are carried further in Yve-Alain Bois and Rosalind E. Krauss, *Formless: A User's Guide* (Cambridge: MIT Press, 1997).

36. The logic elaborated, for example, by Stephen Heath, slides from the phallus as signifier—as thus a wholly differential, nonpositive diacritical mark—to the phallus as form, which is to say gestalt or image. Heath marks this by replacing references to the phallus with the composite "penis-phallus," all the while acknowledging the problems this gives rise to. See Heath, "Difference," pp. 55, 66, 83, 91.

37. Jacques Lacan, *The Four Fundamental Concepts of Psychoanalysis,* trans. Alan Sheridan (New York: Norton, 1978), p. 96.

38. Mulvey, "Cosmetics and Abjection," pp. 71–72.

39. Victor Burgin, "Photography, Fantasy, Function," in *Thinking Photography* (London: Macmillan, 1982), pp. 189–90.

40. In two instances of the publication of this work, different "interpretations" of its meaning are registered by means of the different ways the image has been printed. In *Cindy Sherman* (Munich: Schirmer/Mosel, 1987) the work's darkness and obscurity is respected; whereas in the Whitney Museum's catalogue for Sherman's retrospective, the image has been more highly exposed to force its values upward and thus to reduce its uncanny effect.

41. Lacan, *Four Fundamental Concepts,* p. 94.

42. See Roger Caillois, "Mimicry and Legendary Psychasthenia," *October* 31 (Winter 1984), pp. 17-32.

43. Lacan, *Four Fundamental Concepts,* p. 99.

44. Ibid., p. 96.

45. Lacan, *Four Fundamental Concepts,* p. 99. Joan Copjec's essay, "The Orthopsychic Subject: Film Theory and the Reception of Lacan" is an extremely important analysis of the distinction between film theory's "male gaze" and Lacan's *gaze as objet a.* Her understanding of this point in Lacan's argument diverges from mine, however, since she interprets the "itself" not as the subjectivity of the mimetic entity but as a kind of in-itself that might lie behind the picture and which Lacan is, of course, refusing. But Lacan's use of *lui-même* rather than, for example, *en-soi,* makes her reading difficult. See Joan Copjec, "The Orthopsychic Subject," *October* 49 (Summer 1989), pp. 69-70.

46. Lacan, *Four Fundamental Concepts,* p. 97.

47. That this function of the unlocatable gaze already conditions the subject's visual dimensions in the same pattern of splitting, with the Imaginary already prefiguring the Symbolic, is articulated as follows: "Here too, we should not be too hasty in introducing some kind of intersubjectivity. Whenever we are dealing with imitation, we should be very careful not to think too quickly of the other who is being imitated. To imitate is no doubt to reproduce an image. But at bottom, it is, for the subject, to be inserted in a function whose exercise grasps it" (Lacan, *Four Fundamental Concepts,* p. 100). Jacqueline Rose addresses this visual, Imaginary prefiguration of the Symbolic, stressing its beginning in the rivalrous, aggressive aspects of Lacan's description of the mirror stage; see Rose, *Sexuality in the Field of Vision* (London: Verso, 1986), pp. 180–181, 188, 192–194.

48. Sigmund Freud, *Leonardo da Vinci and a Memory of His Childhood,* trans. Alan Tyson (New York: Norton, 1964), pp. 30–31.

49. Sigmund Freud, *Three Essays on the Theory of Sexuality,* trans. James Strachey (New York: Harper Torchbooks, 1962), pp. 22, 44.

50. Mulvey, "Cosmetics and Abjection," p. 82. [Please note slight changes to this passage in Mulvey's 1996 version of the essay. —Ed.]

51. Ibid., p. 76.

52. Ibid., p. 72, 74, 79.

53. Ibid., p. 79. [Please note that the portion of text appearing after the ellipses appears in Mulvey's 1991 version of the essay but not in the 1996 version. —Ed.]

54. Jacques Derrida, "The Purveyor of Truth," *Yale French Studies* 49 (1975), p. 38.

55. Ibid., p. 44.

56. Ibid., p. 60.

57. Ibid., p. 84.

58. Paul Taylor, "Cindy Sherman," *Flash Art* (October 1985), p. 79.

59. Lisbet Nilson, "Q & A: Cindy Sherman," p. 77.

60. Mira Schor, "From Liberation to Lack," *Heresies* 24 (1989), p. 17.

61. Hal Foster, "Armor Fou," *October* 56 (Spring 1991), p. 86.

62. Ibid., p. 96.

63. Mulvey, "Cosmetics and Abjection," p. 67.

64. [Krauss's essay went to press in early 1993.—Ed.]

How to Face the Gaze

Kaja Silverman

Ever since the publication of Guy Debord's *The Society of the Spectacle,* it has been fashionable to claim that we are more dependent on the image than were the subjects of previous historical periods. "Everything that was directly lived has moved away into a representation," asserts Debord, at one of the many points in his text where he imputes to our predecessors an existential immediacy which we ourselves lack.[1] But there has, in fact, never been a period in which people's access to identity and the world was not mediated by representation. Lacan speaks as much for our medieval or Renaissance counterparts as for us when he remarks, "We are beings who are looked at, in the spectacle of the world."[2] And ever since the inception of cave drawing, it has been via images that we see and are seen. What distinguishes us from earlier generations is not our preoccupation with the visual, but rather our imputation of it to the camera.

Vilem Flusser reiterates Debord's lament about the disappearance of the referent into representation in his provocative book *Towards a Philosophy of Photography.* However, centrally informing this lament is the assumption that the images which intervene between us and the world are primarily photographic in nature—that when we look at something, it is through an imaginary viewfinder. This viewfinder also organizes what we see in relation to the range and formal logic of culturally available photographic representations—to the "program" of the "black box."[3] "Images are meant to render the world accessible and imaginable to man," writes Flusser,

But, even as they do so, they interpose themselves between man and the world. They are meant to be maps, and they become screens.

Instead of presenting the world to man, they re-present it, put themselves in place of the world, to the extent that man lives as a function of the images he has produced. He no longer deciphers them, but projects them back into the world "out there" without having deciphered them. The world becomes image-like.[4]

Not only does this imaginary camera lens intervene between our look and the world, structuring what we see in photographic terms; we also experience ourselves-as-spectacle in relation to it. As Susan Sontag observes, "We learn to see ourselves photographically: to regard oneself as attractive is, precisely, to judge that one would look good in a photograph."[5] When we become conscious of our emplacement within the field of vision, it is in the guise of a photograph. It is also when a real camera is trained upon us that we have our most acute awareness of being seen.

Roland Barthes is perhaps the greatest theorist of this particular variant of the experience of "being seen." For him, it entails, first of all, the "advent" of oneself as "other."[6] One apprehends oneself as emerging—or being made to emerge—as image. This is true of other forms of representational "capture" as well, but because a photograph is related to what it depicts both iconically and indexically, it is harder to distinguish from its referent. There is also something "mortifying" about the experience of being photographed by a real or metaphoric camera. This mortification involves not only that death which is the "*eidos* of [the] Photograph"[7]— an abduction from the realm of the vital into that of the image—but also the congealing of the body into a statue-like rigidity. Barthes literalizes this second meaning of mortification—immobilization, arrestation— through an example drawn from early photography:

> Photography transformed subject into object, and even, one might say, into a museum object: in order to take the first portraits . . . the subject had to assume long poses under a glass roof in bright sunlight; to become an object made one suffer as much as a surgical operation; then a device was invented, a kind of prosthesis invisible to the lens, which supported and maintained the body in its passage to immobility: this headrest was the pedestal of the statue I would become, the corset of my imaginary essence.[8]

Since Barthes is speaking here not so much about the camera in general as about the still camera in particular, the metaphoric applicability of this passage to the gaze might seem limited. However, the still camera pro-

vides a more central metaphor for conceptualizing the gaze than does the film or video camera, particularly when it comes to constituting the subject-as-spectacle. The mobility of the moving image situates it symbolically on the side of vitality and movement, and those values make a film or a video camera a less appropriate signifier for the gaze, which in Lacan's account signifies death and immobilization. "The gaze in itself not only terminates the movement, it freezes it," he remarks in Seminar XI, "it is that which has the effect of arresting movement and, literally, of killing life. At the moment the subject stops, suspending his gesture, he is mortified. This anti-life, anti-movement function of this terminal point is the *fascinum,* and it is precisely one of the dimensions in which the power of the gaze is exercised directly."[9]

The still photograph also dramatizes more strikingly than the moving image both the advent of specular existence as the loss of flux and vitality, and that necessarily suspended state in which any body aspires to formal coherence. Movement disrupts the latter's "composition," in every sense of the word. It is synonymous with dehiscence, with a kind of unraveling of the *Gestalt.* And in moving, the cinematic or video image not only undoes coherence, but also induces a certain amnesia. Because—as Christian Metz points out—we see a new image only at the cost of a certain "forgetting" of the one which preceded it,[10] there is also no longevity to the image itself. It is perhaps for this reason that we can remember a film better visually through the poster which represents it in the theater lobby than through any of its actual images, and that the video industry has felt impelled for memorial purposes to offer a machine for creating still images out of the flow of images constituting a home video. The still photograph, on the other hand, can provide us with a stable and durable image of ourselves. Finally, whereas the all-important relation in cinema is the one linking each image to the next, the all-important relation in still photography is that tying the image to the object it depicts.[11] The latter consequently encroaches much more emphatically than the former upon the referent.

Mortification also has a third meaning—this time one less keyed to the properties of the still camera. We fantasize when our picture is being taken that our sublation from life to the death of representation will at least preserve us—capture and immortalize our "essence." However, we undergo over and over again the mortifying experience of being apprehended in ways which have nothing to do with any such essence or inner "truth," but are—rather—an effect of the screen. Only love, Barthes observes, can erase the often terrible meaning which the camera/gaze inscribes onto the frozen body.[12]

At the same time that the actual or imaginary photographic transaction kills, it also confers "reality" upon what it captures. As Sontag puts it, people in "industrialized countries"—people, that is, for whom the gaze is primarily figured as a camera—"seek to have their photographs taken" because they believe that they are "made real by photographs."[13] This is true not only because it transforms them into a psychically assimilable and affirmable image, but also because the clicking of the actual or metaphoric camera signifies that social "acknowledgement" or "recognition" upon which all subjectivity depends. The camera simultaneously kills and affirms; it lifts the object out of life and into representation, and psychically and socially actualizes it. It would thus seem that what we generally think of as "reality" is on the side of "death" rather than "life," representation rather than being.

Pierre Bourdieu encourages us to extend this argument beyond the individual subject to the institution of the family. In "The Cult of Unity and Cultivated Differences," he maintains that the family exists as such largely in and through the group photograph and photograph album, which confer upon it an actuality and a coherence which it would otherwise lack. Because of the social and psychic importance of the family, photographers—whether amateur or professional—devote themselves to this subject more than to any other. "Photographic practice only exists and subsists for most of the time by virtue of its *family function* or rather by the function conferred upon it by the family group," Bourdieu writes, "namely that of solemnizing and immortalizing the high points of family life, in short, of reinforcing the integration of the family group by [reasserting] the sense that it has both of itself and its unity."[14]

Flusser suggests at one point that "events" also depend upon the camera for their actuality, and that they have such a hyper-developed consciousness of their dependence upon the camera that they actually solicit its attention.[15] Siegfried Kracauer offers a more extreme version of the same argument. He maintains that "the world itself has taken on a 'photographic face,'" and that "it can be photographed because it strives to be completely reducible to the spatial continuum that yields to snapshots."[16] And Robert Smithson describes arriving at a location he planned to shoot, and finding that it was already a photograph. "Noonday sunshine cinematized the site," he writes,

> turning the bridge and the river into an over-exposed *picture*. Photographing it with my Instamatic 400 was like photographing a pho-

tograph. The sun became a monstrous light-bulb that projected a detailed series of "stills" through my Instamatic into my eye. When I walked on the bridge, it was as though I was walking on an enormous photograph that was made of wood and steel, underneath the river existed as an enormous movie film that showed nothing but a continuous blank.[17]

The passages I have just quoted attest more to the thoroughness with which the photographic defines our contemporary field of vision than to some kind of intentionality inherent in objects and events.[18] I have included them here because they are displacements onto the non-human domain of a phenomenon which is a central feature of human subjectivity. Flusser's account of events, Kracauer's of the world, and Smithson's of a landscape make these three entities responsible for representing something which is familiar to all of us from the literal photo session, and which is also a feature of our everyday experience of the gaze: the anticipatory congealing of the body confronted with a real or metaphoric camera into the form of what might be called a "pre-photographic photograph." They resituate onto a non-human category some of the gestures by which the subject offers him or herself to the gaze already in the guise of a particular "picture."

Lacan's primary metaphor for the representations which determine how human beings see and are seen is the screen. In the passage in which he states this most clearly, he also invokes the camera, and it was this invocation that first alerted me to the photographic nature of the field of vision. "What determines me, at the most profound level, in the visible, is the gaze that is outside," Lacan writes there, "It is through the gaze that I enter light and it is from the gaze that I receive its effects. Hence it comes about that the gaze is the instrument through which light is embodied and through which . . . I am *photo-graphed*."[19] In the diagrams which he attaches to this passage, he situates the screen at a distance from the human bodies that it defines, suggesting that they are two separate things. This distance is the precondition for a claim he will subsequently make: the claim that unlike other beings, we are able to "play" with the images through which we are seen.

However, in a discussion of mimicry with the natural domain, Lacan comes up with a very different metaphor. Drawing upon Roger Caillois's important deconstruction of the notion that natural selection precipitates all natural mutations,[20] he discusses the behavior of certain species of

insects, which adopt the shape or color of other natural objects. The example which interests him most is the crustacean called "caprella," which lives among the "quasi-plant animal" known as briozaires. In those surroundings, the caprella imitates the briozaires's intestinal loop, which assumes a stain-like shape. Like Caillois, Lacan quickly dispenses with the notion that this disguise serves a merely protective function by pointing out that it fails to deceive predators. The caprella assumes the disguise, he maintains, so as to become part of a particular "picture": "[The caprella] becomes a stain, it becomes a picture, it is inscribed in the picture. This, strictly speaking, is the origin of mimicry. And, on this basis, the fundamental dimensions of the inscription of the subject in the picture appear infinitely more justified than a more hesitant guess might suggest at first sight."[21]

Significantly, Caillois himself refers to this stain mimicry as "a reproduction in three-dimensional space with solids and voids: sculpture-photography or better *teleplasty*."[22] Although Lacan makes no reference to this striking metaphor, it is crucial to establishing the analogical link between the *caprella,* and the subject who occupies our contemporary field of vision. Like that crustacean, this subject does not always wait passively and unconsciously for the gaze to "photograph" him or her in the shape of a preexisting image. On the contrary, he or she may give him or herself to be apprehended by the gaze in a certain way, by assuming the shape either of a desired representation or of one that has come through less happy circumstances to mark the physical body. When this happens, the subject does not simply hold up the imaginary photograph in front of him or her, but approximates or attempts to approximate its form. His or her flesh and muscles congeal into a photographic representation, a representation that can also implicate the postural schema and indeed the whole of what Henri Wallon calls "proprioceptivity."[23]

Lacan also generates a number of other spatially suggestive metaphors for conceptualizing the relation of subject to image: "envelope," "double," "mask," and "thrown-off skin." "Envelope" suggests that the real or imaginary photograph may enclose the subject, contain him or her either protectively or entrappingly. "Double" points to an identification which is the opposite of the stain: here, rather than assimilating the image proprioceptively, the subject identifies with it at a distance-from-the-self, heteropathically.[24] "Mask" implies self-concealment behind something that is worn, but not psychically assumed. Finally, the notion of the image as a "thrown-off skin" connotes an excretion of the image, a refusal to "wear"

the "photograph" through which one has been ratified as subject. This image of bodily dismemberment is evocative of some of the ways in which Frantz Fanon speaks about his rejection of the screen of "blackness."[25] A moment after introducing this metaphor, Lacan puts it to other interesting uses: the thrown-off skin can be deployed defensively to cover a shield. It can, that is, not only be abjected, but also used as a protective device.

But what precisely does it mean for Smithson to speak of a particular landscape as having assumed the attributes of a photograph before he had even trained his camera on it? More to the immediate point, what does it mean for a subject to invite the camera/gaze to apprehend him or her in a pre-given form? Through what mechanisms or strategies does the subject offer him or herself as a "photograph"?

The Pose

It is first and foremost through the pose that we offer ourselves to a real or metaphoric camera. Much has been written in recent years on the topic of the pose, but only Craig Owens has fully grasped its essentially photographic nature—the fact that, in addition to being imitative of a preexisting image or visual trope, it is imitative of photography itself. "What do I do when I pose for a photograph?" Owens asks: "I freeze . . . as if anticipating the still I am about to become; mimicking its opacity, its stillness; inscribing, across the surface of my body, photography's 'mortification' of the flesh."[26] As Owens suggests, the pose not only arrests the body, hyperbolizing the devitalizing effects of all photographic representation, it also approximates precisely that three-dimensional photography which Caillois associates with mimicry, assimilating proprioceptivity to exteroceptivity, corporeality to the image.

Like the stain, the pose puts the subject who assumes it "in the picture." In the caprella example, this picture preexists the act of stain-like mimicry. However, it need not, because the pose itself can create it. Its representational force extends outward, transforming the space around the body and everything which comes into contact with it into an imaginary photograph. Indeed, the pose includes in itself every other feature of the photographic image which is relevant within the domain of subjectivity. It summons, to begin with, that explicit or implicit frame which marks off all representation from the "real." We may not always know precisely where the frame resides. However, lest we doubt for a moment that it is always there, we need only remember that the body has the capacity to

designate it in a very precise and inexorable way. Simply through dramatic compression or expansion, the body can indicate its enclosure within a smaller or larger-than-usual physical space.[27]

The pose is also generative of mise-en-scène. By positioning a representationally inflected body within space, it converts that space into a "place." This is as true when this body occupies an empty room as when it is positioned within a set as elaborate and cluttered as those found in a Sternberg film. The pose also includes within itself the category of "costume," since it is something "worn" or "assumed" by the body, which, in turn, transforms other worn or assumed things into costumes. When included in the pose, even a sensible winter coat ceases to be a source of protection against the cold, and becomes part of the larger "display."

Finally, the pose signifies "lit-upness" in a larger, metaphoric sense, and encourages us to make formal and conceptual sense of the actual play of light and shadows across the other components of the imaginary photograph. An oblique shadow cast across half of the face of a posed body is no longer random or insignificant; it becomes part of the "picture," and often connotes a photographic source of illumination, as in the Smithson passage, where the sun becomes a "monstrous light-bulb." Although the pose is the most photographically resonant of all of the elements I have just listed, framing, mise-en-scène, costume, and lighting can also be deployed in ways that deepen the photographic qualities of a particular corporeal display. They can also motivate the production of a very different "picture" than that solicited by the pose. They must thus be identified not merely as extensions of the pose, but also as cocontributors to the photographic effect.

It is generally assumed that the pose is something deliberate and active. For instance, it is primarily through his account of mimicry, which represents the theoretical category to which we must subsume the pose, that Lacan factors agency into the field of vision. In *The Four Fundamental Concepts,* he suggests that simple reproduction is the only possible relation of the animal to the image it imitates, but that in the human domain there is another option. "The human subject . . . is not, unlike the animal, entirely caught up in this imaginary capture," he writes, "He maps himself in it. How? In so far as he isolates the function of the screen and plays with it. Man, in effect, knows how to play with the mask as that beyond which there is the gaze."[28] Barthes advances a similar argument. In *Camera Lucida:* "I constitute myself in the process of 'posing,' I instantaneously make another body for myself, I transform myself in advance into an image. This transformation is an active one."[29]

However, even Barthes acknowledges almost immediately that this transformation often has little bearing upon how he is apprehended by the camera/gaze,[30] so that his activity might be said to involve action without a corresponding result. And Bourdieu underscores the unconscious compliance with photographic stereotype which often overdetermines even the most conscious and willfully assumed pose. He also suggests that the specularized subject has at best only the barest modicum of control over how he or she is apprehended by the camera/gaze:

It is always as if, by means of obeying the principle of frontality and adopting the most conventional posture, one were seeking as far as possible to control an objectification of one's own image. Axial composition, in accordance with the principle of frontality, provides an impression that is as clearly legible as possible, as if one were seeking to avoid any misunderstanding. Looking at the person who is looking (or who is taking the photograph), correcting one's posture, one presents oneself to be looked at as one seeks to be looked at.[31]

How are we to reconcile these two very different accounts of what it means to offer oneself as a preexisting photograph to the camera/gaze? By way of answering this question, I will suggest that the agency which Lacan imputes to mimicry—and so, by extension, to the pose—is hemmed about with all kinds of constraints. It consequently does not always come into play, even in a limited way. To assume, in advance, the shape of a particular photograph represents at most an attempt to exercise some control over an unavoidable transaction; it is behavior in which the subject engages at the behest of the camera/gaze, and in response to the impossibility of avoiding specularity. Mimicry also proceeds in relation to a preexisting— and recognizable—image. It is thus limited to what is at a given moment representationally "possible." When we engage in mimicry, we are consequently "inserted in a function whose exercise grasps us."[32]

We also cannot simply choose, from a kind of wardrobe of possible "photographs," what we will "wear" on Monday as opposed to Wednesday; we must also be so apprehended. And not only do our attempts to be seen in a particular way often end in failure, but corporeal details can also be turned into the justification for a dramatically other "photographic" transaction. The other inherently photographic elements which come into play when a body poses—frame, mise-en-scène, costume, lighting— also do not always conspire with it to form the desired "picture"; they, too, can provoke a very different one. Most subjects understand this at least

partially, and attempt to exercise some control over the other features of the "photograph" they offer to the camera/gaze. However, economic and other constraints often drastically limit the success of such attempts. For all of these reasons, the clicking of the imaginary camera often does not produce the desired image.

Mimicry also does not always imply a resistant or even a conscious intentionality. A subject can be coerced into assuming a particular pose through the repeated projection of unflattering images onto his or her body. The pose can also be the corporeal manifestation of an unconscious identification with a cultural ideal. And when a subject identifies with an ideal image, and has that identification symbolically ratified, he or she is not likely to begin questioning the authority of visual normativity. Consequently, instead of augmenting one's agency, success in this domain may actually lead to a further reduction.

In *Camera Lucida,* Barthes provides a humorous description both of his desire to be photographed in the guise of a culturally valorized image and of the refusal on the part of the camera to accommodate this wish. "If only I could 'come out' on paper as on a classical canvas," he writes, "endowed with a noble expression—thoughtful, intelligent, etc.! In short, if I could be 'painted' (by Titian) or drawn (by Clouet)!" Instead, the resulting image is "heavy, motionless, stubborn."[33] The poses adopted by many of the women in Cindy Sherman's *Untitled Film Stills* attest to the same unfulfilled ambition and provoke a similar amusement. As we will see, though, they also open onto a new kind of visual pleasure.

The Untitled Film Stills

The title of the *Untitled Film Stills* suggests that the photographs in it are about the arrest of movement—the freezing of the flow of film into a single frame. It also encourages us to conceptualize this immobilization in ways that are primarily cinematic. However, because of the central place they give to the pose, the images in this series make the film still a metaphor for the immobilization effected by the photograph. The *Untitled Film Stills* are also concerned with the three-dimensional photography that Caillois calls "mimicry." As Arthur Danto suggests, they reverse our usual ways of thinking about the photograph, since instead of treating the photograph as a reference to the world, they treat the world as a reference to the photograph: "The camera . . . does not now simply document the pose, the pose itself draws on the language of the still in such a way that

even if it were never photographically recorded, the pose would be the photographic equivalent of a *tableau vivant*. Since the scene and the actors who compose the still do so for the sake of the still, the camera is internal to the work."[34]

In each of the *Untitled Film Stills,* a solitary white woman played by Sherman herself strikes a pose against a background which is either an extension of that pose, a contradiction of it, or something to which the pose lays claim. The way in which she holds her body indicates her desire to be seen in a particular way by a real or imaginary look, which—because it is more formally than diegetically specified—comes to be symbolic of the camera/gaze. The poses depicted in these images are, as many critics have noted, extremely stereotypical in nature; they evoke normative ideals of one sort or another. However, Sherman's women are seldom "photographed" according to the criteria they have selected; a corporeal or environmental detail usually provokes a very different photographic transaction. A number of the *Untitled Film Stills* also provide a commentary on the other elements of the implicitly photographic image which are imbricated with the pose, and will help us to arrive at a more precise understanding of what such an image involves.

In *Still #2* (fig. 44), a woman turns to look at herself in a bathroom mirror. The rest of her body still points in the other direction, as if she were about to walk out of the bathroom before she turned to look into the mirror. Because of this wracked posture, we see her face only in the reflecting surface: the image which it provides shows her head inclining languorously backward, the forefinger of her right hand just grazing her chin. The mirror image in this photograph clearly represents its protagonist as she wants to be seen: as an embodiment of traditional female beauty. However, the camera/gaze does not cooperate with this wish. It photographs her not from the direction of the mirror, but rather from the other side. And although this position still affords us a view of the woman's framed and idealized self-portrait, it shows that self-portrait to be in striking contrast to the rest of her body. A bit chubby and undefined, the woman's body most definitely does not offer itself to be seen. Not only does her body lack the poised self-consciousness of her stylized head and right hand, but she also attempts to cover it with a large terry-cloth towel, as if to keep it out of the "picture."

Although ostensibly more about a mirror than a photographic transaction, two features of this image make it referential of the camera/gaze. First, as Rosalind Krauss has pointed out, the grain of the image is

37 *Untitled Film Still #3,* 1977
black-and-white photograph
8 × 10 inches

unusually prominent, as if to suggest that photographic objectification of the body upon which I have already repeatedly commented.[35] Second, the frame of the mirror is contained within the larger frame of the doorway, which foregrounds the fact that the image offers a perspective that is outside the dyadic exchange between subject and mirror—a perspective which implies, precisely, the camera/gaze. Together, these two details define the woman's pose more as an appeal to be apprehended in pre-given ways by that apparatus than as a replay of the rapturous accession to ideality of the Lacanian mirror stage.

Whereas *Still #2* proposes certain features of the body itself as counter-indicative of the wished-for "photographic" exchange, *Still #3* (fig. 37) isolates more environmental factors. In this image, a woman stands to the right, facing a sink with a dish rack, a bottle of Ivory dishwashing liquid, an almost-empty juice bottle, and an opened Morton's salt container. She wears a frilly apron and a sexy T-shirt. She looks seductively, with moistened lips, over her left shoulder at an unseen figure, presumably male. Because she leans with her left hand on the counter, her shoulder is provocatively elevated, and her breasts sharply defined. Here,

the woman offers herself to be "photographed" as "vamp," as sexual tease, but the mundane objects in her immediate vicinity contradict this self-definition, and instead proclaim her to be a "*Hausfrau.*"

The upper edge of the still crops the woman's face just above the left eye, cutting off her left eyebrow, forehead, and bangs, foregrounding both the frame, and the perspective from which the image has been shot. It is up to the observant spectator to remark that the point toward which the woman looks is dramatically different than the position from which she is photographed. This disjuncture reminds us, once again, that the camera/gaze does not always apprehend us from the vantage-point to which we direct our self-imaging.

Still #34 (fig. 38) provides yet another example of a woman aspiring to occupy a desired "photograph" through a particular pose. However, it indicates more clearly than *Still #2* or *Still #3* that a body may assume a pose more at the behest of the unconscious than the conscious. This photograph also calls into question the assumption that the pose is unambiguously "active" by pointing to its discursive source. It thereby suggests that mimicry means not only "to be inserted in a function whose exercise grasps" one, but, all too often, a passive compliance to a normative ideal. In it, a dark-haired woman lies on a crumpled black sheet, wearing only a half-unbuttoned shirt and panties. Her head reclines voluptuously, and her body assumes a typical "cheesecake" pose. In front of her lies a pulp novel, of the sort that instigates classically female fantasies. It has been placed face-down, presumably on the pages that inspired the dreamy, far-away look on the woman's face.

The woman clearly seeks to project herself imaginarily into the mise-en-scène suggested by the novel, and her half-conscious pose represents her corporeal claim upon that position. It is as if she would be immediately transported there if she could only succeed in being "photographed" according to the logic of the pose. However, the position adopted by the camera/gaze is once again poorly calculated to satisfy this desire: it shoots the woman from a position closer to her feet than her head, as a result of which the lower half of her body is disproportionately—and unflatteringly—distended in relation to the upper half. Indeed, her head is so small that it seems to belong to a completely other body, an effect which is compounded by the shading of her dark hair into the black sheets on which she lies.

The pose is not the only element of the pro-filmic event "captured" by this still which is inherently photographic. The black sheets showcase the woman's body in a way that connotes "erotic photograph," and are,

38 *Untitled Film Still #34,* 1979
black-and-white photograph
10 × 8 inches

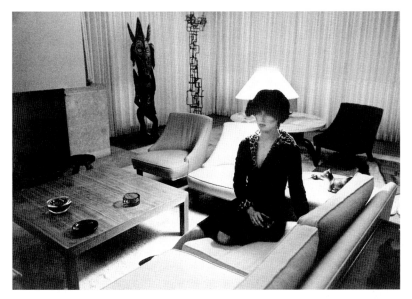

39 *Untitled Film Still #50,* 1979
black-and-white photograph
8 × 10 inches

indeed, an extension of her pose. The edges of the photograph also coincide almost seamlessly with the sides of the bed, as if to suggest that the bed determined in advance the image's frame-lines. The photograph is internal to *Still #34* in yet another way, as well. The half-buttoned shirt worn by the reclining woman is white, which serves to further accentuate the contrast between that pool of brightness which is her body and the shadowy folds of the sheets. Even prior to the installation of the lamp, whose effects make themselves seen on the right side of the frame, and which presumably provided the primary source of illumination for the photograph, the woman in *Still #34* might be said to have been "lit up."

Still #50 (fig. 39) represents another example of a woman posing in self-idealizing ways for an implied camera/gaze. However, it is to be distinguished in this respect from *Still #3,* where the woman seeks to transport herself out of her position in front of the sink and into one more commensurate with her fantasies merely by dint of her pose. Here, through her bodily configuration, the woman attempts to become the rightful occupant of the room she inhabits but to which she does not feel entirely equal. This room is a study in 1960s interior decoration stereotypes;

indeed, it could have been furnished through ideas drawn from magazine illustrations of the time. Both in this respect, and in its exaggerated neatness and the precision with which its contents have been arranged, it is immanently photographic. The room seems almost to solicit the camera/gaze—to say, much like Caillois's caprella, "This is how I want to be seen." It contains Indian rugs, a primitive carving, an abstract sculpture, and a rigorously symmetrical "conversational" grouping of contemporary chairs, couch, and coffee table, placed in front of a minimalist fireplace. The coffee table holds three ashtrays.

The dark-haired woman sits on a couch in a low-cut black dress, trimmed with artificial leopard-skin collar and cuffs. One leg is folded with feigned casualness underneath her, and the other extends gracefully to the floor. However, the woman's upper body is hyperbolically erect, as if she is afraid of making a mistake, and she looks ahead of her with an equally intense attention. The stiffness of her upper body indicates that she is overwhelmingly impressed by the contents and style of the room in which she sits, and that she yearns to be as sophisticated as its owner. The woman holds a cocktail on her lap, again with an attitude of *savoir-faire,* but one has the impression that she is afraid of drinking too much from it, for fear of saying something gauche. However, it is not so much her desire to be adequate to the room which is finally frustrated, as her aspiration to be photographed as the embodiment of sophistication. The first of these wishes is satisfied, albeit in a surprising way, because the room suffers the same fate as the woman. It also tries too hard to be "modern" and "cosmopolitan." Indeed, its three ashtrays might be said to be the non-human equivalent of the woman's rigid torso, making it a very appropriate setting, finally, for its only visible inhabitant.

Not only do the *Untitled Film Stills* reveal the pose to be the primary mechanism through which the subject gives him or herself to be "photographed" by the camera/gaze, they also attest to the pose's reverberative power. A blonde woman in a crumpled apron and cheap housedress stands in the center of *Still #35* (fig. 40), her body facing a black coat hanging on a hook on the wall, but her head looking back toward an unspecified viewer. Her arms are exaggeratedly "akimbo," and her legs robustly spread, as if to suggest that she stands on solid moral ground. Her facial expression is full of righteous indignation. All in all, she is the very image of virtuous and offended womanhood. The corner where the woman stands is shabby. The door which partly frames her is badly scuffed at the bottom, and—

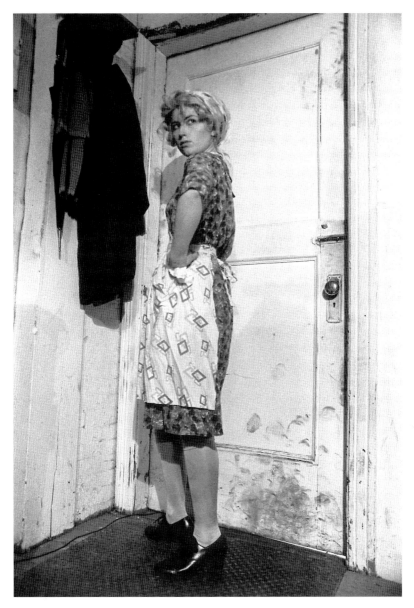

40 *Untitled Film Still #35,* 1979
black-and-white photograph
10 × 8 inches

like the woman's clothing—connotes poverty and neglect. Without the woman in it, these details would go unremarked, but her pose is so expressive that it works to inscribe meaning on everything in the frame. Because of the way she is positioned in front of the coat, we imagine that she has just searched or is about to search its pockets for evidence that its owner has drunk away his week's paycheck, or engaged in some form of sexual malfeasance. As further evidence of the coat owner's brutish character, we "see" that he habitually closes the door by kicking it with his dirty boots.

The woman addresses her pose not so much to this man, who would presumably be incapable of recognizing her suffering or force of character, as to some higher moral authority. Since the point toward which she looks is also the position from which Sherman shot the photograph, the camera/gaze seems at first to embody this authority, and consequently to be uninterested in spectacle. However, it is difficult for a Western eye to look at a photograph of a reasonably young woman without measuring her by the usual standards of feminine beauty, standards which have perhaps as much to do with erotic "self-presentation" as with corporeal features. The insistent centering of this figure in the frame and the slightly lower than usual angle through which we view her also put her "on stage," thereby further specularizing her. In spite of our best intentions, we therefore cannot help but notice that the woman wears clothes which are the very opposite of those in which most of us would seek to be photographed: her stockings "bag" slightly, and her hair is tied into a housewife's kerchief.

These details fade in significance only when the eye strays once again away from the "central exhibit" to the margins, i.e., when we glance for a second time at the scuff marks on the door. These domestic stigmata serve as a powerful reminder of the economic and other circumstances militating against the sublation of certain bodies into an idealizing frame. For the eye which has engaged in this revisionary act of looking it is now also possible to see something which the baggy stockings and rumpled housedress and apron belie: the intelligence, intensity, and even beauty of the face with which the woman looks back over her shoulder.

As I intimated in passing in relation to *Stills #34* and *#50,* the *Untitled Film Stills* also includes a number of images in which not only the woman but the pro-filmic event in its entirety might be said to solicit the camera/gaze, and so help to clarify further the nature of the "photo-

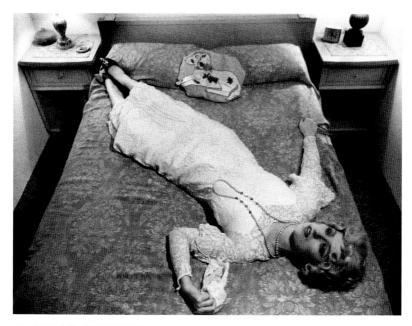

41 *Untitled Film Still #11,* 1978
black-and-white photograph
8 × 10 inches

graphic." *Stills #11* (fig. 41), *#16* (fig. 9), *#37* (fig. 5), and *#43* (fig. 42)
are all striking examples of this. In the first of these photographs, a woman
lies diagonally across a made bed, her head in the lower right-hand cor-
ner, her feet touching the left pillow. She wears a long white lace dress
evocative of the 1930's, a matching coiffure, and a long strand of pearls.
Her right hand clutches the bedspread, in a calculated gesture of despair,
and her raised left hand elevates a lace handkerchief with studied grace.
Her look is a bit out of focus, as if given over more to the mental rather
than the physical act of "seeing," and her expression is just melancholic
enough to be evocative but not disfiguring. She lies at so precise a diago-
nal, and her dress and pearls are so artfully arranged, that one has the im-
pression that the scene has already been carefully rehearsed. "Tragic
Heroine" is the ideal image to which she aspires, and the clock on the
night table conspires with her in articulating this trope: it reads 11:20, the
time of night when one is likely to be alone in one's room in fancy dress
only when the evening has ended badly and (hence) early.

But the carefully controlled conditions under which the woman expresses her grief—her general concern not only to look as attractive as possible while undergoing her "breakdown," but also to offer herself at this precise moment to the camera/gaze—results in a very different photograph than the one the woman solicits, as does the cushion with dog appliqué which rests in the middle of the two pillows. Not only does the woman's body form a precise diagonal across the bed, but the bed is positioned exactly in the exact middle of the room, flanked on either side by identical night tables. And since, through a miracle of precision, the bedroom set fits exactly into the wall space into which it has been inserted, it is framed on either side by a wall, a point which Sherman's camera underscores by matching its own edges to those of the room as a whole.

The light is as hyperbolically internal to *Still #11* as is the frame, since the two lamps resting on the night table provide a lavish source of illumination. Finally, although any item of clothing worn by a body assuming a pose automatically gains the status of a costume, and any hairstyle that of a "coiffure," that is doubly so here, since the woman wears a dress, necklace, and hairstyle which together connote "the thirties," while at the same time occupying a bedroom indicative of the 1950s. Unlike the fashion of the moment, retro always signifies "fancy dress," and—perhaps unavoidably, since that is primarily how we recognize it as such—"photography" and "cinema." "Insincerity" and "artificiality" are the values which come into play over and against the image which the woman offers to the camera/gaze.

In *Still #15*, a dark-haired woman in shorts and a low-cut T-shirt with cinch belt, white socks, and high heels sits in the window of an exposed-brick room. One leg, bent at a right angle, reaches to the floor, while the other rests in a crooked position on the windowsill. The woman's arms are strategically placed to afford the fullest and most idealized view possible of her breasts, waist, thighs, and legs. The three-dimensional photography which might be said to have preceded the actual photographic event sought out its own light and representational frame as well: illumination floods into the image through the uncurtained window before which the woman sits, and the wall surrounding the window encloses all of her body except for her dangling leg in a brick frame.

The woman looks through the window at an unspecified object. But, although she is ostensibly a spectator, she pointedly gives herself to be seen—not by some casual passerby, who would at best glimpse only a distant and partial view of her artfully displayed body, but by an imaginary

gaze *inside the room*. I specify the viewer's location as being inside rather than outside because the woman's pose can only be fully apprehended from there. Surprisingly, Sherman's actual camera assumes that position. This is consequently one of the rare images in the *Untitled Film Stills* where the camera/gaze photographs, as it were, the flattering "photograph." (*Still #32* (fig. 2) is another, where part of the face, neck, shoulders, and arms of a woman swim out of darkness toward the illumination of a single match, with which she is about to light her cigarette. There, however, ideality is so fully an effect of the lighting that it would be dispelled with a single switch of the light.) Only the inappropriate placement of a gold cross between the woman's partly exposed breasts sets up a slight disturbance in the image.

In *Still #37,* a woman stands in front of a rustic brick fireplace, her right arm reclining at a ninety-degree angle on the mantel, with a cigarette in her hand. One leg rests in an elevated position on the hearth, and her left arm hangs at her side. She wears a black sweater, pants, and walking shoes. Above the mantel hangs a stereotypical painting of rocks, mountains, and water, and to its left stands a piece of petrified wood. The photograph is internal to the image because the painting depicts the landscape of the woman's desire—the frame into which she seeks to project herself through the studied "naturalness" of her pose and costume. It is, in fact, doubly so, since the scene is all in all evocative not so much of the natural world as of that highly stylized troping of it familiar to us through a film like Douglas Sirk's *All that Heaven Allows,* with its Thoreau quotes and wood-paneled station wagon.

In *Still #43,* a woman with a '60s style bouffant haircut and cotton sundress sits decoratively on a large, sprawling tree. She gazes dreamily into space. What she "sees" is shown in backdrop through what I take to be an astonishing photographic compilation: the famous vertical rock formations of Monument Valley. This is an imaginary landscape, made famous through the films of John Ford, which the woman has chosen as the scene for an unspecified fantasy, perhaps of the "white woman kidnapped by Indians" variety. Its inclusion here divests the pro-filmic referent of actuality, making the photograph in its entirety more a representation of a representation than a sublation from actuality to art. Both the seeming unself-consciousness of the woman's pose, and her vague look into a fantasmatic "elsewhere" once again call into question the notion that such bodily display always operates at the best of a willed agency, and point to the origin of the pose in a prior textual instance.

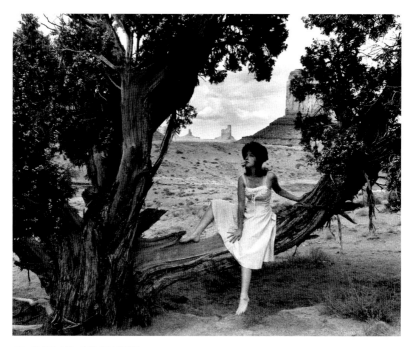

42 *Untitled Film Still #43,* 1979
black-and-white photograph
8 × 10 inches

The "Good Enough"

Many of the readings I have produced of selected *Untitled Film Stills* have involved my isolation of details in those photographs that activate certain almost impossible to avoid meanings, meanings which often collide with a character's desire to be "photographed" in a particular way—details of body, clothing, decor, etc. (Examples of such details include the slight chubbiness of the woman in *Still #2,* the seemingly inappropriate gold cross situated between the breasts of the woman in *Still #15,* the crumpled apron worn by the woman in *Still #35,* and the exaggerated erectness of the woman's posture in *Still #50*). My look has clearly intervened here in idiosyncratic and transformative ways, but most of the pictorial elements to which I have attributed the opening up of an unflattering distance between the actual stills and the photographs Sherman's women solicit would be capable of generating the same meaning within any reader from

the same culture. But this does not mean that this meaning is contained in the images themselves.

As Judith Williamson suggests, the stills themselves are "innocent." It is the viewer "who suppl[ies] the femininity" in question "through social and cultural knowledge."[36] This is because the screen or cultural image-repertoire inhabits each of us, much as language does. When we apprehend another person or an object, we necessarily do so via that large, diverse, but ultimately finite range of representational coordinates which determine what and how the members of our culture see—how they process visual detail, and what meaning they give it. And just as certain words suggest themselves to us more readily than others, because they are the currency of daily use in our society, so certain representational coordinates propose themselves as more appropriate frames through which to apprehend the world than others, simply because they are subject within our society to a more frequent and emphatic articulation. The full range of representational coordinates which are culturally available at a particular moment in time constitute what I have been calling the "screen," and those which propose themselves with a certain inevitability the "given-to-be-seen."[37]

As I have argued elsewhere, the camera/gaze is simultaneously a representational logic and a series of material practices, in complex interaction with each other.[38] In this metaphoric capacity, as in its capacity as illumination, the gaze clearly stands to one side of any human eye. Indeed, in many respects—its mortifying and memorial functions, its "objectivity"[39]—it is antipathetic to the look, which is on the side of flux, memory, and subjectivity. However, the camera/gaze is only a local elaboration of something much more fundamental and durable: what Lacan calls "the presence of others as such."[40] It is the inscription in the field of vision of the symbolic, of the necessity for every subject to be seen in order to "be." And although this scopic transaction is in every sense much "bigger" than the look, the look nonetheless plays a key role in bringing it about.

The normative aspects of the screen may indeed be so deeply rooted within our psyches, and so tightly imbricated with our desires and identifications, that they generally determine what we see at the first moment of looking at a particular object. Fortunately, though, no look ever takes place once and for all. Rather, each act of spectation is subject to a complex series of conscious and unconscious "vicissitudes," which can completely transform the value of what is originally seen, and which cannot be easily predicted in advance. Alone our look can only make a

difference within the ethical domain of intersubjective relations. This difference is not inconsequential: those subjects who are accustomed to having an unflattering set of visual coordinates projected onto them depend for their psychic survival upon the loving look of their intimates, which (as Barthes suggests) can at least temporarily erase the terrible effect of that projection.[41] But if the look acts in concert with enough other looks, it can reterritorialize the screen, bringing new elements into cultural prominence, and casting into darkness those which presently constitute normative representation. Under such necessarily collective conditions, the look could significantly change how the camera/gaze "photographs" the world.

The *Untitled Film Stills* encourage us to engage in this kind of visual *Nachträglichkeit*. Other critics have also sensed that these images invite us to look at them from two different vantage points, but most of them assume this "duplicity" to be ironic in nature. Gerald Marzorati, for instance, claims that Sherman "has sought to capture the look and feel of stills from '50s films, and at the same time has sought to deny it all." He goes on to say that there is a "tension in these pictures" between the stereotypes they portray, and "Sherman's own feelings about the stereotype."[42] Similarly, Michael Danoff speaks about the pleasure which comes when one no longer passively absorbs the stereotypes, but actively "gets" them, a "getting" which once again implies a distanciation from the women who ostensibly embody them.[43]

However, I concur with Peter Schjeldahl's claim that there is "an absence of any reassuring, campy wink or nudge" in these images.[44] We are not invited to laugh, either about the aspiration of the figures in them to be apprehended in idealizing ways, or about the generally doomed nature of that undertaking. The tenderness with which Sherman details her protagonists' narcissistic ambitions helps us to recognize ourselves in them, as does her willingness to put herself *literally* in their place. It is, moreover, not with these women's ideal imagos that the *Untitled Film Stills* invite us to identify, but rather with the women themselves, in all their manifest distance from the mirror. The case needs to be stated even more forcefully: it is *because* the protagonists of the *Untitled Film Stills* are so far from ideality that they exert so powerful an attraction.

It might be assumed, from what I have just said, that our second encounter with the women in the photographs precipitates lack and self-loathing. But although much of Sherman's subsequent work, from the fashion photographs through the "sex pictures," constitutes a virulent at-

tack on the notion of the ideal image, and a commitment to a directly contrary aesthetic, the *Untitled Film Stills* are in my opinion very much to one side of this project. They do not withhold pleasure from us, but rather induct us into a new kind of pleasure, one made possible by a more improvisatory relation to the ideal—"improvisatory" in the sense that one grasps it as a series of unrealizable tropes, which can only ever be provisionally activated through pose, costume, makeup, mise-en-scène, lighting, and other fundamentally extrinsic "props."

The *Untitled Film Stills* propose something like the principle of the "good enough" over and against the binarisms "sufficiency/insufficiency," or "ideal/failure." I borrow this notion from D. W. Winnicott, who maintains that the mother need not be ideal, only "good enough." Indeed, he argues that the "good enough mother" is to be preferred to her ideal counterpart, since she does not attempt to fill the void upon which desire is predicated.[45] Similarly, the *Untitled Film Stills* make available for corporeal identification not the ideal vamp or nature girl, but the "good enough" equivalents of each. Implicit in this principle is the knowledge that since no one can ever *become* the ideal, there is no such thing as either "natural entitlement" or "organic insufficiency" in relation to it. All that is available to us is the possibility of effecting a "good enough" approximation, and—through it—of shaking a little stardust onto the otherwise quotidian expanse of human existence. Also implicit in Sherman's articulation of this principle is the sense that it is triumphant in exact proportion to the adversity it overcomes—that it counts most when circumstances most conspire against it, when it is, from a social standpoint, most *impossible.*

When we look at *Still #3* for the second time, we can see that the woman at the sink is in fact sexy. We don't forget about the bottle of Joy detergent or the container of Morton salt when affirming her as such. On the contrary, we impute value to her pose over and against those objects. Indeed, we come to admire her for triumphing over her environment— or (more precisely) what normative meaning makes of that environment—through the artistry of her self-presentation, and, in a retroactive way, we affirm the three dimensional "photograph" into which she has transformed herself. Similarly, when returning to *Still #50* we realize that sophistication and cosmopolitanism also do not exist in any absolute sense, only in elegant partial gestures and half-approximations, and that the woman sitting on the couch has them in spades.

In most of her work since the *Untitled Film Stills,* Sherman has attempted to counter commercial photography's idealization of a highly

restrictive set of bodily types through an ever-greater insistence upon corporeal disintegration. Indeed, from the fashion photos to the "sex pictures," that work could be grouped together under the rubrics "Dehiscence," "Decomposition," or even "Bodies in Pieces." However, it is my opinion that the *Untitled Film Stills* represent her most important intervention within this psychically and politically fraught terrain. They disburden us of lack. They also democratize the field of vision. Finally, they show us how to "play" with the gaze, both as seers, and as part of the spectacle of the world.

Notes

1. Guy Debord, *The Society of the Spectacle,* trans. Fredy Pearlman (Detroit: Radical America and Black and Red, 1970), p. 1.

2. Jacques Lacan, *The Four Fundamental Concepts of Psychoanalysis,* trans. Alan Sheridan (New York: W. W. Norton, 1978), p. 75.

3. Flusser characterizes the camera as a "black box," to whose program most photographers are blindly subservient, and to the extension of which the most gifted and original photographers work. Scarcely a second intervenes between the production of a genuine "new" image and the expansion of the program to include it. Within this model it is difficult to imagine any genuinely contestatory gesture.

4. Vilem Flusser, *Towards a Philosophy of Photography* (Göttingen, West Germany: European Photography, 1984), p. 7.

5. Susan Sontag, *On Photography* (New York: Farrar, Straus & Giroux, 1977), p. 85.

6. Roland Barthes, *Camera Lucida: Reflections on Photography,* trans. Richard Howard (New York: Hill and Wang, 1981), p. 11.

7. Barthes, *Camera Lucida,* p. 15.

8. Ibid., p. 13.

9. Lacan, *Four Fundamental Concepts,* pp. 117–118.

10. Christian Metz, "Photography and Fetish," in *The Critical Image: Essays on Contemporary Photography,* ed. Carol Squiers (Seattle: Bay Press, 1990), p. 158.

11. Ibid., p. 156.

12. Barthes, *Camera Lucida,* p. 12.

13. Sontag, *On Photography,* p. 161.

14. Pierre Bourdieu, "The Cult of Unity and Cultivated Differences," in *Photography: A Middle-brow Art,* trans. Shaun Whiteside (Stanford: Stanford University Press, 1990), p. 19.

15. Flusser, *Towards a Philosophy of Photography,* p. 14.

16. Siegfried Kracauer, "Photography," *Critical Inquiry* vol. 19, no. 3 (1993), p. 433.

17. From Smithson's "The Monuments of Passaic," quoted by Craig Owens in *Beyond Recognition: Representation, Power, and Culture,* ed. Scott Bryson, Barbara Kruger, and Jane Weinstock (Berkeley: University of California Press, 1992), p. 27.

18. I am no longer of the opinion that intentionality is an exclusively human prerogative. For a discussion of the intention of creatures and things to appear, see my *World Spectators* (Stanford: Stanford University Press, 2000), Chapter 6.

19. Jacques Lacan, *Four Fundamental Concepts,* p. 106.

20. Roger Caillois, "Mimicry and Legendary Psychasthenia," trans. John Shepley, *October* 31 (Winter 1984).

21. Lacan, *Four Fundamental Concepts,* p. 99.

22. Roger Caillois, "Mimicry and Legendary Psychasthenia," p. 23.

23. For a discussion of proprioceptivity, and of the bodily ego in a larger sense, see my *The Threshold of the Visible World* (New York; London: Routledge, 1996), Chapter 1.

24. I also discuss heteropathic identification in another chapter of the volume from which this essay derives. See *The Threshold of the Visible World,* Chapter 2.

25. Frantz Fanon, *Black Skin, White Masks,* trans. Charles Lamm Markmann (London: Pluto Press, 1976), p. 112. I discuss this passage in *The Threshold of the Visible World,* pp. 27–31, in the context of a larger meditation upon the bodily ego.

26. Craig Owens, "Posing," in his *Beyond Recognition: Representation, Power, and Culture* (Berkeley: University of California Press, 1992), p. 210.

27. The still photographs Cindy Sherman produced using a "centerfold" format could be said to offer a sustained dramatization of this principle. The unnatural poses assumed by the women in an attempt to fit into a much shallower than usual frame—and, in some cases, one which is generally too constrained—would imply the latter even if it were not there.

28. Lacan, *Four Fundamental Concepts,* p. 107.

29. Barthes, *Camera Lucida,* p. 10.

30. Ibid., pp. 11–12.

31. Pierre Bourdieu, "The Social Definition of Photography," in *Photography: A Middle-Brow Art,* p. 83.

32. Lacan, *Four Fundamental Concepts,* p. 100.

33. Barthes, *Camera Lucida,* pp. 11; 12.

34. Arthur Danto, "Photography and Performance: Cindy Sherman's Stills," in *Cindy Sherman, Untitled Film Stills* (New York: Rizzoli, 1990), p. 13.

35. Rosalind Krauss, "Cindy Sherman: Untitled," reprinted in this volume, p. 109.

36. Judith Williamson, "Images of 'Woman'—the Photographs of Cindy Sherman" (1983), reprinted in this volume as "A Piece of the Action: Images of 'Woman' in the Photography of Cindy Sherman," p. 40.

37. See *The Threshold of the Visible World,* Chapter 5.

38. See Ibid., Chapter 4.

39. By "objectivity," I mean both the camera's traditional claim to see things as they actually are, and its isolation from subjectivity.

40. Lacan, *Four Fundamental Concepts,* p. 84.

41. Barthes, *Camera Lucida,* p. 12.

42. Gerald Marzorati, "Imitation of Life," *ARTnews,* September 1983, pp. 85–86.

43. Michael Danoff, "Cindy Sherman: Guises and Revelations," *Cindy Sherman* (New York: Pantheon Books, 1984), p. 194.

44. Peter Schjeldahl, "The Oracle of Images," in *Cindy Sherman* (New York: Whitney Museum of American Art, 1987), p. 8.

45. See, for instance, D. W. Winnicott, *Playing and Reality* (London: Penguin, 1974), p. 163, where the author differentiates the notion of the "good enough mother" from that of the "perfect mother," and endorses the former, and pp. 11–12, where he associates good enough caretaking with the opening up of the child to lack.

Hal Foster

In contemporary art and theory, let alone in contemporary fiction and film, there is a general shift in conceptions of the real: *from the real understood as an effect of representation to the real understood as an event of trauma.* There are several ways to think about this shift, yet as it bespeaks a pervasive turn to psychoanalysis in critical culture, I want to graph it here in its terms—specifically in relation to the Lacanian discussion of the gaze in *The Four Fundamental Concepts of Psychoanalysis.*

This is a notorious text, of course, much cited but little understood (so little that I will risk another résumé). For example, there may well be a male gaze, and no doubt capitalist spectacle is constructed from a masculinist perspective, but there is little brief for such arguments in *this* seminar of Lacan. For here the gaze is not embodied in a subject at all, at least not in the first instance. To an extent like Sartre in *Being and Nothingness* (1943), Lacan distinguishes between the look (or the eye) and the gaze, and to an extent like Merleau-Ponty in *The Phenomenology of Perception* (1945), he locates this gaze *in the world.* As with language in Lacan, then, so with the gaze: it preexists the subject, who, "looked at from all sides," is but a "stain" in "the spectacle of the world."[1] Thus positioned, the Lacanian subject feels the gaze as a threat, as if it queried him or her, and so it is that "the gaze, *qua objet a,* may come to symbolize this central lack expressed in the phenomenon of castration."[2]

Even more than Sartre and Merleau-Ponty, then, Lacan challenges the presumed transparency of the subject in sight. His account of the gaze mortifies this subject, especially so in the famous anecdote of the sardine can. Afloat on the sea and aglint in the sun, this can seems to look at the

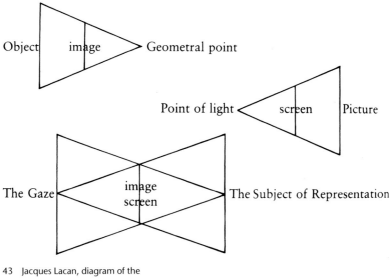

43 Jacques Lacan, diagram of the
gaze, from *The Four Fundamental
Concepts of Psychoanalysis*. © 1973
Éditions du Seuil. English translation
© 1977 Alan Sheridan. By permission
of W. W. Norton & Company, Inc.

young Lacan in the fishing boat "at the level of the point of light, the point
at which everything that looks at me is situated."[3] Thus seen as (s)he sees,
pictured as (s)he pictures, the Lacanian subject is fixed in a double posi-
tion, and this leads Lacan to superimpose on the usual cone of vision that
emanates from the subject another cone that emanates from the object, at
the point of light (fig. 43). It is this regard that he calls the gaze.

The first cone is familiar from Renaissance treaties on perspective: the
object focused as an image for the subject at a geometral point of viewing.
But, Lacan adds immediately, "I am not simply that punctiform being
located at the geometral point from which the perspective is grasped. No
doubt, in the depths of my eye, the picture is painted. The picture, cer-
tainly, is in my eye. But I, I am in the picture."[4] That is, the subject is also
under the regard of the object, photographed (as it were) by its light, pic-
tured by its gaze: thus the superimposition of the two cones, with the
object also at the point of light (now called the gaze), the subject also at
the point of the picture (now called the subject of representation), and the
image also in line with the screen.

The meaning of this last term, the screen, is obscure. I understand it to stand for the cultural reserve of which every image is one instance. Call it the conventions of art, the schemata of representation, the codes of visual culture, this screen mediates the object-gaze for the subject. But it also *protects* the subject from this object-gaze, for it captures the gaze, "pulsatile, dazzling and spread out," and tames it in an image.[5] This last formulation is crucial. For Lacan, animals are caught in the gaze of the world; they are only on display there. Humans are not so reduced to this "imaginary capture,"[6] for we have access to the symbolic—in this case to the screen as the site of picture-making and viewing, where we can manipulate and moderate the gaze. In this way the screen allows the subject, at the point of the picture, to behold the object, at the point of light. Otherwise it would be impossible, for to see without this screen would be to be blinded by the gaze or touched by the real.

Thus, even as the gaze may trap the subject, the subject may tame the gaze. This is the function of the screen: to negotiate a *laying down* of the gaze as in a laying down of a weapon. Note the atavistic tropes of preying and taming, battling and negotiating; the gaze is given strange agency here, and the subject is positioned in a paranoid way.[7] Indeed, Lacan imagines the gaze not only as maleficent but as violent, a force that can arrest, even kill, if it is not disarmed first.[8] At its more urgent, then, picture-making is apotropaic: its gestures (think of Expressionist painting) are made to arrest the gaze before the gaze can arrest us. At its more "Apollonian,"[9] picture-making is placating: its perfections (think of Neoclassical painting) are intended to pacify the gaze, to "relax" the viewer from its grip. Such is aesthetic contemplation according to Lacan: some art may attempt a *trompe l'oeil*, a tricking of the eye, but all art aspires to a *dompte-regard*, a taming of the gaze.

I want to suggest that much contemporary art refuses this age-old mandate to pacify the gaze, to unite the imaginary and the symbolic against the real. *It is as if this art wanted the gaze to shine, the object to stand, the real to exist, in all the glory (or the horror) of its pulsatile desire, or at least to evoke this sublime condition.* To this end it moves not only to attack the image but to tear at the screen, or to suggest that it is already torn. This shift from the image-screen, the focus of most postmodernist art in the 1980s, to the object-gaze, the focus of most postmodernist art in the 1990s, is registered most clearly in the art of Cindy Sherman. Indeed, if we divide her work into three rough groups, it almost seems to move across the three main positions of the Lacanian diagram.

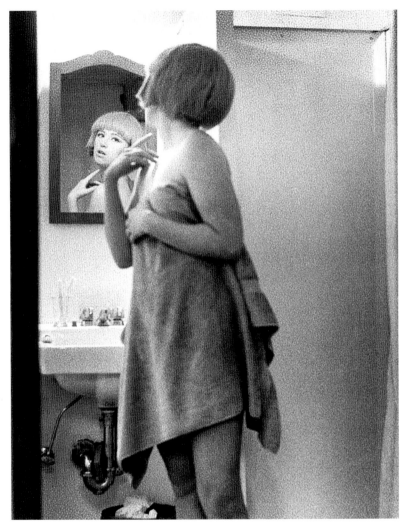

44 *Untitled Film Still #2,* 1977
black-and-white photograph
10 × 8 inches

In her early work of 1975–82, from the film stills through the rear projections to the centerfolds and the color tests, Sherman evokes the subject under the gaze, the subject-as-picture, which is also the principle site of other feminist work in appropriation art. Her subjects see, of course, but they are much more *seen,* captured by the gaze. Often, in the film stills and the centerfolds, this gaze seems to come from another subject, with whom the viewer may be implicated; sometimes, in the rear projections, it seems to come from the spectacle of the world; yet sometimes, too, it seems to come from within. Here Sherman shows her female subjects as self-surveyed, not in phenomenological reflexivity (*I see myself seeing myself*) but in psychological estrangement (*I am not what I imagined myself to be*). Thus in the distance between the made-up woman and her mirrored face in *Untitled Film Still #2* (1977) (fig. 44), Sherman points to the gap between imagined and actual body-images that yawns within each of us, the gap of (mis)recognition that we attempt to fill with fashion models and entertainment images every day and every night of our lives.

In her middle work of 1983–90, from the fashion photographs through the fairy-tale illustrations and the art history portraits to the disaster pictures, Sherman moves to the image-screen, to its repertoire of representations. (This is a matter of focus only: she addresses the image-screen in the early work too, and the subject-as-picture hardly disappears in this middle work.) The fashion and art history series take up two files from the image-screen that have affected our self-fashionings profoundly (fig. 45). Here Sherman parodies vanguard design with a long runway of fashion victims, and pillories art history with a long gallery of butt-ugly aristocrats (in ersatz Renaissance, Baroque, Rococo, and Neoclassical types) (fig. 46). But the play turns perverse when, in some fashion photographs, the gap between imagined and actual body-images becomes psychotic (one or two sitters seem to have no ego awareness at all) and when, in some art history photographs, deidealization is pushed to the point of desublimation: with scarred sacks for breasts and funky carbuncles for noses, these bodies break down the upright lines of proper representation, indeed of proper subjecthood.[10]

This turn to the grotesque is marked in her fairy-tale and disaster images, some of which show horrific accidents of birth and freaks of nature (a young woman with a pig snout, a doll with the head of a dirty old man). Here, as often in horror movies and bedtime stories alike, horror means, first and foremost, horror of maternity, of the maternal body made strange, even repulsive, in repression. This body is the primary site of the

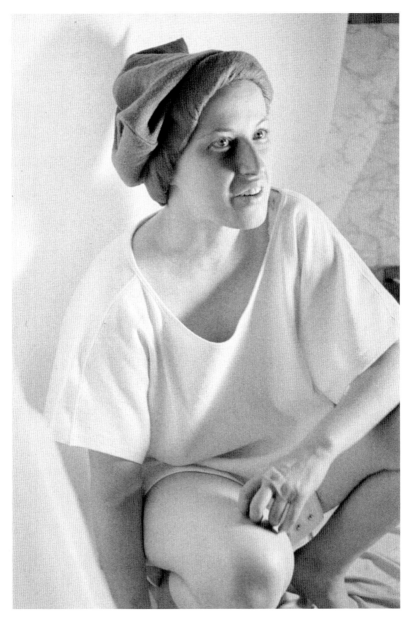

45 *Untitled #120,* 1983
color photograph
34^1/$_2$ × 21^3/$_4$ inches

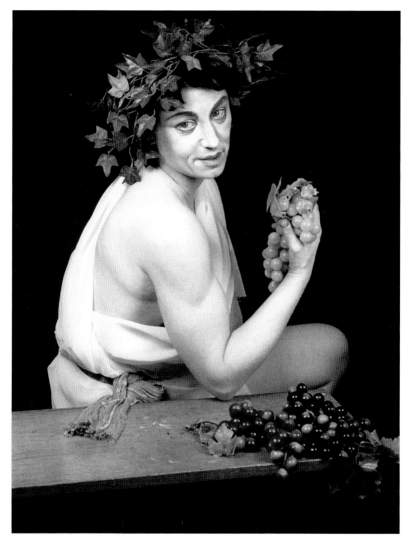

46 *Untitled #224,* 1990
color photograph
48 × 38 inches

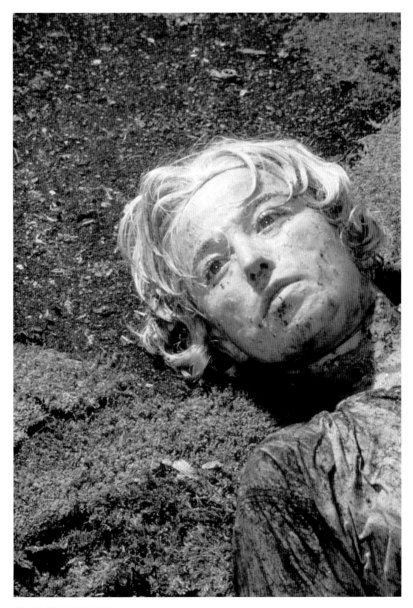

47 *Untitled #153,* 1985
color photograph
67¹/₄ × 49¹/₂ inches

abject as well, a category of (non)being defined by Julia Kristeva as neither subject nor object, but before one is the first (before full separation from the mother) or after one is the second (as a corpse given over to object-hood).[11] Sherman evokes these extreme conditions in some disaster scenes suffused with signifiers of menstrual blood and sexual discharge, vomit and shit, decay and death (fig. 47). Such images tend toward representation of the body turned inside out, of the subject literally abjected, thrown out. But this is also the condition of the outside turned in, of the invasion of the subject-as-picture by the object-gaze. At this point some images pass beyond the abject, which is often tied to particular meanings, not only toward the *informe,* a condition described by Bataille where significant form dissolves because the fundamental distinction between figure and ground, self and other, is lost, but also toward the *obscene,* where the object-gaze is presented *as if there were no scene to stage it, no frame of representation to contain it, no screen.*[12]

This is the domain of her work after 1991 as well, the civil war and sex pictures, which are punctuated by close-ups of simulated damaged and/or dead body parts and sexual and/or excretory body parts respectively. Sometimes the screen seems so torn that the object-gaze not only invades the subject-as-picture but overwhelms it. And in a few of the disaster and civil war images we glimpse what it might be like to occupy the impossible third position in the Lacanian diagram, to behold the pulsatile gaze, even to touch the obscene object, without a screen for protection. In one image (*Untitled #190,* 1989) (fig. 48) Sherman gives the evil eye a horrific visage of its own.

In this scheme of things the impulse to erode the subject and to tear at the screen has driven Sherman from the early work, where the subject is caught in the gaze, through the middle work, where it is invaded by the gaze, to the recent work, where it is obliterated by the gaze. But this double attack on subject and screen is not hers alone; it occurs on several fronts in contemporary art, where it is waged, almost openly, in the service of the real.

<div align="center">★</div>

"Obscene" does not mean "against the scene," but it suggests an attack on the scene of representation, on the image-screen. As such it also suggests a way to understand the aggression against the visual so evident in contemporary art and alternative culture—as an imagined rupture of the image-screen, an impossible opening onto the real.[13] For the most part,

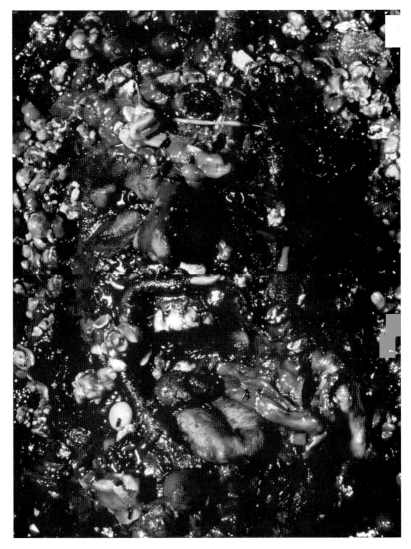

48 *Untitled #190,* 1989
color photograph
(each of two panels) 48¹/₄ × 73 inches

however, this aggression is thought under the label of the abject, which has a different psychoanalytic valence.

According to the canonical definition of Kristeva, the abject is what I must get rid of in order to be an I at all. It is a phantasmatic substance not only alien to the subject but intimate with it—too much so in fact, and this overproximity produces panic in the subject. In this way the abject touches on the fragility of our boundaries, of the spatial distinction between our insides and outsides as well as of the temporal passage between the maternal body and the paternal law. Both spatially and temporally, then, abjection is a condition in which subjecthood is troubled, "where meaning collapses";[14] hence its attraction for avant-garde artists and writers who want to disturb these orderings of subject and society.

The notion is rich in ambiguities, on which the cultural-political valence of abject art may depend.[15] Some are familiar by now: Can the abject be represented at all? If it is opposed to culture, can it be exposed in culture? If it is unconscious, can it be made conscious and remain abject? In other words, can there be a *conscientious abjection,* or is this all there can be? Indeed, can abject art ever escape an instrumental, indeed moralistic, use of the abject?[16]

A crucial ambiguity in Kristeva is the slippage between the operation *to abject* and the condition *to be abject.* For her the operation to abject is fundamental to the maintenance of subjectivity and society, while the condition to be abject is subversive of both formations. Is the abject, then, disruptive of subjective and social orders or foundational of them, a crisis in these orders or a confirmation of them? If subjectivity and society abject the alien within, is abjection not a regulatory operation? That is, is abjection to regulation what transgression is to taboo—an exceeding that is also a completing?[17] Or can the *condition* of abjection be mimed in a way that calls out, in order to disturb, the *operation* of abjection?

In her account of modernist writing, Kristeva views abjection as conservative, even defensive. "Edged with the sublime,"[18] the abject is used to test the limits of sublimation, but the task remains to sublimate the abject, to purify it. Whether or not one agrees with this account, Kristeva does intimate a cultural shift in our own time. "In a world in which the Other has collapsed," she states enigmatically, the task of the artist is no longer to sublimate the abject, to elevate it, but to plumb the abject, to fathom, "the bottomless 'primacy' constituted by primal repression."[19] In a world in which the Other has collapsed: Kristeva implies that the paternal law that underwrites our social order is in crisis.[20] In terms of the visuality outlined

here, this implies a crisis in the image-screen as well; and some artists do attack it, while others, under the assumption that it is torn, probe behind it for the obscene object-gaze of the real. Meanwhile, in terms of the abject, still other artists explore the repressing of the maternal body said to underlie the symbolic order so as to exploit the disruptive effects of its material and/or metaphorical rem(a)inders.

Obviously the condition of image-screen and symbolic order alike is all-important; locally the valence of abject art also depends on it. If it is deemed intact, then the attack on the image-screen retains a transgressive value. However, if it is deemed torn, then such transgression is beside the point, and this old vocation of the avant-garde is at an end. But there is a third option as well, and that is to reformulate this vocation, to rethink transgression not as a rupture produced by a heroic avant-garde posited outside the symbolic order, but as a fracture traced by a strategic avant-garde positioned ambivalently within this order.[21] In this view the goal of the avant-garde is not to break with the symbolic order absolutely (this old dream is dispelled), but to expose it in crisis, to register its points not only of breakdown but of breakthrough, the new possibilities that such a crisis opens up.

For the most part, however, abject art has tended in two other directions. The first is to identify with the abject, to approach it somehow—to probe the wound of trauma, to touch the obscene object-gaze of the real. The second is to represent the condition of abjection in order to provoke its operation—to catch abjection in the act, to make it reflexive, even repellent in its own right. The danger, of course, is that this mimesis may confirm a given abjection. Just as the old transgressive Surrealist once called out for the priestly police, so an abject artist (like Andres Serrano) may call out for an evangelical senator (like Jesse Helms), who then completes the work, as it were, negatively. Moreover, as left and right may agree on the social representatives of the abject, they may shore each other up in a public exchange of disgust, and this spectacle may inadvertently support the normativity of image-screen and symbolic order alike.[22]

These strategies of abject art are thus problematic, as they were in Surrealism over sixty years ago. Surrealism also used the abject to test sublimation; indeed, it claimed the point where desublimatory impulses confront sublimatory imperatives as its own.[23] Yet it was at this point too that Surrealism broke down, that it split into the two principal factions headed by André Breton and Georges Bataille. According to Breton, Bataille was an "excrement-philosopher" who refused to rise above big

toes, mere matter, sheer shit, to raise the low to the high.[24] For Bataille, Breton was a "juvenile victim" involved in an Oedipal game, an "Icarian pose" assumed less to undo the law than to provoke its punishment: despite his celebration of desire Breton was as committed to sublimation as the next aesthete.[25] Elsewhere Bataille termed this aesthetic *le jeu des transpositions,* the game of substitutions, and he dismissed it as no match for the power of perversions: "I defy any amateur of painting to love a picture as much as a fetishist loves a shoe."[26]

I recall this old opposition for the perspective that it offers on abject art today. In a sense Breton and Bataille were both right, at least about each other. Often Breton and company did act like juvenile victims who provoked the paternal law *as if to ensure that it was still there*—at best in a neurotic plea for punishment, at worst in a paranoid demand for order. And this Icarian pose is again assumed by contemporary artists who are almost too eager to talk dirty in the museum, almost too ready to be tweaked by Hilton Kramer or spanked by Jesse Helms. On the other hand, the Bataillean ideal—to opt for the smelly shoe over the beautiful picture, to be fixed in perversion or stuck in abjection—is also adopted by contemporary artists discontent not only with the refinements of sublimation but with the displacements of desire. Is this, then, the option that abject art offers us— Oedipal naughtiness or infantile perversion? To act dirty with the secret wish to be spanked, or to wallow in shit with the secret faith that the most defiled might reverse into the most sacred, the most perverse into the most potent?

This mimesis of regression is pronounced in contemporary art. But, again, it can also be a strategy of perversion—that is, of *père-version,* of a turning from the father that is also a twisting of his law. In the early 1990s this defiance was manifested in a general flaunting of shit-substitute (the real thing was rarely found). In Freud the order essential to civilization is opposed to anal eroticism, and in *Civilization and its Discontents* (1930) he presents the famous origin myth meant to show us why. The story turns on the erection of man from all fours to two feet, for with this change in posture, according to Freud, came a revolution in sense: smell was degraded and sight privileged, the anal was repressed and the genital pronounced. The rest is history: with his genitals exposed, man was returned to a sexual frequency that was continuous, not periodic, and he learned shame; and this coming together of sex and shame impelled him to seek a wife, to form a family, to found a civilization, to go boldly where no man had gone before. Wildly heterosexist as this zany tale is, it does reveal a

normative conception of civilization—not only as a general sublimation of instincts but as a specific reaction against eroticism that is also a specific abjection of (male) homosexuality.[27]

In this light the shit movement in contemporary art may intend a symbolic reversal of this first step into civilization, of the repression of the anal and the olfactory. As such it may also intend a symbolic reversal of the phallic visuality of the erect body as the primary model of traditional painting and sculpture—the human figure as both subject and frame of representation in Western art. This double defiance of visual sublimation and vertical form is a strong subcurrent in twentieth-century art (which might be subtitled "Visuality and its Discontents"),[28] and it is often expressed in a flaunting of anal eroticism. "Anal eroticism finds a narcissistic application in the production of defiance," Freud wrote in his 1917 essay on the subject; in avant-gardist defiance too, one might add, from the chocolate grinders of Duchamp through the cans of *merde* of Piero Manzoni, to the shitty sculptures of John Miller and the shitty performances of Mike Kelley.[29] In contemporary art anal-erotic defiance is often self-conscious, even self-parodic: it may test the anally repressive authority of traditional culture, but it also mocks the anally erotic narcissism of the vanguard rebel-artist. "Let's Talk About Disobeying" reads one banner emblazoned with a cookie jar by Kelley. "Pants-shitter and Proud of It" reads another that derides the self-congratulation of the institutionally incontinent.[30]

However pathetic, this defiance can also be perverse, a twisting of the paternal law of difference—sexual and generational, ethnic and social. Again, this perversion is often performed through a mimetic regression to "the anal universe where all differences are abolished."[31] Such is the fictive space that artists like Miller and Kelley set up for critical play. "We interconnect everything, set up a field," Kelley has the bunny say to the teddy in *Theory, Garbage, Stuffed Animals, Christ* (1991), "so there is no longer any differentiation."[32] Like Miller, Kelley explores this space where symbols are not yet stable, where "the concepts *faeces* (money, gift), *baby* and *penis* are ill-distinguished from one another and are easily interchangeable."[33] Both artists push this symbolic interchange toward aformal indistinction—push the baby and the penis, as it were, toward the lump of shit. However, this is done not to celebrate mere indistinction but to trouble symbolic difference. *Lumpen,* the German word for "rag" that gives us *Lumpensammler* (the ragpicker that so interested Benjamin) and *Lumpenproletariat* (the mass too ragged to form a class that so interested Marx,

"the scum, the leavings, the refuse of all classes"),[34] is a crucial word in the Kelley lexicon, which he develops as a third term between the *informe* (of Bataille) and the abject (of Kristeva). In a sense, he does what Bataille urges: he bases materialism "on psychological or social facts."[35] The result is an art of lumpy things, subjects, and personae that resist shaping, let alone sublimating or redeeming. Unlike the *Lumpen* of Napolean III, Hitler, or Mussolini, the *Lumpen* of Kelley refuses molding, much less mobilizing.

<div align="center">★</div>

Is there a cultural politics here? Often in the general culture of abjection (I mean the culture of slackers and losers, grunge and Generation X) this posture of indifference expresses only a fatigue with the politics of difference. Yet sometimes too this posture seems to intimate a more fundamental fatigue: a strange drive to indistinction, a paradoxical desire to be desireless, a call of regression that goes beyond the infantile to the inorganic.[36] In a 1937 text crucial to the Lacanian discussion of the gaze, Roger Callois, another associate of the Bataillean Surrealists, considered this drive to indistinction in terms of visuality—specifically of insects assimilated into space through mimicry.[37] This assimilation, Caillois argued, allows for no agency, let alone subjecthood (these organisms are "dispossessed of [this] privilege"), which he likened to the condition of extreme schizophrenics:

> To these dispossessed souls, space seems to be a devouring force. Space pursues them, encircles them, digests them in a gigantic phagocytosis [consumption of bacteria]. It ends by replacing them. Then the body separates itself from thought, the individual breaks the boundary of his skin and occupies the other side of his senses. He tries to look at himself from any point whatever in space. He feels himself becoming space, *dark space where things cannot be put*. He is similar, not similar to something, but just *similar*. And he invents space of which he is "the convulsive possession."[38]

The breaching of the body, the gaze devouring the subject, the subject becoming the space, the state of mere similarity: these are conditions evoked in much art today. But to understand this convulsive possession in its contemporary guise, it must be split into its two constituent parts: on the one hand an ecstasy in the imagined breakdown of the image-screen

and/or the symbolic order; on the other hand a horror at this breakdown followed by a despair about it. Early definitions of postmodernism evoked this first, *ecstatic* structure of feeling, sometimes in analogy with schizophrenia. Indeed, for Fredric Jameson the primary symptom of postmodernism was a schizophrenic breakdown in language and time that provoked a compensatory investment in image and space.[39] And in the 1980s many artists did indulge in simulacral intensities and ahistorical pastiches. In recent intimations of postmodernism, however, the second, *melancholic* structure of feeling has dominated, and sometimes, as in Kristeva, it too is associated with a symbolic order in crisis. Here artists are drawn not to the highs of the simulacral image but to the lows of the depressive thing. If some high modernists sought to transcend the referential object and some early postmodernists to delight in the sheer image, some later postmodernists want to possess the real thing.

Today this bipolar postmodernism seems pushed toward a qualitative change: some artists appear driven by an ambition, on the one hand, to inhabit a place of total affect and, on the other, to be drained of affect altogether; on the one hand, to possess the obscene vitality of the wound and, on the other, to occupy the radical nihility of the corpse. This oscillation suggests the dynamic of psychic shock parried by protective shield that Freud developed in his discussion of the death drive and Benjamin elaborated in his discussion of Baudelairean modernism—but now placed well beyond the pleasure principle.[40] Pure affect, no affect: *It Hurts, I Can't Feel Anything.*

Why this fascination with trauma, this envy of abjection, today? To be sure, motives exist within art, writing, and theory alike. As I suggested at the outset, there is a dissatisfaction with the textual model of reality—as if the real, repressed in poststructuralist postmodernism, had returned as traumatic. Then too, there is a disillusionment with the celebration of desire as an open passport of a mobile subject—as if the real, dismissed by a performative postmodernism, were marshaled against a world of fantasy compromised by consumerism. But obviously there are other forces at work as well: a despair about the persistent AIDS crisis, invasive disease and death, systemic poverty and crime, a destroyed welfare state, indeed a broken social contract (as the rich opt out in revolution from the top, and as the poor are dropped out in immiseration from the bottom). How one articulates these different forces is a difficult question—perhaps a definitive question for cultural criticism. In any case, together they have driven the contemporary concern with trauma and abjection.

And one result is this: a special truth seems to reside in traumatic or abject states, in diseased or damaged bodies. To be sure, the violated body is often the evidentiary basis of important witnessings to truth, of necessary testimonials against power. But there are dangers with this siting of truth as well, such as the restriction of our political imagination to two camps, the abjector and the abjected, and the assumption that in order not to be counted among sexists and racists one must become the phobic object of such subjects. If there is a subject of history for the culture of abjection at all, it is not the Worker, the Woman, or the Person of Color, but the Corpse. This is a politics of difference pushed beyond indifference, a politics of alterity pushed to nihility.[41] "Everything goes dead," says the Kelley teddy. "Like us," responds the bunny.[42] But is this point of nihility a critical epitome of impoverishment where power cannot penetrate, or is it a place from which power emanates in a strange new form? Is abjection a refusal of power or its reinvention in a strange new guise, or is it somehow both these events at once?[43] Finally, is abjection a space-time beyond redemption, or is it the fastest route for contemporary rogue-saints to grace?

Today there is a general tendency to redefine experience, individual and historical, in terms of trauma: a *lingua trauma* is spoken in popular culture, academic discourse, and art and literary worlds. Many contemporary novelists (e.g., Paul Auster, Dennis Cooper, Steve Erickson, Denis Johnson, Ian McEwan, Tim O'Brien) and filmmakers (e.g., Atom Egoyan in *Exotica,* Terry Gilliam in *12 Monkeys,* the Monty Python version of *La Jetée*) conceive experience in this paradoxical modality: experience that is *not* experienced, at least not punctually, that comes too early or too late, that must be acted out compulsively or reconstructed after the fact, almost analytically. Often in these novels and films narrative runs in reverse or moves very erratically, and the peripeteia is an event that happened long ago or not at all (per the logic of trauma this is sometimes ambiguous).

On the one hand, especially in art, writing, and theory, this trauma discourse continues the poststructuralist critique of the subject by other means, for strictly in a *psychoanalytic* register there is no subject of trauma—the position is evacuated—so the critique of the subject seems most radical here. On the other hand, especially in therapy culture, talk shows, and memoir-mongering, trauma is treated as an event that guarantees the subject, and in this *psychologistic* register the subject, however disturbed, rushes back as survivor, witness, testifier. Here a traumatic subject does indeed exist, and it has absolute authority, for one cannot challenge the

trauma of another: one can only believe it, even identify with it, or not. *In trauma discourse, then, the subject is evacuated and elevated at once.* And in this way it serves as a magical resolution of contradictory imperatives in contemporary culture: the imperative of deconstructive analyses on the one hand, and the imperative of muliticultural histories on the other; the imperative to acknowledge the disrupted subjectivity that comes of a broken society on the one hand, and the imperative to affirm identity at all costs on the other. Today, thirty years after the death of the author, we are witness to a strange rebirth of the author as zombie, to a paradoxical condition of *absentee authority.*

Notes

This very partial lexicon of contemporary art and theory is extrapolated from *The Return of the Real* (Cambridge: MIT Press, 1996), where a much more complete discussion of these terms can be found.

1. Jacques Lacan, *The Four Fundamental Concepts of Psychoanalysis,* trans. Alan Sheridan (New York: W.W. Norton, 1978), pp. 72, 75.

2. Ibid., p. 77.

3. Ibid., p. 95.

4. Ibid., p. 96. Curiously, the Sheridan translation adds a "not" ("But I am not in the picture") where the original reads "Mais mois, je suis dans le tableau" (*Seminar XI* [Paris: Editions du Seuil, 1973], p. 89). This addition has abetted the mistaking of the place of the subject mentioned in the next note. Lacan is clear enough on this point; e.g., "the first [triangular system] is that which, in the geometral field, puts in our place the subject of representation, and the second is that which turns *me* into a picture" (p. 105).

5. Ibid., p. 89. Some readers place the subject in the position of the screen, perhaps on the basis of this statement: "And if I am anything in the picture, it is always in the form of the screen, which I earlier called the stain, the spot" (p. 97). The subject is a screen in the sense that, looked at from all sides, (s)he blocks the light of the world, casts a shadow, is a "stain" (paradoxically, it is this screening that permits the subject to see at all). But this screen is different from the image-screen, and to place the subject only there is to contradict the superimposition of the two cones wherein the subject is both viewer and picture. The subject is an agent of the image-screen, not one with it. In my reading, then, the gaze is not already semiotic, as it is for Norman Bryson in *Tradition and Desire: From David to Delacroix* (Cambridge: Cambridge University Press, 1984). In some respects his account improves on Lacan, who, through Merleau-Ponty, renders the gaze almost animistic. Yet to read the gaze as already semiotic may be to tame it before the fact, and indeed, for Bryson, it is the gaze that is benign, "a luminous plentitude," and the screen that "mortifies" rather than protects the subject ("The Gaze in the Expanded Field," in *Vision and Visuality,* ed. Hal Foster [Seattle: Bay Press, 1988], p. 92).

6. Lacan, *Four Fundamental Concepts,* p. 103.

7. In "The Gaze in the Expanded Field" Bryson argues that, however threatened by the gaze, the subject of the gaze is also confirmed by its very alterity. (On paranoia as the last refuge of the subject, see Leo Bersani, *The Culture of Redemption* [Cambridge: Harvard

University Press, 1990], pp. 179–199.) As Bryson notes, other models of visuality are also tinged with paranoia—the male gaze, surveillance, spectacle, simulation, and so on. What produces this paranoia, and what might it serve—that is, besides this paradoxical in/security of the subject?

On the atavism of the nexus of gaze, prey, and paranoia, consider this remark of Philip K. Dick: "Paranoia, in some respects, I think, is a modern-day development of an ancient, archaic sense that animals still have—quarry-type animals—that they're being watched. . . . I say paranoia is an atavistic sense. It's a lingering sense, that we had long ago, when we were—our ancestors were—very vulnerable to predators, and this sense tells them they're being watched. And they're being watched probably by something that's going to get them. . . . And often my characters have this feeling. But what really I've done is, I have atavised their society. That although it's set in the future, in many ways they're living—there is a retrogressive quality in their lives, you know? They're living like our ancestors did. I mean, the hardware is in the future, the scenery's in the future, but the situations are really from the past" (extract from a 1974 interview used as an epigraph to *The Collected Stories of Philip K. Dick,* vol. 2 [New York: Carol Publishing, 1990]).

8. Lacan relates this maleficent gaze to the evil eye, which he sees as an agent of disease and death, with the power to castrate: "It is a question of dispossessing the evil eye of the gaze, in order to ward it off. The evil eye is the *fascinum* [spell], it is that which has the effect of arresting movement and, literally, of killing life. . . . It is precisely one of the dimensions in which the power of the gaze is exercised directly" (p. 118). For Lacan the evil eye is universal, and no equivalent beneficent eye exists, not even in the Bible. Yet much Christian art is fixed on the gazes of the Madonna upon the Child and the Child upon us. Typically, Lacan focuses instead on the exemplum of envy in Saint Augustine, who tells of his murderous feelings of exclusion at the sight of his little brother at the maternal breast: "Such is true envy—the envy that makes the subject pale before the image of a completeness closed upon itself, before the idea that the *petit a,* the separated *a* from which he is hanging, may be for another the possession that gives satisfaction" (p. 116). Here Lacan can be contrasted with Walter Benjamin, who imagines the gaze as auratic and replete, from within the dyad of mother and child, rather than as anxious and invidious, from the position of the excluded third. Indeed, in Benjamin one discovers the beneficent eye that Lacan denies, a magical gaze that implicitly reverses fetishism and undoes castration, a redemptive aura based on the memory of a primal relationship with the maternal body. For more on this distinction, see my *Compulsive Beauty* (Cambridge: MIT Press, 1993), pp. 193–205.

9. Lacan, *Four Fundamental Concepts,* p. 101.

10. Rosalind Krauss conceives this desublimation as an attack on the sublimated verticality of the traditional art image in "Cindy Sherman: Untitled" (1993), reprinted in this volume. She, too, discusses the work in relation to the Lacanian diagram of visuality, albeit in a different way, as does Kaja Silverman in *The Threshold of the Visible World* (New York: Routledge, 1996).

11. Or, rather, intimations of such conditions. See Julia Kristeva, *Powers of Horror,* trans. Leon S. Roudiez (New York: Columbia University Press, 1982).

12. Regarding these differences, see "The Politics of the Signifier: A Conversation on the *Informe* and the Abject," *October* 67 (Winter 1994), and Rosalind Krauss, *Informe* without Conclusion," *October* 78 (Fall 1996).

13. This is manifest, for example, in the insistence on the factuality of the body as against the fantasy of transcendence in spectacle, virtual reality, cyberspace, and the like—an insistence that, again, is very different from the postmodernist delight in the image world where it was often assumed that the real had succumbed to the simulacral.

The attack on the image-screen has assumed other guises in other periods; see, for example, Louis Marin on the ambition of Caravaggio "to destroy painting" in *To Destroy Painting* (Chicago: University of Chicago Press, 1995). In this century this ambition is especially active in Dada and décollage (where spectacle is targeted). Such antivisuality may be related to the paranoia of the gaze noted above.

14. Kristeva, *Powers of Horror,* p. 2.

15. A fundamental ambiguity is the relation of subject and society, the psychological and the anthropological, the inside (as it were) and the outside. With her recourse to the work of Mary Douglas (especially *Purity and Danger*) Kristeva tends to align, indeed to conflate, the two, with the result that a disturbance of the one is automatically, traumatically, a disturbance of the other. This does not contribute much to the political clarity of critiques of the subject nor the psychological clarity of critiques of the social.

There are many readings of the Kristevan abject. For a critical elaboration, see Judith Butler, *Gender Trouble* (New York: Routledge, 1990) and *Bodies That Matter* (New York: Routledge, 1993). Kristeva tends to primordialize disgust; to map abjection onto homophobia may be to primordialize it in turn. But then for many subjects both disgust and homophobia are primordial.

16. This points to a parallel question: Can there be an obscene representation that is not pornographic? Today it is important to insist on the difference, which might be thought along these lines: The obscene is a paradoxical representation without a scene to stage the object so that it appears too close to the viewer. The pornographic, on the other hand, is a conventional representation that distances the object so that the viewer is safeguarded as a voyeur.

17. "Transgression does not deny the taboo," runs the famous formulation of Bataille, "but transcends and completes it." *Erotism: Death and Sensuality* (1957), trans. Mary Dalwood (San Francisco: City Lights Books, 1986), p. 63. There is a third option: that the abject is double and that its transgressive value is a function of this ambiguity. (Bataille, no less than Freud, was drawn to such double, adialectical terms.)

18. Kristeva, *Powers of Horror,* p. 11.

19. Ibid., p. 18.

20. But then when is it not? The notion of hegemony suggests that it is always under threat, if not in crisis. In this regard the notion of the symbolic order may project more solidity than the social possesses.

21. Radical art and theory often celebrate failed figures, especially deviant masculinities, as transgressive of the symbolic order, but this avant-gardist logic of an inside and an outside assumes (affirms?) a stable order against which these figures are posed. In *My Own Private Germany: Daniel Paul Schreber's Secret History of Modernity* (Princeton: Princeton University Press, 1996), Eric Santner offers a brilliant rethinking of this logic: he relocates transgression within the symbolic order, at a point of crisis, which he defines as "symbolic authority in a state of emergency."

22. The obscene may have this effect too. Many contemporary images render the obscene thematic and so safe, in the service of the screen, not against it—which is what most abject art does, against its own wishes. Indeed, the obscene may be the ultimate apotropaic shield *against* the real—partaking of it in order to protect against it.

23. "Everything tends to make us believe," Breton wrote in the *Second Manifesto of Surrealism* (1930), "that there exists a certain point of the mind at which life and death, the real and the imagined, past and future, the communicable and the incommunicable, high and low, cease to be perceived as contradictions. Now, search as one may one will never find

any other motivating force in the activities of the surrealists than the hope of finding and fixing this point" (in *Manifestoes of Surrealism,* trans. Richard Seaver and Helen R. Lane [Anne Arbor: University of Michigan Press, 1972], pp. 123–124). Signal works of modernism emerge at this point between sublimation and desublimation (there are examples in Picasso, Pollock, Twombly, Eva Hesse, many others). Perhaps they are so privileged because we need the tension between the two or, more precisely, because we need this tension to be treated, both incited and soothed, *managed.*

24. See Breton, *Manifestoes of Surrealism,* pp. 180–187. At one point Breton charges Bataille with "psychasthenia" (more on which below).

25. See George Bataille, *Visions of Excess,* trans. Allan Stoekl (Minneapolis: University of Minnesota Press, 1985), pp. 39–40. For more on this opposition, see *Compulsive Beauty,* pp. 110–114.

26. Bataille, "L'Esprit moderne et le jeu des transpositions," *Documents* 8 (1930). The best discussion of Bataille on this score remains Denis Hollier, *Against Architecture,* trans. Betsy Wing (Cambridge: MIT Press, 1989), especially pp. 98–115. Elsewhere Hollier has specified the fixed aspect of the abject according to Bataille: "It is the *subject* that is abject. That is where his attack on metaphoricity comes in. If you die, you die; you can't have a substitute. What can't be substituted is what binds subject and abject together. It can't simply be a substance. It has to be a substance that addresses a subject, that puts it at risk, in a position from which it cannot move away" ("The Politics of the Signifier II: A Conversation on the *Informe* and the Abject," p. 120).

27. Abjected and/or repressed, these terms are rendered critical, able to disclose the heterosexist aspects of these operations. Yet this logic may accept a reduction of male homosexuality to anal eroticism, and, as with the infantilist parody of the paternal law or the infantilist exploration of the maternal body, it may accept the dominance of the very terms that it opposes.

28. For an incisive reading of this discontented modernism, see Rosalind Krauss, *The Optical Unconscious* (Cambridge: MIT Press, 1992), and for a comprehensive history of this antiocular tradition, see Martin Jay, *Downcast Eyes: The Denigration of Vision in Twentieth-Century French Thought* (Berkeley: University of California Press, 1993).

29. Sigmund Freud, "On Transformations of Instinct as Exemplified in Anal Erotism," in *On Sexuality,* ed. Angela Richards (London: Penguin, 1977), p. 301. On the primitivism of this avant-gardist defiance, see my "'Primitive' Scenes" *Critical Inquiry* (Winter 1993) and reprinted in *Prosthetic Gods* (Cambridge: MIT Press, 2004). Mediations of anal eroticism, as in the "Black Paintings" of Robert Rauschenburg or the early graffiti paintings of Cy Twombly, tend to be more subversive than declarations of anal defiance.

30. Here and elsewhere Kelley pushes infantilist defiance toward adolescent dysfunction: "An adolescent is a dysfunctional adult, and art is a dysfunctional reality, as far as I am concerned" (quoted in *Catholic Tastes,* ed. Elisabeth Sussman [New York: Whitney Museum of American Art, 1994], p. 51).

31. Janine Chasseguet-Smirgel, *Creativity and Perversion* (New York: W. W. Norton, 1984), p. 3. Differences are not abolished in this universe (this formulation tends to the homophobic) so much as transformed. The exemplar of this transformation in contemporary fiction is Dennis Cooper.

32. Mike Kelley, *Theory, Garbage, Stuffed Animals, Christ,* quoted in *Catholic Tastes,* p. 86.

33. Freud, "On Transformations of Instinct," p. 298. Kelley plays on both psychoanalytic and anthropological intuitions about the interconnection of all these terms—feces, money, gifts, babies, penises. . . .

34. Karl Marx, *The Eighteenth Brumaire of Louis Bonaparte* (1852), in *Surveys from Exile,* ed. David Fernbach (New York: Vintage Books, 1974), p. 197.

35. Bataille, *Visions of Excess,* p. 15.

36. What was the music of Nirvana about if not the Nirvana principle, a lullaby droned to the dreamy beat of the death drive? See my "Cult of Despair," *New York Times,* December 30, 1994.

37. Roger Caillois, "Mimicry and Legendary Psychasthenia," trans. John Shepley, *October* 31 (Winter 1984). Denis Hollier glosses "psychasthenia" as follows: "a drop in the level of psychic energy, a kind of subjective detumescence, a loss of ego substance, a depressive exhaustion close to what a monk called *acedia*" ("Mimesis and Castration 1937," *October* 31 [Winter 1984], p. 11).

38. Caillois, "Mimicry and Legendary Psychasthenia," p. 30.

39. This was first broached in "Postmodernism and Consumer Society," in *The Anti-Aesthetic: Essays on Postmodern Culture,* ed. Hal Foster (Seattle: Bay Press, 1983). This ecstatic version cannot be dissociated from the apparent boom of the early 1980s, nor the melancholic version (noted below) from the actual bust of the late 1980s and early 1990s.

40. See Freud, *Beyond the Pleasure Principle* (1920), trans. James Strachey (New York: W. W. Norton, 1961), and Benjamin, "On Some Motifs in Baudelaire" (1939), in *Illuminations,* trans. Harry Zohn (New York: Schocken Books, 1977). This bipolarity of the ecstatic and the abject provides one affinity, sometimes remarked in cultural criticism, between the baroque and the postmodern. Both are drawn toward an ecstatic shattering that is also a traumatic breaking; both fix on the stigma and the stain.

41. To question this politics of indifference, however, is not to dismiss the possibility of a noncommunitarian politics, a subject of much provocative work in both cultural criticism (e.g., Leo Bersani) and political theory (e.g., Jean-Luc Nancy).

42. Kelley quoted in *Catholic Tastes,* p. 86.

43. "Self-divestiture in these artists," Leo Bersani and Ulysse Dutoit write of Samuel Beckett, Mark Rothko, and Alain Resnais in *Arts of Impoverishment* (Cambridge: Harvard University Press, 1993), "is also a renunciation of cultural authority." Yet then they ask: "Might there, however, be a 'power' in such impotence?" (pp. 8–9). If so, it is a power they seem to advocate rather than to question.

I

This was her work, to disappear from all her former venues of aspect and bearing and to become a blankness, a body slate erased of every past resemblance. She had a fade cream she applied just about every-where, to depigment herself. She cut off some, then more of the hair on her head. It was crude work that became nearly brutal when she bleached out the color. In the mirror she wanted to see someone who is classically unseen, the person you are trained to look through, bled of familiar effect, a spook in the night static of every public toilet.

—Don DeLillo, *The Body Artist*[1]

A disappearance *and* a persistence: this is how we come to understand the protagonist Don DeLillo sketches in his 2001 novel, *The Body Artist*. Yet "sketch" is probably the wrong word here, implying, as it does, *contours* of some kind. Rather, the author shades a kind of human penumbra into and out of focus, creating a figure who is hardly a protagonist, unless one turns to two of the word's less conventional definitions: tethered to agony as a dramatic (and thus, often pleasurable) extreme, on the one hand, and to the movements caused by the contractions of particular muscles, on the other. Not that DeLillo's is a story without a plot, or without a leading character—indeed, both are instantly recognizable as such in the text—but these exist only as the necessary precursors for their own slow, pointed dissolutions (or, better, nonnarrative transformations). The story line,

insofar as it can be glossed, situates the artist Lauren Hartke alone in a ram-shackle summerhouse, acclimating to her husband's unexpected suicide, and preparing to perform an extreme new body work. More important, however, are the stubborn details of the story, those that refuse neat sum-mations and whose significance only becomes clear in hindsight after the body work has finally been performed: the little man with "no protective surface" who might or might not exist and whose sole means of commu-nication with Hartke is mimicry; the computer on which the artist watches hours of live-streaming video of a two-lane road in Finland; the patiently repeating unsexed synthesized voice on a friend's anwering ma-chine; the paint-can man and burlap-sack squirrel (inanimate objects that first evince, and then refuse, mistaken surges of empathy); the handheld taperecorder wielded by Hartke to capture the past and predict the future; the tools—pumice and razors, elaborate contortions and breathwork—that reshape both the interior and exterior of her body, as preparation to shed it. Such supplemental details—resistant as they are to the smooth mechanics of narrative—finally come to make up the core repertoire of Hartke's 1½-hour performance, titled "Body Time," in which the artist, having "shaken off the body—hers anyway,"[2] shimmers in and out of visi-bility, a pure medium, a body slate screening a collection of aggressively rendered representations.

Hartke, DeLillo's denizen of millennial body art, with her recourse to technological morphology (merging bodily affect with mechanically (re)produced disaffect) and ability to exhibit the body as both base mate-rial and semiotic field bears uncanny resemblance to one of the better-known artists of the last decades: Cindy Sherman. While Sherman is by and large defined under the auspices of photography (the medium in which she works), what is absent from the critical literature is the possi-bility of considering her practice as a form of body art—one that increas-ingly relies on the persistent disappearance of a body in order to make the representation of that body present. Such a consideration is the focus of this essay.

II

Throughout my life I've tried to keep looking different, so my hair has been all different colors, all lengths and styles. As a result, a lot of these characters look like me in the periods of my life *since* I shot the *Film Stills*—perhaps unconsciously I've been following them, or

at least their hairstyles. Occasionally, I've felt that as I've gotten older I've come to look more like some of them.

—Cindy Sherman[3]

In a monographic tome covering Sherman's photographic works produced between 1975 and 1993, Rosalind Krauss and Norman Bryson offer two views on the artist's oeuvre.[4] While their essays tell somewhat discordant tales (Krauss disavowing myth-infused readings of Sherman and Bryson constructing one of his own), they each conclude with a similar hunch: proposing that, reading Sherman's various photographic series *retrospectively*, one will find traces of her later work gestating in the earliest. To this effect, Bryson ventures a comparison: "Two images from Sherman, a song of innocence and one of experience, *Untitled Film Still, #48* (fig. 26), of 1979, and *Untitled #274* (fig. 27), of 1992. They could hardly be more different. At what point did Sherman go over to the dark side? Turning back the pages of the 'complete works,' one sees with hindsight that despite the earlier image's optimism, its upbeat quality of 'setting out' . . . the symptomatic structure is already fully in place. . . ."[5] While I can't quite sign on to the assertion that *Untitled Film Still, #48* (a twilight scene in which a bobby-socks-clad blonde with a suitcase stands on the shoulder of a deserted two-lane highway) is an optimistic "song of innocence" (the scene embodies anxiety for this viewer), it is true that pairing that image with *Untitled #274* can perhaps reveal patterns (formal and otherwise) in the former's structure that were illegible—to viewers and artist alike—at the time of its making. Bryson categorizes these lurking, if not yet manifest, elements of the *Film Stills* as tangible only "at the edges" of the photographs themselves (a metaphor clearly meant to evoke the dramatic more than the photographic) and as *felt* rather than seen: "an atmosphere of dread, off-screen and at the fringes of the representation, a fear *for* and *of* the body at the very moment of its sublimation or disappearance into the representational theater."[6]

Krauss, too, suggests that a kind of "coherence" can be wrested from Sherman's body of work precisely by "doubling back," and addressing (and perhaps *redressing*) it retrospectively.[7] Though she otherwise disagrees with Laura Mulvey's reading of the artist's work, Krauss cites the theorist approvingly when it comes to methodological hindsight, borrowing her observation that "the visitor [of a Sherman retrospective exhibition] who reaches the final images and then returns, reversing the order, finds that

with the hindsight of what was to come, the early images are trans-
formed."[8] What is the nature of this transformation, obtained as it is by
means of retrospection? Does such "reading-in" provide a kind of narra-
tive teleology that too rapidly limits or assigns meaning after the fact? Or
might this after-the-fact positing of a coherent oeuvre provide counter-
intuitively the platform by which individual works and the body repre-
sented in them can yield to an opposing impulse? That is to say, might we
at once grasp a larger, ongoing framework while letting individual ele-
ments productively fall apart? My own rereading of Sherman's work is
intended to intertwine these two positions, while positing the materiality
of the body as the sticking point to both. Shifting away from the now-
familiar story of Sherman à la gaze and representation, this tale (perhaps
it's important to consider all such endeavors productive misreadings) is
one of aggressive corporeality.

Consider a provocative suggestion made by Krauss as she looked back
over two decades of work by Sherman. Having already proposed a con-
tingency between *Untitled Film Still #36* (fig. 30), 1979, and a negative/
positive pair of photographs of a ballerina taken by Degas (and published
in a 1978 article by the critic Douglas Crimp)[9], she concludes by point-
ing to a possible hinge between Sherman's then-recent works—the early
1990s "sex pictures," which heavily utilized mannequins and prosthetic
parts—and photographic images by Hans Bellmer, about which Hal Fos-
ter wrote extensively in 1991. Krauss was neither source hunting nor sug-
gesting that Sherman was directly (or even unconsciously) appropriating
from contemporaneous critical forays. Rather, she hoped to point to the
"discursive horizon" (a phrase borrowed from Bakhtin) of the artist's
work, in part to illuminate the larger dialogue in which that work was in-
volved and in part to counter reductive criticisms that Sherman herself was
unwilling to illuminate (i.e., to talk about) the meanings (i.e., intentions)
behind her work. Interestingly, following the publication of Krauss's essay,
which concluded speculatively, there were some ten years of new work by
Sherman and a general dearth of risky writing about it. Rather than look-
ing back at the *Film Stills* to reread them in light of new work, critics be-
gan to take the *Stills* as a kind of stable meaning-source with which to
explain (away) the complexities of all that followed. In a recent Sherman
catalogue, one author sums up Sherman's as a "career-long interest in ar-
tifice and masquerade."[10]

While Krauss suggests a compelling parallel between the work of
Sherman and Bellmer—in addition to striking formal similarities, both

have been read alternately as deconstructing and reinscribing representations of erotic fetish—I want to carry forward an implicit, if unstated, aspect of the comparison. By gesturing toward the article in which Foster takes up Bellmer's photographs, Krauss inadvertently provides an angle from which to retrospectively consider Sherman's entire oeuvre (and one that becomes particularly fruitful now, ten years later, when reflecting on Sherman's most recent work). "Armor Fou," as the article's title indicates, considers what Foster names a "psychic apprehension of the body as *armor*" by addressing the work of two artists, Max Ernst and Hans Bellmer.[11] Foster's interest in pursuing such psychic recastings of the body was primarily to explore various links of corporeal representation and fascism, particularly as these manifested very differently in Ernst and Bellmer, the first of whom was working during and responding to the aftermath of World War I, the second during the rise of the Nazi party and World War II. For Foster, while both artists recognized bodies as an armor that simultaneously served a protective (binding) function and revealed its already-shattered status, Ernst's machine-bodies *mirrored* (and sheltered against) damaged psychic and social strata, while Bellmer's (specifically female) deconstructed-constructions *sustained* the shattered erotic body, struggling against such armor while disallowing fixed mastery and unleashing polymorphous, metonymic desires and perversions. Fascist armoring, then, aimed to hold interior, uncontrollable (gendered, raced, othered) impulses at bay, defending "against the fragmentary and the fluid, the dispersed and the dissolute, as represented by the feminine."[12]

Bellmer's *poupées* weren't, as is sometimes argued, representations of the artist's sadistic fantasies involving actual girls: rape scenes qua rape scenes (though they were perhaps in part this too). Rather, in Foster's view, Bellmer's photographs of his dolls, with multiplying, disjointed limbs and adorned in bows and patent leather mary-janes, didn't depict the fairer sex at all. The artist's images of the fragmented female body served to address, even make uncannily visible, two *male* subjects, if necessarily indirectly. Bellmer's deeply ambivalent pleasure derived in the *poupées* can be seen along with "the *perversion* of the dolls precisely as a *turning away* from the father, from his law," here in both the Lacanian and literal senses—as Bellmer himself was vehemently anti-fascist and his father was an active Party member.[13] At the same time, while Bellmer's interaction with the *poupées* can only be described as sadistic, he simultaneously identified with the dolls, thereby *becoming* the masochistic subject upon which his own sadism was enacted. Thus, the *poupées* at once figured as

aggressive defense *against* the name of the father and *as* Bellmer's own frag-
mented and fragmenting alter ego. This is a cursory reading of what is a
more complicated argument by Foster, though it does allow me to make
the following points: in this reading of the (fascist) *armored* subject, there
can be *no female subject* per se but rather femininity rendered as the artifi-
cial symbol of interiority, disorder, flow, and otherness (and, thus, as
weapon and/or threat). Any portrayal of a fragmented, dissolute female
form, then, necessarily refers to its male counterpart's own deepest fears
and/or wishes for self-annihilation. While I am hardly the first to make the
observation that such economies prohibit, indeed, render impossible, fe-
male representation (one need only recall Luce Irigaray's critique of
Freud, in which she observes that for him there is only one sex—male—
and the not-quite that is female), I make it here—and with regard to the
armored and/or aggressive subject—with a particular purpose in mind.[14]
The question that becomes available via this observation is the following:
how can aggressive representations (either servicing or defying armoring)
by and of a female artist manifest, if armoring itself is decidedly levied
against the incursion of all that is coded feminine? One possibility is that
the terms would necessarily invert, armor itself would become coded
feminine (and, perhaps then, as fluid, transitive, *becoming*), and that any no-
tion of a holistic interior would necessarily be displaced. Of course, this
reversal would no longer be armoring, or resistance to it, but would rep-
resent a kind of middle state, perhaps one in which the boundaries of sub-
jectivity would become muddled and indistinguishable, rather than
dialectically shattered and bound.

Much of the criticism surrounding Sherman's work (from the first
showing of the *Film Stills* and continuing today) tends to focus on mass
and cultural media (films, TV, magazine spreads, pornography, fashion
photography, art history, horror flicks) as the presumed (real) points of ref-
erence from which to understand the images. There is an equally insistent
urge to posit Sherman's characters—from *film noir* actress to prosthetic pig
face—as *passive and preyed upon:* in danger of (or in process of) being con-
sumed variously by the (media-produced) male gaze, by culture at large,
even by space itself.[15] What does it mean to rethink Sherman's characters
outside of those modes of passivity and instead as figures who present a
kind of aggressive feminine armor? Krauss's suggestion that we consider
the then-recent work being produced by Sherman in light of contempo-
rary theoretical work on Bellmer allows us today to reconsider one pri-
mary characteristic of the *poupées*—aggressive resistance—and think

about its relation to Sherman's images, which are typically imagined as disallowing passivity's foil. The possibility of aggressivity inherent in much of Sherman's later work has, perhaps unsurprisingly, been little noted in critical narratives that plot her oeuvre. In part, this is because "images of woman" (this still the common gloss used to describe the work) are deeply and automatically associated with passivity, even when they are produced to work *against* such constructions. Along these lines, Sherman has also been noticeably read *away* from any association with body art (often considered a much more aggressive—and even embarrassingly so—genre of art making) and has been read almost solely *into* the genre of photography, as such. And while Sherman's work is certainly manifested using photographic means, it has also consistently portrayed what might be considered body art as filtered through and inscribed with the signifiers of various media technologies: from film in the earliest instance to digital manipulation in the latest. In this way, photography is never held up as transparent, for Sherman self-consciously mimes the procedures of (various kinds of) image production itself. In performing this kind of double projection, of the (already mediated, i.e., culturally known) character onto the screen of the body and the body onto the screen of the photograph, Sherman is able to present a kind of temporally impossible image: as though what has not yet come to pass is presented as if having already occurred. These are fantasies as much as phantoms—one part *that-has-been,* one *that-has-not.*[16] Here the insistence of the body (Sherman's body, passing through and between frames as though through states of being) disables the photograph's smooth transition into the past. Instead, the photographic as such is dragged forward, despite itself, by the weight of Sherman's relentless—if forever shifting—corporeality.

III

In the mid-'80s I made the works that people call the "disgusting series"—photos with vomit in them, et cetera. "Put that over your sofa!" I thought.

—Cindy Sherman[17]

People, of course, *do* now hang images from the "disgusting series" over their sofas, just as they proudly display all of Sherman's "later" (i.e., post–*Film Stills*) works: including the "fashion photos," "fairy tales," "disasters," "history portraits," "sex pictures," and "horror pictures." Still, Sherman's

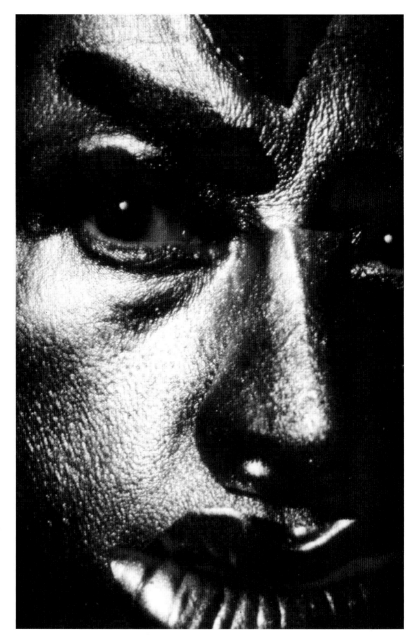

49 *Untitled #323,* 1996
color photograph
57⁷/₈ × 39 inches

work is mostly understood (and its continued critical meaning con-structed) by way of those earliest images that, almost universally, are ex-plained by way of recourse to an active/passive visual model (the male gaze directed at the female subject), whose mechanisms the artist is thought to both record and reveal, to critique and reinscribe. The sequence of Sher-man's series from the mid-'70s until the mid-'90s is oft-iterated, though what has happened since has been somewhat less charted. Appropriately enough, given Rosalind Krauss's invocation of Bellmer as a potential figure on the discursive horizon,[18] Sherman was, in 1994, considering tropes of Dada and Surrealism, thinking about collage, photomontage, and hand tinting, while continuing all the while to assemble mannequin and prosthetic parts, sporadically inserting her own—increasingly inde-terminate—face or body into the compositions. Many of these images were incredibly tightly cropped, exploring the contours of a mask/face that, whether purely prosthetic or flesh/plastic hybrid, evoked both an ab-sence and a presence—a kind of synecdochical slide from part-object to part-subject. That is to say, Sherman's post-1993 images began to suggest, rather overtly, that signifiers for the "subject" could be located or dislo-cated at will, and relied on the aggressivity of overt superficiality paired with an undeniably focused, if not necessarily definable or ever stable, *stare. Untitled #323* (1996) (fig. 49), for instance, depicts a character with painted skin and pasted-on lips and nose. Human eyes—Sherman's eyes—stare out. In *Untitled #324* (1996) (fig. 50), the melted contours of a skin-thin mask with punctured nose holes stares back with glass eyes: no less startling, no less present in its address, somehow no less invested with Sherman's presence. While making this work, Sherman noted her interest in de Sade and her own (in her view failed) attempt to "explore a violent, misogynistic direction, à la de Sade and the boys."[19] She had for some time voiced concern about the continued use of her own body within her images and, as is obvious, more and more frequently employed surrogates, sometimes in pieces, sometimes alone, sometimes as supplements to her body. If there is, however, a single body of work that is critically dismissed (repressed even), it is the group of works shown in 1999 at Metro Pictures Gallery—small black-and-white images (the first—and last—since the *Stills*) depicting the mutilated bodies of actual dolls—from busty Barbies to ripped wrestlers—charred, mutilated, stacked (fig. 51).[20] Here, there was no unmoored subjectivity: only the literal, if disturbing, effects of a kind of failed misogynistic play. In turn, one might cursorily conclude that the body, even if (or perhaps *only if*), represented as an absence, is itself

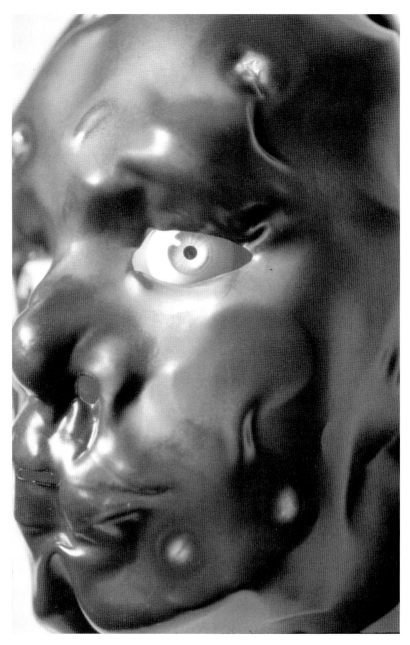

50 *Untitled #324*, 1996
color photograph
57³/₄ × 39 inches

51 *Untitled #343*, 1999
black-and-white photograph
38¹/₂ × 25¹/₂ inches

A Body Slate

52 *Untitled #402,* 2000
color photograph
36 × 24 inches

necessary to the work. The (recognizable) body returned, with images of Sherman in the characters of East and West Coast women from 2000 (fig. 52)—aging, usually "ungracefully," to use a term that should be understood here as resistant, even potentially aggressive.

IV

A photograph should transcend itself, the image its medium, in order to have its own presence.

—Cindy Sherman[21]

Sherman's most recent series of photographic work, hanging at Metro Pictures Gallery at the time of the writing of this essay in spring 2004, portrays in each image a clown or a number of clowns (fig. 53). These are, by turns, pathetic, horrific, and psychotic, but in their exaggerated differences, they share a single characteristic: each clown aggressively addresses the viewer, in part because the body qua body has been entirely (and overtly) clad—armored, one could say—in ridiculous, sometimes scary, costuming but more obviously because each notably projects a direct, even foreboding (if exaggeratedly sad or happy) stare. Taking up the vocabulary of theatrical photography, Sherman here presents her characters as poised self-consciously somewhere between the fictional and the real, with one foot, as it were, inside the frame and the other planted squarely outside it. The images are, for the first time in Sherman's work, digitally manipulated—the schizophrenically bubble gum-colored backgrounds have been produced on the computer, and the multiple figures (all Sherman) have been brought together using imaging tools that, rather than aiding artifice, expose it. The press release would like us to think, yet again, of these works primarily as distant cousins of the *Film Stills*—"Behind the sheer visual lushness and latent humor/horror of the portraits lies Sherman's interest in revealing the underlying pathos of the hysterically happy or intensely nasty clown image; the sadness of the character behind the greasepaint." Yet, to read the images only in this way is to underestimate them, and the *Stills* as well. As Krauss, Judith Williamson, and others have pointed out, to conflate consciously theatrical (or dramatic) clusters of signifiers with either an actual figure (*woman,* say, or the artist herself) is to miss what's actually there (and what's not). There is no character behind the greasepaint (which does *not* exclude the presentness of a

53 *Untitled #421,* 2004
color photograph
54.7 × 78.7 inches

body); indeed, Sherman's perverse portrayals of clowns risk tautology since
the clown is recognized precisely for its lack of depth, its total definition
based on only the props, gestures, and costumes that allow it to be simul-
taneous figure for both the superego (performing caricatural acts of polic-
ing and judgment) and pure id (pursuing base desires).[22] This is why the
empty cipher of the clown—invoked as a figure of pleasure—is also
equally available as a figure of horror (think of all the B movies that take
this theme) or, interestingly, of unabated aggression (Bruce Nauman cer-
tainly appears on Sherman's discursive horizon here).

 Sherman's clowns are distinct and yet generic, as were the women ap-
pearing in her *Film Stills,* yet the clowns work less to draw out the desires
and identifications of viewers. Rather than mirror or screen yearning, the
figures here stare back, conjuring rather than representing anxiety, baring
fake teeth in smiles that sometimes appear to be predatory postures. While
the aggressive armoring of Foster's fascist subject revealed itself to be in-
ternally shattered while deferring or denying that shattering through a
kind of protective exterior binding, Sherman's "armor" manifests itself as
pure surface—that is, without an interior to protect. Any notion of such

an interior is solely produced by a viewer (who doesn't identify with the image, but hopes to probe it for reassuring content all the same), and it is this tension—between the aggressive address of Sherman's radical superficiality and a viewer's projection of, or need for, a (vulnerable) interiority—that produces such ambivalence in the artist's works. In addition, Sherman slyly reverses the presumed hierarchy between viewer and object—placing the image in an unlikely (and impossibly held) position of power and the viewer transfixed (rather than transfixing) by something that won't be pinned down (or opened up).

I have suggested that we reread Sherman by thinking through the possibility of a kind of "feminine aggressivity," a possibility enabled by a turn to the body and one that would perhaps course through and connect viewer and object in a way dissimilar to those models in which the female subject is consumed/undone/dissolved. It is perhaps telling that in Lacan's writing on aggressivity, in which he posits the term as one component of ego formation (whose complement, important for this discussion, is narcissism), he discusses the period between six months and two and a half years (not coincidentally overlapping with the mirror stage) when human children have not yet secured for themselves a stable *imago* of the human form.[23] A child in this age range experiences the world and herself *transitively*—that is, as extending without boundaries into the bodies/space of others.

> During the whole of this period, one will record the emotional reactions and the articulated evidences of a normal transitivism. The child who strikes another says that he has been struck; the child who sees another fall, cries. Similarly, it is by means of an identification with the other that he sees the whole gamut of reactions of bearing and display, whose structural ambivalence is clearly revealed in his behavior, the slave being identified with the despot, the actor with the spectator, the seduced with the seducer.[24]

It is precisely this transitive period, immediately *before* the ego crystallizes by way of aggressively marking distinctions between the I and the Other, that particularly interests me here. First, because the description of transitivism uncannily recalls the activities of clowns (whose mimed reactions are unmoored from their own bodies, feeling the pain of blows inflicted on others, falling when someone else is pushed, etc.). Lacan's extension of transitivism to the dialectics of despotism, seduction, and theatricality is

also illuminating here, particularly for what observations may be made with regard to body art. And, finally, I cannot help but wonder if the inverted armor produced by way of aggressive feminine representation might take its form (or *informe*) as a kind of transitive materiality, without clear borders, where one then alternately overinvests in the body and disallows comprehending it as an autonomous object. Which is to say that while a viewer may not know, for a time, how to place herself in relation to such an image, she knows for sure that she is placed *somewhere*.

Sherman's photographs might be productively read as images that, to some degree, present "body work," an admittedly vague term to this point in the present analysis, modeling my version of Sherman on DeLillo's Hartke, an artist who "quote[s] by rote in another conceptual frame."[25] I've reiterated the fact that while critical rehearsals of Sherman's work generally maintain that she strives to reveal and undermine hierarchical structures of photography (by both posing for and shooting her images, by repeating stereotypes only to lay bare the mechanisms of their naturalization, by desublimating abject and erotic elements of the cultural imaginary, etc.), her subjects are, nonetheless, most often read as caught, consumed, or in a state of entropic abjection. Is this an effect of Sherman's subject matter, which has, not always but often, taken up representational structures of women? Or can it, in part, be taken as an effect of the medium—photography—itself as imbricated within particular paradigms of mastery? Essays on Sherman regularly (and importantly) take up theories of the gaze, sometimes to emphasize its gendered effects, but more interestingly to show the ways in which Sherman's work cannot be cast in the landscape of Cartesian singlepoint perspective. However, as much as the literature posits the phenomenological gaze, the dispersed gaze, the object's inanimate gaze, even the abject gaze, it seems such engagements preclude an aggressive gaze or, better, a transitive one.

V

The power of the piece is Hartke's body. At times she makes femaleness so mysterious and strong that it encompasses both sexes and a number of nameless states. In the past she has inhabited the bodies of adolescents, pentecostal preachers, a one-hundred-and-twenty-year-old woman sustained by yogurt and, most memorably, a pregnant man. Her art in this piece is obscure, slow, difficult and sometimes agonizing. But it is never the grand agony of stately images and sets. It is about you and me. What begins in solitary otherness becomes

familiar and even personal. It is about who we are when we are not rehearsing who we are.

—DeLillo, *The Body Artist*[26]

Lea Vergine begins her 1974 book, *Body Art and Performance: The Body as Language,* with an epigraph from Katherine Mansfield: "There are certain tremendous moments in life when a creature comes out of his corner and looks around, and it's frightening."[27] This is the transitive gaze—apparent already in the ambiguity of the very first words to appear in Vergine's book. Just what is the "it" that frightens—the creature or what he sees as he looks around? Here, then, is the transitive (moving, liminal, undecidable) gaze, found, appropriately enough, in the context of the frightening *or* frightened body.

Vergine, while not naming Lacan, turns nonetheless to his poles of ego-construction, aggression and narcissism, which she names as two of the major (and interlocked) tendencies of body art, itself defined loosely by the author as that which is practiced by artists who are either "exclusively concerned with their own bodies," or who have "made use of their bodies sporadically or episodically, but, nonetheless, deal with something *repressed* that subsequently returns to the surface of experience with all of the narcissism that surrounds it."[28] This expansive view of body art—pertaining to figures from Vito Acconci to Richard Serra, Trisha Brown to Annette Messager—would surely, if considering today's artists, include Cindy Sherman. Indeed, many of those presented in the pages of Vergine's book utilize photography as the means to present their body work: whether as documentary effects of attended performances, proof of unattended ones, or as work in and of itself—supplementing nothing.

Aggressivity, Vergine argues, manifests in all works of body art as an effect of the inevitable failure on the part of its producers (and thus, as a symptom of society at large) to procure primary love. "This unobtained love is what transforms itself into the aggressivity that is typical of all of these actions, events, photo-sequences and performances. It is also redirected to other versions of the self, and the self is doubled, camouflaged, and idealized."[29] Narcissism, defined here as a redirection of sexual aggression into "other versions" of the self (as doubled, camouflaged, and idealized), lends a compellingly photographic shade to a term that, for Freud, at least, had over time inhabited several (transitory) positions with regard to the subject. Initially posited as the stage between autoerotism and object-love, narcissism was the slippery slope on which a subject

moved between taking her own body as love-object and unifying her sex-
ual instincts in preparation to project them outward. Eventually, narcis-
sism was split into primary and secondary forms, in which the first implies
absolutely no connection with the outside world (i.e., the impossible re-
turn to an intrauterine state) and the second implies an ego-driven nar-
cissism in which a cathected (and disappointed) libido is withdrawn from
outside objects and internally applied to the self.[30]

Vergine proposes that body art, however, redirects such aggression
not back onto the self as such but onto new (multiple) versions of that self,
which operate, it seems, as both extensions and prosthetics. This is to say,
narcissism (the inevitable companion of aggressivity), deployed as a mate-
rial element of body art, disallows the interiorization of the libido, pulled
back from failed object-conquests in the world. Rather, such artwork
exteriorizes the narcissistic process, taking the self as love object but only
as it makes that self other, exterior (doubled, camouflaged, idealized),
imaged, transitively experienced *as* imago by both audience and artist alike.
Suspended between the poles of aggression and narcissism, body art nec-
essarily manifests as a site of transitivity (sometimes working to evoke si-
multaneous distanciation and identification in its audience members).

One of the most insistently repeated tropes called upon to support
Cindy Sherman's work, of course, is that none of her photographs—even
the 1982 "pink robe" series, in which the artist photographed herself
without costume or makeup—are self-portraits (fig. 54). They are *charac-
ters* that momentarily take up residence on the artist's person, quite liter-
ally, before being "shot" and then released or, better, removed. Therefore,
charges of narcissism have been mostly avoided; indeed, to accuse an artist
who never actually portrays herself of narcissism would be ludicrous, es-
pecially at a moment when so many (particularly female) photographers
are engaged in embarrassingly literal narcissistic projects (think of the
recent Yale "girl" photographers).[31] However, if we are to think beyond
the colloquial understanding of narcissism (whereby it is conflated with
overwhelming conceit), we actually find ourselves back at Vergine's ini-
tially odd-sounding construction. While I am not positing Sherman as a
body artist in order to trace the artistic consequences of inherently failed
and narcissistically redirected primal love through her thirty-year career
(though this might, in fact, be quite theoretically fruitful), I do find that
the aggressive nature of her work becomes clear by way of reconsidering
its narcissistic (as defined here) elements.[32] And, while photography has
often been characterized as a site of loss (this-has-been), body art, as de-
fined by Vergine, allows an artist *to be,* "to grasp the existent in all of its

54 *Untitled #98,* 1982
color photograph
45 × 30 inches

brutal physicality, to communicate something that has been previously felt but that is lived in the very moment of communication, to return to the origins without leaving the present, to lead the individual to relationship with both himself and others, to lead the individual, in short, back to his specific mode of existence."[33] Back, that is (in case the previous sentence carried shades of transcendental possibility) to delusion, failure, and un-obtainable love, but back to a *present,* nonetheless.

In his famous 1980 essay, "The Photographic Activity of Postmod-ernism," Douglas Crimp arrives at a similar crux with regard to a group of young artists (of whom Sherman is one). How is it that certain experi-ences of *presence* are best felt as *supplemental absences*? For our purposes, how are Sherman's images fuller by virtue of the fact that she has emptied her-self out of them (and yet remains there)? Crimp's argument takes up pho-tography at a moment when it falls under particular suspicion, wielded by the *Pictures* artists (named thus by Crimp himself) as a means of repre-senting representation itself. For Crimp, the particular presence of these artists' work (including—in addition to Sherman—Sherrie Levine, Jack Goldstein, Robert Longo, and others) is effected by revealing the *absence* of any possibility of an original. Thus, he concludes that the aura of the artwork had, in the photographic activity of postmodernism, "become only a presence, which is to say, a ghost."[34] Yet this presence that appears as a (substantive) absence is always *in addition to,* a supplement, and it is, Crimp is careful to remind us, one produced through the use of repro-ductive technologies. This was particularly easy to note in Sherman's early work, the *Film Stills,* where each image seems to have a source that is already-known and yet nonexistent. This remains true of all of her work, each series differently supplemented by another presence that can only be recognized as an absence—revealing both the construction and break-down of recycled stereotypes as well as the technological traces of their making. (While Sherman's pictures reference many other media—from film to TV to magazine—they remain stubbornly photographic and, thus, consistently reveal the absence of that which they claim to represent.)

Yet I detect another presence-as-absence in Sherman's work, one that I've explored by way of that work's growing, if ambivalent, move toward aggressivity, a transitive narcissism that disallows consumption of the photographic image and refers more to a body that, over three decades, has become increasingly camouflaged and doubled (if idealized, only to monstrous effect). Near the end of DeLillo's fictional tale of Lauren Hartke, the artist submits to an interview some days after "Body Time"

has officially finished a three-day run. She pointedly characterizes her own work—which typically drives audience members off mid-performance due to its aggressive, unrelenting repetition—as nothing more than vanity, reminding her interviewer (and reader) that the etymology of the word, from the Latin *vanitas,* means emptiness.

Notes

1. Don DeLillo, *The Body Artist* (New York: Scribner, 2001), p. 86

2. Ibid., p. 106

3. David Frankel, ed., *Cindy Sherman The Complete Untitled Film Stills,* (New York: Museum of Modern Art, 2003), p. 15.

4. The monograph is titled *Cindy Sherman 1975–1993* (New York: Rizzoli International, 1993). Both essays contained in that volume, Rosalind Krauss's "Cindy Sherman: Untitled," and Norman Bryson's "House of Wax," are reprinted in this October Files book.

5. Norman Bryson, "House of Wax," in this volume, pp. 93–95.

6. Ibid. Bryson performs a familiar slippage here, even while he hopes to sidestep it. Although initially positing a *similarity* between the two images, he eventually delivers the usual (gendered) difference. While he retrospectively locates dread in the *Film Still,* it is one "offscreen," and thus, lurking and omnipresent, dangerous to the female character we are told is "optimistic" (i.e., clueless). The dread of the later image can, on the other hand, be located precisely in the cobbled prosthetic body before us, itself the threatening male body par excellence. Indeed, the character is one of the most (unusually) literal to be found in Sherman's work, depicting Old Man Fitcher, a Brothers Grimm character who stalks and dismembers young women. Perhaps a more compelling point of convergence is the viewer's urge to project supplemental (i.e., not present) meaning onto the images—conjuring dread from their own (citationally inspired) desire.

7. Rosalind Krauss, "Cindy Sherman: Untitled" in this volume, p. 137. I pose the possibility of *redress* in addition to retrospective *address* because the former implies reparation in the Kleinian sense, which is to say that a rethinking of Sherman's older work necessarily entails exposing interior divisions that themselves were deferred. It is often argued that the *Film Stills* offer singular (if oxymoronically multiplicitous) images of female types, and that every series to follow the *Stills* enacts another level of slow, yet progressive, breakdown on the discrete body. To enlist a *redressive* strategy, however, would be to insist, in keeping with Lacan's theories of the subject, that every body (or subjectivity) is always already fractured, coming undone, even when not immediately recognized as such. See Melanie Klein and Joan Riviere, *Love, Hate and Reparation* (New York: W. W. Norton, 1964). Also see Mignon Nixon, "Bad Enough Mother," *October* 71 (Winter 1995) for a brilliant, differently focused essay on Klein, aggression, and female artists including Louise Bourgeois.

8. Krauss, p. 137. From Laura Mulvey, "A Phantasmagoria of the Female Body: The Work of Cindy Sherman" (1991), reprinted in this volume as "Cosmetics and Abjection: Cindy Sherman, 1977–87" p. 67. Krauss feels that Mulvey, too, has ascribed to a mythic reading of Sherman's work, in this case the myth of "woman as object of the male gaze." See Mulvey, especially pp. 68–72 and Krauss, especially pp. 108–109.

9. Douglas Crimp's article on Degas is titled "A Note on Degas's Photographs," and appeared in *October* 5 (Summer 1978).

10. Rochelle Steiner, "Cast of Characters," in *Cindy Sherman,* exhibition catalog (London: Serpentine Gallery; Art Data, 2003), p. 20.

11. Hal Foster, "Armor Fou," *October* 56 (Spring 1991), pp. 64–97.

12. Ibid., p. 95.

13. Ibid., p. 91.

14. See Luce Irigaray, *Speculum of the Other Woman,* trans. Gillian C. Gill (New York: Cornell University Press, 1985).

15. I refer here in the first instance to unmodified repetitions of ideals culled from crucial (but dated) texts on the male gaze, specifically Laura Mulvey's "Visual Pleasure and Narrative Cinema," *Screen* 13 (Autumn 1975); in the second to formulations of culture as erasing distinctions between individual and collective, specifically Peter Schjeldahl, "Shermanettes," *Art in America* (March 1982) and Arthur Danto, "Photography and Performance: Cindy Sherman's Stills," from *Cindy Sherman Film Stills* (New York: Rizzoli, 1990); in the third to texts that take up the compelling idea (much loved by both the Surrealists and Lacan) of Roger Caillois, that certain kinds of mimicry are aligned not with adaptation but with the death drive, as a body loses the concept of its own contours and acquiesces to the surrounding space.

16. I refer, in this construction, to Roland Barthes's famous formulation of the photograph as proof of the "that-has-been" and, therefore, to the photograph as sight of trauma. While I do not want to counter the rich readings that have linked this inherent photographic trauma with the trauma inherent in many (if not all) of Sherman's works, I do want to—if briefly—examine Sherman's work as existing (even if supplementally) outside the sphere of the photograph and within the bodies (of the artist, of the audience) that exceed it. This said, perhaps the most aggressive reading of Sherman's work to date comes precisely from the sight/site of trauma. Hal Foster's "Obscene, Abject, Traumatic," in this volume, discusses the work as traumatic and, thus, in some proximity to the real, or, better, as images that levy "an attack on the scene of representation." As Foster describes the trajectory of Sherman's work: "In this scheme of things the impulse to erode the subject and to tear at the screen has driven Sherman from the early work, where the subject is caught in the gaze, through the middle work, where it is invaded by the gaze, to the recent work, where it is obliterated by the gaze." (p. 179). Yet, even in this description, the subject is "caught, invaded," and eventually "obliterated." While my insistence on aggression will, soon enough, have to bend to accommodate that impulse's complement, for the moment I want to hold onto its possibility. In part, this is how my hypothetical "that-has-not" comes to be formulated—as a resistance that is not locatable in the photograph (or the traumatic) but in the exchange that occurs between artwork and viewer.

17. "Cindy Sherman Talks to David Frankel," *Artforum* 41, no. 7 (March 2003), p. 55.

18. It is interesting to note Krauss's certainty that Sherman's discursive horizon was more informed by critics' ideas—namely those of Crimp and Foster—than by the artists they discussed. I imagine the opposite is true, as evidenced by Sherman's process-based research of artists including Bellmer.

19. From handwritten notes by the artist, reproduced in *Cindy Sherman Retrospective* (MOCA, Chicago and MOCA, LA, 1997), pp. 184–185.

20. Significantly, given the small scale of the dolls, Sherman appears in none of the images, nor is it possible to speculate on her presence there. After seeing this show, I have not found an image from it referred to in any critical writings.

21. Cindy Sherman, Untitled Statement, *Documenta* 7, 1 (Kassel: Documenta, 1982) p. 411.

22. I am risking—by announcing that there is nothing *behind* the surface of clown or screen-actress—sliding into the definition of "woman as lack" as configured by Lacan in his explanation of masquerade. This is meant to be quite the opposite; rather I am hoping to suggest a move *away* from any interior/exterior postulation and move to an extended, undecidable one.

23. In "Armor Fou," Foster discusses Lacan's aggressivity/narcissism pair, particularly as it relates to binding/shattering in the fascist subject. Here, I will pursue a slightly different path—the transitional space between them—in order to posit the seemingly oxymoronic "feminine aggressivity."

24. Jacques Lacan, "Aggressivity in Psychoanalysis," *Ecrits,* trans. Alan Sheridan (New York: W. W. Norton, 1977), p. 19.

25. DeLillo, *The Body Artist,* p. 60. It is not inconsequential that Hartke's recently deceased husband, whose words continue to circulate throughout the book, never moored to any one body, was an art-film director.

26. DeLillo, *The Body Artist,* pp. 110–111.

27. Lea Vergine, *Body Art and Performance: The Body as Language* (Milan: Skira Editions, 2000), p. 7.

28. Ibid., pp. 9–12.

29. Ibid., p. 7.

30. For the earlier formulation, see Freud, *Totem and Taboo,* Standard Edition, Volume 13; for the later see Freud, *The Ego and the Id,* Standard Edition, Volume 19 (London: Hogarth Press: Institute of Psychoanalysis, 1953–1974). See also the definition for "Narcissism," in J. Laplanche and J. B. Pontalis, *The Language of Psychoanalysis,* trans. Donald Nicholson-Smith (New York: W. W. Norton, 1973), pp. 255–257.

31. The literal medium-specificity of narcissism was discussed in Rosalind Krauss's essay, "Video: The Aesthetics of Narcissism" *October* 1 (Spring 1976), which, bearing discursive horizons in mind, was published during the time frame in which Sherman was working on her *Film Stills.* Describing then-recent video practices as employing narcissism itself as a medium, Krauss defined the narcissistic turn as one that created "a collapsed present," (p. 53) "the body or psyche as its own surround," (p. 53) and a "mirror-reflection of synchronous feedback," (p. 55). Significantly, the only video works to circumvent the pitfalls of pure narcissism, in Krauss's view, sought to represent a rift in subjectivity and, simultaneously, in the technology that represented it. Richard Serra's *Boomerang* and Joan Jonas's *Vertical Roll* were two such examples.

32. Kaja Silverman, in 1996, however, embarks on a recasting of Sherman's work that does take love very much into account. Her essay on Sherman, "The Screen," claims that Sherman's work might perhaps encourage a kind of untraining of the eye, leaving nonideal bodies to be reseen as desirable and worthy of the gift of love. See Silverman's revised version of this essay, here titled "How to Face the Gaze," in this volume.

33. Vergine, *Body Art and Performance,* p. 8. The relationship between photography, which arguably can only display what has already passed, and performance, which exists only in the present, is an incredibly complex one. I am not proposing—to be clear—that Sherman's photographs are documents of works she has performed. Rather, I am suggesting that the role of the body in her work complicates distinctions between medium-based temporalities.

34. Douglas Crimp, "The Photographic Activity of Postmodernism," in this volume, pp. 36. It is significant that Crimp's discussion addresses theatricality and its relationship to photo-based practices of the 1970s.

Index

Page numbers in boldface type indicate illustrations.